artist has a responsibility to change the world, or they can do anything in the name of Art. Rather, it demonstrates the *way* of art: i.e., the *life* of art. How do we give a life to each art in our society? This task is not only fulfilled by artists, but also sustained by audiences.

The word "function" has been associated with a "functional object," which is linked to the realm of commerce in western art historical discourse. Fine art should not be consumed because it is *amoral* to do so in the western art convention. Morality is both a cultural value and a judgment. This judgment is passé because as contemporary artists no longer think in this manner. My investigation of Judd's furniture making shows that it is not merely about the production of furniture, but more about the *way* of life and how the artist related to a society. It is about Judd constantly struggling and coping with the dysfunctional society through his own ideas and means. I see Judd not only as an artist, but also as a responsible citizen who fulfilled his artistic ambition and missions through the realization of large-scale permanent installations in Marfa. Judd ranched his own large-scale permanent art installations because the current art museum system doesn't function for the *life* of his art. Judd made no distinction between art and functional objects in his total artwork.

While rethinking the meaning of "function" in art and society, I hope to introduce a wider discourse regardless of cultural differences. When artists ask how their society can function better, they are inevitably getting into the field of management. The concept of function is linked to the practice of management: i.e., making solutions and alternatives to solve or mitigate problems. Through art making, artists are aware of how society functions for better or worse based on individual's needs and happiness. Initially, Judd's furniture production was born out of the necessity. For Judd, fabrication of his own furniture was a simple way to fulfill his needs and take a charge of his living environments in Marfa. Soon, he developed his own large-scale art installations, total works of art, in order to give a life to his visions.

Because of moral and social obligations, Judd officially kept a distinction between his art and design projects; he didn't wish to confuse his audiences. For Judd, this moral reason was inherent: the implicit hierarchy of fine art over functional objects in the western culture. Scott Burton (1939-1989) has been seen as one of the leading artists investigating the assumptions underlying the distinction between design and art in both his work and writing. Burton used

"functional art objects" installed in public arena as a radical gesture to fight against this hierarchy because Judd's conception of "moral" was narrowly defined. Likewise, the art and design discourse of the 1970s focused on the truth in artwork; the high status of Fine Art was questioned. The postmodern cultural environment of the 1980s embraced functional art objects as Art because truth and beauty were no longer absolute values that defined artwork. In the 1990s, artists became increasingly aware of the loss of control wrought by powerful trends in globalization and institutionalization. With a wider scope, artists look for "ethical" value in organizations and for greater social function of art. The usable art of 1980s transformed into a larger arena where art is tested in society. The mission of functional art was to break the hierarchical boundaries of the old art institutional system in the 1980s. Whereas later, art was designed to "function" in a certain context so that our society might be better "functioning."

As the emphasis of usable art shifted from breaking boundaries to *functioning* in the real world, the artist's role in management increased. *Management* is an unfamiliar term in art historical discourse, but as art meets the utility and works with organizations we need to introduce this new perspective in order to investigate new forms of art.

This book examines Judd's furniture in the socio-cultural context of the 1970's, while paying attention to the later development of functional art's role in social change in the 1990s. The book illuminates Judd's political undercurrents and relationship to the progressive do-it-yourself cultural phenomenon as seen through his collaboration with local carpenters which created intentionally naïve-looking furniture in Marfa, Texas during the 1970s. Judd's furniture production moved toward a more sophisticated and skilled mode of fabrication in the 1980s, while his furniture and artwork became intertwined in the philosophical, the formal, and the realms of fabrication, installation, and marketing. This book demonstrates how Judd's furniture design became integral to the permanent installations he orchestrated in Marfa and how he eventually shaped a certain way of living into his carefully organized environments. The ambiguity of the distinctions between functional objects and art pieces in the Minimalist ambit stimulated a rise of usable sculpture created by a succeeding generation of artists, including Scott Burton. With respect to their emphasis on the role of the viewer or user, and on leading art into the everyday, Judd's and Burton's art-furniture both originated from aspects of individual presence and action in society rather than from a taste for good design.

The usable art generated by artists is intended both to *function* and to redefine how art *works* in a society. While constructing his total work of art in Marfa, Texas, Judd left practical lessons as to what worked and what did not work about the interplay between art and society. Burton attempted to break boundaries between fine art and design products in cultural institutions, whereas the later generation of artists in the 1990s extended their artwork and projects that *functioned* in a certain condition in a society. It may sound very simple but there is truth in the viewer's trust in the artist's ethical commitment toward social improvement and a better functioning society. We understand that art is not a panacea, but the existence of artists is equivalent to the action of citizenship in functional art. This book hopes to introduce its readers to this vision—how functional art exists in dysfunctional society.

ACKNOWLEDGEMENTS

This book has indebted me to a number of people. First of all, I thank my dissertation advisor, Anna C. Chave, for her encouragement and for pushing me to explore the topic farther and to arrive at interesting analyses in my dissertation. As I broadened my dissertation with an interdisciplinary scope, Peter F. Drucker's works on management provided me with valuable insights as to the relationship between art and society in relation to the very meaning of "function." Drucker (1909-2005), one of the fathers of management theory and practice, called himself a "Social Ecologist." He saw management as liberal arts because of its focused upon human beings and their organizations. His concept of a "functioning society" became key to rethinking the "functional art" generated by Judd and other artists. I attempt to investigate how functional art *operates* in our society because art doesn't exist alone, and the way in which Druker analyzed modern society inspired me to redefine the agendas of my writing.

I am especially grateful to fabricators of Judd's art and furniture—Peter Ballantine, Jim Cooper, Ichiro Kato, Jeff Jamieson, Rupert Deese, Alfredo Mediano, Ramon Nuñez, Lee Donaldson, Raoul Hernandez, and Ursla Menet at Lehni A.G.—for providing invaluable accounts of their experiences with and knowledge of making Judd's furniture and artwork.

Judd's daughter Rainer Judd was kind enough to share a memory of her father during our rocky drive to one of Judd's ranches on the occasion of the 2005 Open House in Marfa, Texas. Madeline Hoffmann, Michele F. Felicetta, Craig Rember, and Jennifer Moon at the Judd Foundation assisted my access to the Architecture Studio (the Bank) in Marfa and generously responded to a lot of my inquiries on Judd's furniture production. Marianne Stockebrand, Rob Weiner, Nick Terry, Francesca Esmay, and David Tompkins at the Chinati Foundation were helpful in discussing Judd's furniture design with me when I visited Marfa in 2005 and 2006. The Chinati Foundation invited me in December 2005 and June 2006 as a visiting scholar while I conducted interviews and research in Marfa. Dennis Dickinson at 2D Gallery and Elizabeth and Josh Burns in Marfa were greatly instrumental to my research in that town, and I cherish their friendship.

vi ACKNOWLEDGEMENTS

My dissertation reader Rosemarie Bletter has been helpful in discussing with me the nature of craftsmanship in the do-it-yourself culture in the United States. Claire Bishop's work on installation and participation-oriented art was inspirational. Romy Golan supported my dissertation from the outset and introduced me to the dissertation's outside reader, Christine Mehring. I thank Urs Peter Flückiger for sharing his knowledge of Judd's renovation of buildings in Marfa, and Keith Jordan for enlightening me about philosophies of anarchism. Special thanks go also to individuals who were associated with Judd and who were generous enough to share their experiences of working with the artist, such as Barbara Haskell, Dudley Delbalso, Lauretta Vinciarelli, Rhona Hofmann, Gianfranco Verna, Ellie Meyer, Piet de Jonge, Elisabeth Cunnick, Hester van Roijen, Ulrich Fiedler, William Aronowitsch, Robert Halpern, and Shaw Skinner.

I am thankful to all the galleries and museums I have contacted for their archival materials. In particular, my gratitude goes to Amanda Parmer at the Paula Cooper Gallery, Kristen N. Leipert at the Whitney Museum of American Art, Michelle Bolinger at Rhona Hofmann Gallery, Thimo te Duits and Jacqueline Rapmund at Museum Boymans-van Beuningen, Rotterdam, Annemarie Verna at Annemarie Verna Gallery, Katharina Tiemann at LWL-Archivamt für Westfalen in Münster, Megan Stillman at the Museum of Fine Arts in Boston, Norma Sindelar at the Saint Louis Art Museum, Jon Mason at PaceWildenstein Gallery, Jon Tomlinson and Rebecca Kong at Artware Editions, Natasha Roje at Gagosian Gallery, Sally Hough and Ekaterina Kitaina at David Gill Galleries, Jennifer Tobias, Michelle Harvey, and Mattias Herold at The Museum of Modern Art, New York, and Ted Mann at the Solomon R. Guggenheim Museum.

My dissertation was funded in part by a grant from the Catherine Hoover Voorsanger Fellowship. I appreciate the family and friends of the late Catherine Hoover Voorsanger for their spiritual and financial support of my project. I thank David Humphries and Deborah Helaine Morris for their comments and for editing my writings carefully and patiently.

The materialzation of this sharp-edged book is indebted to the innovative publisher Bunshindo. Their editors, Takashi Maeno and Katsunori Yamazaki, provided genuine understanding and support for bridging art and management. I can't thank them enough. Lastly and importantly, without my family I would not have been able to accomplish this work. My mother M. K. Murayama, a brave woman, traveled with me to the 2005 Open House in Marfa. She and my father,

Motofusa Murayama, cheered me throughout my research and writing process. I dedicate this dissertation to them.

Filling the Gap between Amateur and Professional … 64
Marxist and Other Critiques of Do-It-Yourself … 66
Collaboration between Judd and His Fabricators … 68
Judd's Open-Ended Control … 70

CHAPTER 3
THE INTERRELATIONSHIP OF FURNITURE AND SCULPTURE … 73

Furniture Springing from Art Practices … 73
Ambivalence of "Furniture is Furniture" in Judd's Writings … 78
The Fabricators of Judd's Artwork and Furniture … 84
Furniture and Art Making Unfolded Side by Side … 87
Seamless and Decorative Joints … 87
Technical Differences … 89
Symmetry and Serial Variation … 92
Single and Multiple Colors … 93
Marketing Judd's Furniture … 96
Installations of Judd's Furniture and Artwork … 103

CHAPTER 4
TOTAL WORK OF ART AND SOCIAL ECOLOGY … 112

Private and Public Spaces as Counterparts … 112
A Simple Lifestyle and Renovation Scheme … 113
Towards the Makings of an Aesthetic Lifestyle … 121
Living with Judd's Design = Living like Judd … 126
A Life Attached to the Land: Social Ecology … 130

CHAPTER 5
ART INTO LIFE: DONALD JUDD AND SCOTT BURTON … 137

Theater and Minimalism … 137
Comparing Furniture by Judd and Burton … 143
Art and Design Discourse Is Real Furniture Real Art? … 152
No Utopian Unity between Art and Design … 156
Social Function of Art … 160

CONCLUSION … 169

APPENDIX
FURNITURE COLLECTIONS AND INSTALLATIONS AT THE
ARCHITECTURE STUDIO, MARFA 173

BIBLIOGRAPHY 181

ILLUSTRATIONS

Figure
1. Robert Rauschenberg, *Pilgrim*, 1960, oil, pencil, paper, printed paper, and fabric on canvas, with painted wood chair, 6 ft 7.25 x 4 ft 5.87 x 1 ft 6.62 in. (201.3 x 136.8 x 47.3 cm).
2. Marcel Duchamp, *Bottle Rack*, lost original 1914, steel, height 24.8 in. (63cm).
3. Marcel Duchamp, *In Advance of the Broken Art*, lost original 1915, view of Donald Judd's 101 Spring Street building, New York
4. Constantin Brancusi, *Endless Column*, Tirgu Jiu, Romania, 1938
5. Carl Andre, *Lever*, original 1966, reconstruction 1969, 137 firebricks, 4.5 x 8.9 x 348 in. (11.4 x 22.5 x 883.9 cm).
6. Dan Flavin, *the diagonal of May 25, 1963 (to Constantin Brancusi)*, 1963, yellow fluorescent light, length 8 ft. (244 cm).
7. Richard Artschwager, *Table with Pink Tablecloth*, 1964, Formica on wood, 25.5 x 44 x 44 in. (64.8 x 111.8 x 111.8 cm).
8. Claes Oldenburg, *Soft Switches*, 1964, Vinyl filled with Dacron and canvas, 47 x 47 x 3.62 in. (119.4 x 119.4 x 9.1 cm).
9. Dan Graham, "Homes for America," 1966-67, the artist's original layout of his essay published in *Arts Magazine* with different images, written and printed texts and black-and-white and color photographs mounted on illustration board 2 panels, each 40 x 30 in. (101.6 x 76.2 cm).
10. Sol LeWitt, *Serial Project No.1 (ABCD)*, 1966, baked enamel on aluminum, 20 x 163 x 163 in. (51 x 414 x 414 cm).
11. Donald Judd, Untitled, 1967, lacquer on galvanized iron, 5 x 40 x 8.75 in. (12.7 x 101.6 x 22.2 cm).
12. La Mansana de Chinati (The Block), Marfa, TX view of the South Library with furniture by Donald Judd, Image courtesy JuddFurniture.com/Judd Foundation.
13. Advertisement by Donald and Julie Judd, from Aspen Times, 29 August 1968, 2C, reprint in Donald Judd, *Donald Judd, Complete Writings 1959-*

xiv ILLUSTRATIONS

 1975, (Halifax: Press of the Nova Scotia College of Art and Design; New York: New York University Press, 2005), 218-19.
14. Map of Marfa in Texas
15. Donald Judd, *American Flag in Negative Colors of the Spectrum*, c.1968, cotton, 70 x 45 in. (177.8 x 114.3 cm).
16. Lujan House, Marfa, photograph, 2006
17. Lauretta Vinciarelli, Desk, 1977, plywood, fabricated by Peter Ballantine
18. Donald Judd, Children's desk, 1978, pine, 30 x 48 x 32 3/4 in. (76.8 x 121.4 x 83.1 cm). fabricated by Donald Judd, *A good chair is a good chair*, Ikon, 2010, Image courtesy Ikon, photography: Stuart Whipps.
19. Donald Judd, Children's bed #8, 1977, pine, 82.25 x 94 x 12 in. (209 x 239 x 142 cm). fabricated by Donald Judd, Image Courtesy Judd Foundation/Judd Furniture
20. Arena, Marfa, interior view with large tables, chairs, and bench by Donald Judd
21. Arena, Marfa, outside view with a table, benches, grill by Donald Judd, photograph 2005
22-a. Dowel joint
22-b. Biscuit joint
23. Ramon Nuñez at the workshop of Chinati Foundation, Marfa, photograph, 2006
24. Donald Judd, Table and benches outside Arena, Marfa, Photograph 2005
25. Donald Judd, Untitled, 1965, galvanized iron, 7 units, each 9 x 40 x 30 in. (23 x 101.6 x 76.2 cm) with 9 in. (23 cm) intervals.
26. Donald Judd, Untitled, 1966, painted steel each 48 x 120 x 120 in. (121.9 x 304.8 x 304.8 cm) Whitney Museum of American Art, New York, Photography by Sheldan C. Collins ©Judd Foundation/VAGA, NewYork/JASPAR, Tokyo 2014
 D0852
27. Donald Judd, Table, 1958-59, mahogany, 8 x 22.5 x 29.5 in. (20 x 57.5 x 74.3 cm). constructed without nail by Donald Judd
28. Donald Judd, Bookshelves, 1966, pine, 13.4 x 33.5 x 9.5 in (34 x 85 x 24 cm); 13.6 x 33.5 x 9.5 in. (34.5 x 85 x 24 cm); 8.5 x 33.5 x 9.5 in (21.5 x 85 x 24 cm). fabricated by Donald Judd and his father R.C. Judd, *A good chair is a good chair*, Ikon, 2010, Image courtesy Ikon, photography: Stuart

Whipps
29. Donald Judd, Untitled (Double Coffee Table), 1970-71, stainless steel, 22 x 48 x 36 in. (56 x 121.9 x 91.4 cm). fabricated by Bernstein Brothers, New York
30. Donald Judd, Untitled, 1965, brown enamel on hot-rolled steel, 22 x 50 x 37 in. (56 x 127 x 94 cm).
31. Dovetail joint
32. Donald Judd, Untitled, 1986, Douglas fir and orange Plexiglas, 6 units, each 39.37 x 39.37 x 29.5 in. (100 x 100 x 75 cm) with 19.7 in. (50cm) intervals.
33-a. Judd Furniture chair #84-85 colored Fin-Ply (suite of 5, styles 1, 7, 6, 2, 10) view 1, 30 x 15 x 15 in. (76 x 38 x 38 cm).
33-b. Judd Furniture chair #84-85 colored Fin-Ply (suite of 5, styles 1, 7, 6, 2, 10) view 2, Image courtesy Judd Furniture.com/Judd Foundation
34. Judd Furniture Seat-Table-Shelf #57/#58, 18 variations of aluminum furniture pieces in 20 painted colors, 1984, painted aluminum, first fabricated by Wili Bühler at Lehni A.G., Switzerland, Image Courtesy Judd Furniture.com/Judd Foundation
35. Donald Judd, Untitled, 1991, enameled aluminum, 59 x 64 x 295 in. (149.9 x 162.6 x 749.3 cm).
36. Installation view of the exhibition *Donald Judd, Sculpture/Furniture* (1985), Rhona Hoffman Gallery, Chicago, Image Courtesy Rhona Hoffman Gallery
37. Installation view of the exhibition *Donald Judd Retrospective*, Whitney Museum of American Art, New York, 1988, photography by Jerry L. Thompson, ©Judd Foundation/VAGA, NewYork/JASPAR, Tokyo, 2014 D0852
38. Installation view of the exhibition *Donald Judd, Furniture Retrospective*, Museum Boymans-van Beuningen, Rotterdam, 1993
39. Artillery Shed 1, Marfa, interior view with mill-aluminum works by Donald Judd
40. La Mansana de Chinati (The Block), view of East Building, bedroom with art works and a bed by Donald Judd and a bench and a chair by Gustav Stickley
41. 101 Spring Street building, view of fourth floor, dining room with Judd's table and Zig-Zag Chairs by Gerrit Rietveld, artworks by Dan Flavin, Frank

INTRODUCTION

Art and Design Discourse

Although Donald Judd had become a canonical artist of Minimalism, by the mid-1960s, his furniture, initially made for his private use beginning in 1966, has been almost invisible, not only in official museum spaces, but also in the art historical and design discourse of the United States. First, American formalist art critics largely dismissed the intertwining of art and everyday objects which had been one of the radical modernist practices of the pre-World War II period.[1] Secondly, since Judd's furniture does not fit neatly into either the fine art or design categories, it is prone to being overlooked. Finally, artists who design functional objects often meet with a degree of skepticism among critics on account of the objects' inevitable enhancement of the commodity status of art.[2] Countering such assumptions, this dissertation will examine Judd's neglected furniture production and explore its significant social and cultural dimensions.

The connections between art and design in modernist art movements had a critical influence on Judd's artwork and furniture. Judd's factory-produced art and functional objects had many historical precedents and parallels: the experimental products of the Bauhaus; some innovations of the De Stijl members and the Russian Constructivists; Duchamp's ready-mades; and Pop Art's consumer culture-

1 Notably, Clement Greenberg criticized Minimalist "boxes" for resembling "Good Design" products in his essay "Recentness of Sculpture" in American Sculpture of the Sixties (Los Angeles: Los Angeles County Museum of Art, 1967); reprint in *Minimal Art: A Critical Anthology*, ed. Gregory Battcock (New York: E.P. Dutton, 1968; reprint Berkeley, Calif.: University of California Press, 1995), 185–86.
2 For example: "When Calvin Klein opened his flagship store on Madison Avenue last year, embellished with furniture designed by the late Donald Judd, one could still wonder what the notorious anarchist Judd might have said, if heard in Klein's court"; Benjamin H.D. Buchloh "Critical Reflections," *Artforum* 35, no.5 (January 1997): 69. Klein's choice of Judd's furniture was not merely a casual one because the Minimalist architect John Pawson, who designed the interior of Klein's flagship store, had flown Klein to Marfa, Texas to look at Judd's works.

oriented works, as epitomized by Claes Oldenburg and Richard Artschwager. In general—whether he acknowledged it or not—these practices had a major impact on the ways in which Judd's artwork and furniture were created and configured. Further, while Judd's industrial-looking art and design objects would seem to represent a counter to the tactile warmness of sculptures and functional objects by Constantin Brancusi (1876–1957) and Isamu Noguchi (1904–1988), all three artists were profoundly engaged with issues entailed in design and with the articulation of space.

Although there have been several exhibitions in past years exploring the interrelationship between art and design, a substantial discourse has not yet been established. Alex Coles's *DesignArt, On Art's Romance with Design* (2005) and an anthology of essays and interviews edited by the same author, *Design and Art* (2007), offered some contributions to this emerging scholarship. An exhibition, entitled "Design ≠ Art, Functional Objects from Donald Judd to Rachel Whiteread" held at the Cooper-Hewitt National Design Museum in 2004 was another attempt to explore this arena.[3] Barbara Bloemink, curator of that show, pointed out that the distinction between fine art and design entailed "a fairly recent Western conceit" of art being "non-functional."[4] She observed that this conceit was in part prompted by government-sponsored art academies which placed painting and sculpture at the highest position among the visual arts in the late eighteenth century. Artwork doesn't exist in a vacuum, as Bloemink rightly claimed: "Throughout Western history, art has functioned as religious, ideological, and political propaganda, economic currency, commodity, decoration, and as a vehicle for personal self-aggrandizement."[5] Examining the development of functional objects made by Minimalist and post-Minimalist artists, Bloemink noted that, unlike Judd, who was preoccupied with the Kantian definition of fine art existing for the eyes, as opposed to design existing for its utility, many post-

[3] Other examples of exhibitions noted by Coles: "Trespassing: Houses x Artists" at the MAK Center for Art and Architecture, Los Angeles, 2003; "Beau-Monde: Toward a Redeemed Cosmopolitanism," Santa Fe, 2001–02; "Against Design" at the Institute for Contemporary Art, University of Pennsylvania, Philadelphia, 2000; and "What If? Art on the Verge of Architecture and Design" at the Moderna Museet in Stockholm, 2000.

[4] Barbara Bloemink, "Introduction: Sameness and Difference," in *Design ≠ Art, Functional Objects from Donald Judd to Rachel Whiteread* (New York: Merrell and Cooper-Hewitt, National Design Museum, 2004), 18.

[5] Ibid.

Minimalist artists refused to categorize their own work as either art or non-art.[6] Likewise, in the conclusion to *DesignArt*, Coles suggests that currently it is the perception of the user and beholder that decides whether a seemingly hybrid object made by an artist should be classified as art or as a design object.

In short, present-day artists in general no longer insist upon their supreme right to classify their works as belonging to either hierarchical status—art or non-art; instead, they are more open to the input and participation of audiences and users. Dichotomized, rigid, hierarchical ideas about art and use value seem to be absent among contemporary artists many of whom are more concerned with living circumstances and environments, including the ecological crisis, globalization, customized lifestyles, cultural identity, and local community issues interrogated at the personal or public level. Artists nowadays not only make usable objects for their own personal use, but also test them at venues inside and outside of museums, including public spaces, local community places, private homes, or cyberspace.[7] Likewise, art historians and critics generate a wholistic and wider

[6] Ibid., 33; Bloemink, "Dialogues on the Relationship of Art and Design: Donald Judd," in Design ≠ Art, 37. The terms "art" and "fine art" tend to be used almost as synonyms in the art and design discourse. The definition of the word "art" includes: "The expression or application of creative skill and imagination, typically in a visual form such as painting, drawing, or sculpture, producing works to be appreciated primarily for their beauty or emotional power. Also: such works themselves considered collectively." "Fine art" means: "In pl., the arts which are concerned with 'the beautiful', or which appeal to the faculty of taste; in the widest use including poetry, eloquence, music, etc., but often applied in a more restricted sense to the arts of design, as painting, sculpture, and architecture. Hence in sing. one of these arts; also transf. an art or employment requiring refined and subtle skill comparable to that required in the practice of 'the fine arts'." Meanwhile, "non-art" is defined as an adjective: "That [which] is not connected with the creative (esp. visual) arts; that does not constitute what is normally thought of as art," and as a noun: "Something that is not art, or does not conform to the accepted idea of art; spec. a form of art which rejects conventional modes and methods. Also, more rarely: artistic creation which avoids artifice." Oxford English Dictionary, 2d ed., s.v. "art" "fine art" and "non-art." However, any attempt to define fine art and non-art seems to be impossible once artists begin to deal with non-traditional art materials or everyday, functional objects. See Ben Tilghman's "Crossing Boundaries," *British Journal of Aesthetics* 46, no.2 (April 2006): 178–91, for an essay on the unclear boundaries between art and non-art within the contemporary practices of the art world. Tilghman argues that there should be more emphasis placed on observing individual cases, in view of the cultural contexts of place, the social concerns of the time period, and individual responses to artwork, instead of attempts to define art as opposed to non-art according to metaphysical judgments or mere differences of taste.

[7] By way of example, consider the cases of: Andrea Zittel, Joep van Lieshout, Lucy Orta, N55, Superflex, Jorge Pardo, Rirkrit Tiravanija and Liam Gillick. Interviews with these artists about the ↗

scope to investigate such artwork, while rediscovering the concept of a "total work of art."

The Influence of Marcel Duchamp and Constantin Brancusi

The hierarchy between art and non-art in the history of modern sculpture was first contested by Marcel Duchamp's ready-mades in the 1910s and by Constantin Brancusi's complicating of the distinction between bases and sculptures from the 1910s forward. Members of the Constructivist, Bauhaus, and De Stijl movements were also precursors in exploring the unification of art and life in the inter-war period in Europe. Their progressive political ideas and, in some cases, uplifting mystical visions were infused into their furniture and interior design work in ways that were meant to inspire individuals and so, eventually, to help regenerate society as a whole. In contrast, Duchamp and Brancusi advanced a critique of western fine art practices or cultural conventions in more individual ways. As such, their objects seem to lack a programmatic ambition to systematically change the nature of the world. In the Cold War political and cultural climate of the United States, however, the impact of Duchamp and Brancusi on an emerging generation of Minimalist artists seems to have been stronger, generally speaking than the impact of Constructivism, De Stijl, or the Bauhaus. Pertinent factors may include the actual presence of Duchamp in the U.S. and the prominent representation of his and Brancusi's works in U.S. collections.[8]

↘ design aspect in their projects may be found in Coles's *Design and Art*.

8 Although the design projects of Russian Constructivism were occasionally visible in New York through a show such as "Art in Revolution: Soviet Art and Design Since 1917," held at the New York Cultural Center in 1971, I have been unable to find any extensive comments from Judd on the Russian Constructivist experiments in bridging art and life through their interior, fashion, textile, poster, and theater designs. Judd did admire paintings by Kasimir Malevich and wrote an essay "Malevich: Independent Form, Color, Surface" (1974) with an emphasis on the unity of color and form on the surfaces of Malevich's canvases. Judd also extensively collected furniture pieces by members of the Bauhaus and De Stijl, as I discuss in Appendix A, "Furniture Collections and Installations at the Architecture Studio, Marfa." Judd's collections of early modernist furniture do not correspond with complete agreement on the prewar idealist vision of uniting art and life with the goal of regenerating society as a whole. Rather, his was more of a pragmatic, solitary vision of the individual whose immediate approach to everyday life was inspired by the philosophies of anarchism and pragmatism. See: Art Council of Great Britain, *Art in Revolution: Soviet Art and Design since 1917* (London: Arts Council of Great Britain, 1971). This show opened at the Hayward Gallery ↗

Duchamp's first ready-made emerged in 1913 when he combined a bicycle wheel and a kitchen stool. His *Bicycle Wheel* (lost original 1913; reproduction 1951) was a kind of Cubist collage in a three-dimensional form. As it unfolded, his practice of producing ready-mades increasingly articulated a critical approach to art-making convention. In 1915, Duchamp gave a seemingly contingent title, "In Advance of the Broken Arm," to a snow shovel he allegedly purchased at a hardware store in New York. Through this gesture of giving a name to a mundane object, Duchamp posed a social and semantic question as to how and when an ordinary object may be transformed into a fine art object. Was it the moment when Duchamp chose the shovel; when he gave it a title; or when it was purchased by art collectors and cultural institutions?

Duchamp's critical anti-art gesture of insinuating a commonplace object into a high art context was barely noticed by artists in the United States during the heyday of Abstract Expressionism in the early 1950s. Abstract Expressionist artists based in the New York art scene mostly devoted themselves to creating original, fine artwork distinct from that of their European precursors. In their journey of searching for cultural and individual identity through their works, these artists tried to express their subjectivities through distinctively singular, abstract formal vocabularies. They were often inspired by spiritual considerations found in diverse religious experiences of awe and the sublime, in Native American rituals, in the realm of a human collective psyche as expressed in Jungian terms, or in attachment to natural landscapes. It is not surprising that in this postwar climate concerned with the discovery of cultural identity through artistic expression, a half Japanese, half American artist, Isamu Noguchi would travel extensively to east and south Asia, including to Japan, his father's land. Although Noguchi's sculpture paralleled that of certain New York School artists, in Japan he discovered what became a lifelong project after 1951—designing lamps he called *Akari*, light sculptures that are both an art medium and a light source. Thus, he decisively separated himself from the exclusive fine art-orientation of his U.S. peers.

Some Neo-Dada and Pop artists in the United States continued to explore cultural identity in their artworks, in part by discovering their subjects in

↘ in London and traveled to New York and to the Art Gallery of Ontario in Toronto. Donald Judd, "Malevich: Independent Form, Color, Surface," *Art in America* 62, no. 2 (March/April 1974): 52–58.

American society. For instance, Jasper Johns's familiar subject matter includes a series of U.S. flags begun in 1954, and variations on U.S. maps begun during the 1960s. Around the same time, Robert Rauschenberg adopted the Duchampian, satirical gesture of using found objects in his "combines." But, by contrast with Duchamp, Rauschenberg pursued more of a creative practice for discovering an artistic medium from within his everyday environment. His seemingly contingent, yet calculated combinations of familiar objects and imagery invited layered interpretations and open-ended narratives from the mind of each viewer. Unlike Duchamp's relatively small-scale found objects, Rauschenberg's combines are often large enough to physically confront viewers. For instance, a chair attached to a canvas seems to evoke the invisible presence of a figure sitting on the chair or to invite a viewer to interact with it. (fig.1) Although many saw Pop Art as a triumphant artistic manifestation of the affluence of mass culture and the proliferation of the commodity in the postwar United States, Andy Warhol's adaptation of Duchamp's example went farther, amounting, arguably, to a profound cultural and social criticism. His deliberate choice of subjects such as Campbell's soup cans, a Brillo box, and images of celebrities from films and politics afforded acute critical insights into the consumer-oriented mass culture and production system existing in United States society in the 1960s.

It seemed to many that the adaptation of Duchamp's ready-mades by leading Minimalist artists, such as Judd, Carl Andre, Dan Flavin, and Robert Morris, was focused on their formal aspects, by contrast with the socially-conscious approach of certain Neo-Dada and Pop artists. Donald Judd acquired and installed later reproductions of Duchamp's *Bottle Rack* (lost original 1914) and *In Advance of the Broken Arm* (lost original 1915) at his residence at 101 Spring Street in SoHo, but Judd never fully embraced Duchamp's stance. (fig.2/fig.3) Judd evidently didn't express any doubt about the higher status of art over functional objects at any point during his career. Likewise, Dan Flavin treated found objects as more of a precious art form. Flavin's studio on the lower west side of New York City was filled with things he explained as "curiosities—a dance of strung out objects—arranged like a strange, dirty, cumulative composition but with a random look. All the materials displayed there were found in my wanderings along the waterfront."[9]

9　Dan Flavin, "'… in daylight or cool white,' an autobiographical sketch," *Artforum* 4, no.4 ↗

Flavin soon felt dissatisfied with his sentimental ritual of rescuing and commemorating urban debris: "By 1961, I was tired of my three year old romance with art as tragic practice. I found that all my small constructions, with the exception of 'mira, mira,' were memorial plaques," and he decided to "change those small celebrations into something grander—a more intelligent and personal work." [10] Then Flavin developed a series of "icons," painted square structures with electric lights attached. Thus, the laconic yet powerful presence of actual light emanates from a blank painted surface without any imagery of saints or religious texts. Flavin used the term "icon" not to indicate a strictly religious object; he was interested in the rhetorical relationship between the blank square structure and the placement of actual light "over, under, against" it.[11] Unlike Duchamp's ready-mades, eventually circulated in a form of reproductions or editions without originals, Flavin's artworks began as singular entities of "memorial plaques." Using fluorescent light as an artistic medium, Flavin developed effectively spatial art pieces installed at and incorporated with gallery and museum locations during the 1960s. As such, his adaptation of artificial light doesn't completely continue the Duchampian use of found objects as a means to critique cultural institutions.

Robert Morris's early works, such as *Box With the Sound of Its Own Making* (1961) and *I-Box* (1962), seem to entail a clever adaptation of Duchampian wit and humor. Morris's *Box With Sound* contains audio equipment which conveys the sound of making the box. In contrast to the known source of sound in Morris's *Box With Sound*, Duchamp's *With Hidden Noise*, a ball of twine sandwiched between two brass plates, contains an unknown rattling object designed to make the beholder wonder about the hidden item. The identity of the object in Duchamp's *With Hidden Noise* remains a mystery. In contrast, Morris tended to clarify the identity of the substances inside of his Duchampian objects. Thus, Morris placed his proud, humorous male nude self-portrait photograph inside the *I-Box*, whereas Duchamp is known for creating a pseudo female persona, whom he humorously named Rose Sélavy—destabilizing the specific gender of the artist.

It seems that Judd, along with most of the Minimalist artists, somewhat tamed

↘ (December 1965): 22.
10 Ibid.
11 Flavin wrote: "I used the word 'icon' as descriptive, not of a strictly religious object, but of one that is based on a hierarchical relationship of electric light over, under, against and with a square-faced structure full of paint light." Ibid., 24.

Duchamp's conceptually-invested, perplexingly provocative, anti-aesthetic gestures and turned away from his destabilizing plot against the norms of the art-making process and the ordained role of the artist, while generally embracing the "thingness" and "material fact" of ready-mades as paradigmatic of a new vocabulary for creating fine art in the early 1960s.

Considering the Minimalists' preoccupation with artworks situated in between art and everyday objects, Brancusi provided more practical, lasting, and rational models for Judd, Morris, Carl Andre, and Flavin to adopt. Scholars have rightly identified Brancusi's influence on Minimalism. For instance, Francis Naumann pointed out that Andre's approach to materials and techniques in his works of the late 1950s reflected Brancusi's *Endless Column* (fig.4) and its repetitions of the same unit, which was echoed in Judd's "stacks" of boxes in the mid-1960s as well.[12] In 1966, Robert Morris wrote his master's thesis on the morphological aspects of Brancusi's work while at Hunter College, City University of New York.[13]

Anna Chave's in-depth investigation of Brancusi's sculptures, pedestals, and studio environment in her *Constantin Brancusi, Shifting the Bases of Art* (1993) illuminates how Brancusi subverted the western social hierarchy between fine art and design objects through his creation of bases as independent, unique objects:

> *The Endless Column* could function as base, as sculpture, as architectural element, or as monument: almost all sculptural functions rolled into one. By making a sculpture that supported itself, or a base that was sculptural, Brancusi subverted the hierarchy of objects inherent in the mounting of sculpture. By making a column without a capital, for that matter, he eliminated precisely that element of columns that, in the classical tradition, indicates their order (Doric, Ionic, Corinthian), and by extension, their social status.[14]

Chave continued to argue that through these methods, Brancusi not only restructured the meaning of sculpture, but also incorporated sculpture into its

12 Francis Naumann, "From Origin to Influence and Beyond: Brancusi's 'Column without End'," *Arts Magazine* 59, no. 9 (May 1985): 112–18.
13 Ibid.
14 Anna C. Chave, *Constantin Brancusi, Shifting the Bases of Art* (New Haven: Yale University Press, 1993), 247.

surrounding environments:

> By rejecting conventional pedestals designed to elevate and isolate sculpted objects from mundane objects, Brancusi *de*based sculpture and reaffirmed its identity as an object among objects. From another perspective, however, Brancusi rebased sculpture on sculpted mounts of his own design, thereby articulating his work's relation to its context and assuming a measure of control over the terms of display. In short, Brancusi did not see his purview or responsibility as an artist as ending at the limits of the art object in the accustomed way, but as extending to encompass the relation of the object to its surroundings.[15]

The destabilization of the hierarchical relationship between bases and sculptures explored in Brancusi's works had a crucial impact on the way artists reinvented art media at the dawn of Minimalism. Andre himself said of his piece *Lever* (1966), consisting of 137 firebricks lined up on the floor, "All I'm doing is putting Brancusi's *Endless Column* on the ground instead of the sky."[16] (fig.5) Brancusi provided the lesson of sculptural elements entering into spaces. "I wanted to make sculpture the space of which you could somehow enter into," said Andre.[17] Flavin came up with a work entitled *the diagonal of May 25, 1963 (to Constantin Brancusi)* (1963) using a strip of commercially available fluorescent light displayed at a forty-five degree angle directly attached to the wall. (fig.6) He developed the idea via Brancusi's *Endless Column*: "It occurred to me then to compare the new 'diagonal' with Constantin Brancusi's past masterpiece, 'the endless column.' That 'column' was a regular formal consequence of seemingly numerous similar wood wedge-cut segments surmounting one another—a hand hewn sculpture (at its inception)." Flavin perceived that Brancusi's *Endless Column* and his own *diagonal* both structurally ascended into spaces. For Flavin, *Endless Column* connotes an "archaic mythologic totem," whereas his *diagonal* has "the potential for becoming a modern technological fetish."[18]

15 Ibid.
16 Carl Andre, quoted in David Bourdon, "The Razed Sites of Carl Andre, A Sculptor laid low by the Brancusi Syndrome," *Artforum* 5, no.2 (October 1966): 15.
17 Carl Andre, "Carl Andre on his sculpture II," *Art Monthly* 17 (June 1978): 9.
18 Flavin, "… in daylight or cool white.," 24.

Brancusi's influence in destabilizing the status of art media was also an important precedent for Judd's characterization of "new art" as something other than the conventional forms of painting or sculpture in his iconic essay "Specific Objects" (1965). Once the concept of the autonomy of painting or sculpture lost its absolute validity, artwork went beyond its physical and semantic confinement in traditional art forms. Neo-Dada, Happenings, Fluxus, new dance, Pop Art, and Minimalism were radical artistic movements that occurred almost simultaneously while Judd himself observed them as they unfolded in New York City during the late 1950s and the 1960s. However, as an art critic Judd tended to focus on formal qualities: compositions, colors, and conditions of material surface in his exhibition reviews of new artwork, regardless of any association the work might have with everyday objects. Judd wrote of Robert Rauschenberg's paintings, combines and drawings shown at the Jewish Museum in 1963:

> Rauschenberg is almost the only major artist using the traditional European structure in a way that both retains its quality and is credible and strong. The combination, both the basic schemes and the small parts, is a direct continuation of rationalistic European composition. The color, and the brushwork in another way, is also traditional.[19]

Obviously, Judd was not so much paying attention to the fragmented narratives with political and personal implications found in the combines.

Agendas of Taste in Art

In the New York art scene, Richard Artschwager, who has been loosely associated with Pop Art, Minimalism, and Conceptualism, presented an interesting body of artworks in the 1960s. Artschwager's use of Formica[20] in his furniture-like objects

19 Donald Judd, exhibition review of Robert Rauschenberg show at the Jewish Museum, April 1-May 1, *Arts Magazine* 37, no.9 (May/June 1963); reprint in *Donald Judd, Donald Judd, Complete Writings 1959-1975* (Halifax: Press of the Nova Scotia College of Art and Design; New York: New York University Press, 2005), 86.
20 Formica is a brand name for a countertop material made out of decorative paper and laminate. The name of the brand became so well known that by the 1950s it signified a product in itself. I adopt the word Formica because Artschwager also uses the name of the brand when he discusses the product.

reveals the impact of consumer orientated furniture design and the methods of industry in the United States. (fig.7) He earned his living as a furniture maker after 1950 and fabricated custom-made fine furniture constructed with expensive, beautiful wood.[21] Artschwager considered "Formica, the great ugly material, the horror of the age" and so he deployed it to question the reign of good taste in fine art practices.[22] His three-dimensional, furniture-like pieces are made of two-dimensional, plastic sheets of a photographic, fake surface that, for instance, resembles the fine materials of wood. Artschwager described his *Table with Pink Tablecloth* (1964) as follows:

> It's not sculptural. It's more like a painting pushed into three dimensions. It's a picture of wood. The tablecloth is a picture of a tablecloth. It's a multi-picture. There is something special about furniture. Pieces of furniture are close to the human scale. This gives furniture a human quality. It relates more intimately to the body in so many ways. You have to think about it—the shapes, the meaning.[23]

The furniture-like object on a human scale evokes the beholder's personal consciousness of the condition of a living environment full of mass-produced, functional objects. Artschwager's furniture-like objects, with their critical stance, amount to a clever criticism of the reality of everyday life comparable to Oldenburg's soft sculptures which mimic and amplify functional objects. (fig.8) However, Judd had contrasting views of Oldenburg and Artschwager, and his reviews clearly indicate his preference for the former artist, though he was not

21 In the 1950s Artschwager's brother-in-law introduced Artschwager to his relatives who hired the artist to make furniture. Artschwager made fine pieces of furniture in small numbers in the beginning. As the business grew, Artschwager and his crew supplied their furniture to Pottery Barn, a home-furnishing retailer backed by the postwar housing boom. As a manufacturer of furniture, Artschwager was a successful "petit-bourgeois businessman" in his words. But, everything changed when he was put into terrible debt by a loft fire in 1958. The event was a turning point for the artist to restart his art career, and he began to see furniture in a new light inspired by Duchamp's ready-mades. Steven Henry Madoff, "Richard Artschwager's Sleight of Mind," *Art News* 87, no.1 (January 1988): 114–16.
22 Richard Artschwager, interview with Jan McDevitt, "The Object: Still Life," Craft Horizon 25, no.5 (September/October 1965); reprint in *Richard Artschwager: Up and Across* (Nuremberg, Germany: Verlag für moderne Kunst, 2001), 130–32.
23 Ibid.

entirely articulate about his attraction to Oldenburg's works. Judd wrote, "I think Oldenburg's work is profound. I think it's very hard to explain how." [24]

Oldenburg's soft objects such as a light switch, toaster, and typewriter gave Judd the strong impression of a single wholeness of form and an emotive anthropomorphic shape that subtly changes over time.[25] Although both Artschwager's and Oldenburg's works deal with the representation of functional objects, Oldenburg's soft sculptures are removed from the actual dimensions of everyday products, whereas Artschwager's furniture-like objects are approximate to the scale of ordinary furniture. It seems that Judd was moved not by the everyday subject matter, but by the animated, gravitational materiality of Oldenburg's soft objects, their being out of an everyday context due to their blown up sizes. In other words, for Judd, Oldenburg's representational objects somehow maintained the integrity of their fine art status through their out-of-scale material presence and concomitant removal from everyday experience. In contrast, Judd criticized Artschwager's works for amounting to mimicry of actual furniture: "Artschwager's work purposely resembles furniture. Everything is veneered with formica, whether an area simulates wooden parts, cloth or space. Artschwager overdoes the resemblance; the pieces are not as strong they might be or as interesting." [26]

Again, as an art critic, Judd's viewpoint tended to be particularly focused on specific formal values; he valued anti-compositional and non-representational qualities, and a sense of wholeness. Others' artwork was often judged as being "good," "strong" or "weak" through these criteria. In print, Judd did not express any interest in the social and political agendas suggested by Oldenburg's and Artschwager's works. Through their furniture-like works Oldenburg and Artschwager posed questions about the dominant taste in mass-produced domestic products and interior designs, while questioning the idea of aesthetics as the dominant criterion in judging artwork. As for Artschwager's use of Formica, Jörg Heiser pointed out the social issues surrounding taste evident in such artwork:

This sudden tactile transition from precious wood to cheap imitation suggests

24 Donald Judd, exhibition review of Claes Oldenburg show held at Janis from April 7 to May 2, *Arts Magazine* 38, no.10 (September 1964); reprint in *Judd, Complete Writings 1959–1975*, 133.
25 Ibid.
26 Donald Judd, exhibition review on Richard Artschwager show held at Castelli, *Arts Magazine* 39, no.6 (March 1965); reprint in *Judd, Complete Writings 1959–1975*, 167.

a social one as well: putting it simply, from craftsmanship to industry, conservative upper class sophistication to lower class imitation. But this is not merely banal social polemic, for the fascinating and the disconcerting emerge on both sides respectively: "good taste" appears self confident and refined, but can also be restrictive and dominating, insisting on traditional classical value. "Bad taste," on the other hand, not only impresses by virtue of its sheer popularity and light-hearted anarchist mix of styles, but also tends to an almost pathological oblivion of the past. This oblivion resembles the surface of Formica: it can be laminated on all sorts of materials, it is washable and resistant to stains.[27]

As the validity of aesthetic conventions of taste was called into question through works by Pop artists, there arose questions as to what makes something a work of fine art in a western social and cultural context.[28] In his *Distinction, A Social Critique of the Judgment of Taste*, French sociologist Pierre Bourdieu (1930–2002) pointed out that aesthetic judgment is not a universal, absolute value, as Immanuel Kant conceived it, but rather a socially determined value.[29] His empirical study revealed that taste is formed through education and the living environments integral to the social class to which one belongs. Judd was not interested in the issue of the exploration of bad taste in new art. In part, this stance was probably rooted in Judd's preoccupation with works by empirical philosophers such as the Scottish philosopher David Hume (1711–1776). Hume wrote "Of the Standard of Taste" (1757) in which he assumed that taste was something universal, that it could be learned through education.[30]

27 Jörg Heiser, "Elevator, Richard Artschwager in the Context of Minimal, Pop, and Conceptual Art," in *Richard Artschwager, The Hydraulic Door Check*, ed. Peter Noever (Vienna: MAK, 2002), 50–51.

28 See Dick Hebdige, *Hiding in the Light, On Images and Things* (London and New York: Routledge, 1988), especially chapter 5: "In Poor Taste: Notes on Pop." In 1975 Joseph Masheck criticized the "Good Design" preoccupation of MoMA, NY for its emphasis on a good taste as a focus of collecting. Joseph Masheck, "Embalmed Objects: Design at the Modern," *Artforum* 13, no.6 (February 1975): 49–55.

29 Pierre Bourdieu, *Distinction, A Social Critique of the Judgment of Taste*, trans. Richard Nice (Cambridge, Mass: Harvard University Press, 1984).

30 David Raskin discusses Judd's educational background with an emphasis on the influence of empiricist philosophy in Raskin's "Donald Judd's Skepticism" (Ph.D. diss., University of Texas at Austin, 1999), 41–51. David Hume, *Of the Standard of Taste and Other Essays*, with an introduction ↗

Art Objects and Everyday Products

Despite Judd's indifference to the social issues addressed in Pop Art, Judd, Oldenburg, and Artschwager actually followed a similar structural logic of making objects outside of sculptural conventions. They all constructed art objects using simple techniques and ordinary materials, and they made three-dimensional objects from two-dimensional sheets of common materials: metal, fabrics, and plastics. In fact, Judd was not trained as a sculptor during his art education; he initially learned to paint.[31] The emergent ambiguities between painting and sculpture as different art media bring up an interesting social question about the production process. Artschwager's fabrication technique was based on the process of furniture making, whereas the fabrics used in Oldenburg's "soft sculptures" were pieced together by a sewing machine. The welding and screwing process entailed in Judd's "stacks" follows the basic techniques endemic in the fabrication of metal commodities.

In terms of basic production techniques and materials, there seems to be little gap between art objects made by these artists (and their collaborators at small workshops) and everyday products mechanically manufactured at a larger factory. The viewer can easily associate such production-oriented art objects with mass fabricated products found in living environments. The introduction, in Pop and Minimalist works, of functional objects as subjects evidencing formal proximity to everyday products tacitly inserted this art into the social and political nexus of

by John W. Lenz (Indianapolis: Bobbs-Merrill, 1965), 3-28. Scholars have argued over the problems with Hume's theory on art; for instance, Brian Ribeiro pointed out that Hume's argument in his "Of the Standard of Taste" ironically does not adopt his own philosophical principle of a "sceptic" approach. Hume didn't cast any doubt on the validity of aesthetic judgment itself while believing in the universality of people's aesthetic judgment, possibly achieved through education; see Brian Ribeiro, "Hume's Standard of Taste and The De Gustibus Sceptic," *British Journal of Aesthetics* 47, no.1 (January 2007): 16–28.

31 Judd didn't regard his artworks as sculpture in a conventional sense. When he was asked by an interviewer whether he would define himself as a sculptor, Judd replied, "It depends. That's a matter of definition. I don't use the word because literally, it's not sculpting. I think the work is three-dimensional and then it's sculpture if you think of sculpture as all work that's three-dimensional." Judd answered the follow-up question as to whether he would call himself an artist, "Oh yes! And sculpture's very much a part of me – fabrication." Donald Judd, "Donald Judd: An Interview with John Griffiths," *Art & Design* (1990): 47.

everyday life. The vague status of these works not only destabilized the specificity of art mediums in the minds of puzzled audiences, but effectively opened up new horizons within the art and design discourse of society regarding how art functions within society.

Chapter Summaries

This book is focused on Judd's furniture production viewed in conjunction with his own thoughts and in relation to the socio-cultural conditions of the time. Intertwining art and everyday objects, Judd persisted in concerning himself with aesthetic and political principles in his designs, so that his furniture bears a pronounced resemblance to his artwork.

The primary resources on Judd's art and furniture production in this book include: Judd's own writings published in art and architectural magazines and his exhibition catalogues; a number of interviews I conducted with his fabricators and affiliates; several visits to Judd's collections of books, art and design objects; and observations of such materials included in installations in both private and public spaces in New York and Marfa, Texas. As an art critic in his early career, Judd published a large number of exhibition reviews after 1959 in major art magazines such as *Art News*, *Arts Magazine*, and *Art International*. He issued several political statements in the late 1960s and the early 1970s, when he was inspired by anarchist philosophies; and later, in 1991, Judd published his anti-war position during the crisis of the Gulf War. Judd's writings and comments on his furniture design and interior furnishings were mostly published in the 1980s and the 1990s, after he began to show his furniture in 1984 and around the time when his spaces in SoHo and Marfa were increasingly featured in art and architectural magazines.

The chronological development of Judd's furniture production is documented in his first furniture retrospective exhibition catalogue from 1993, published just prior to his death in 1994. I used the catalogue to ground my research, but this chronology does not include all of his furniture output. There are some furniture pieces that Judd designed or ordered for fabrication that were excluded from this catalogue.[32] Thus, my analysis on Judd's furniture in this book has a thematic and

32 Besides his furniture production, Judd also designed doors or gates for his properties and other functional objects including plates, a water bottle, and a set of cup and saucer.

contextual focus rather than a strictly chronological emphasis.

In Chapter 1, "Judd's Decentralized Position and his Move to Marfa, Texas," I explore Judd's political motive, which influenced his furniture designs and the idea of permanent installations that he developed in his SoHo residence beginning in the late 1960s. Referencing the extensive philosophical anarchist writings found in Judd's libraries, I discuss how Judd's involvement with political activities in the late 1960s and his continued insistence on the ideals of self-managing, small organizations led him to shape his own living environments with furniture and artwork, as well as the large-scale permanent installations he orchestrated in Marfa, Texas, where he moved with his children in 1976.

In Chapter Two, "Do-it-yourself Furniture Making in Marfa, Texas," I argue that the underlying model for Judd's early rustic furniture-making scheme was the do-it-yourself approach toward constructing furniture and living environments that flourished in the 1960s and 1970s. Politically speaking, anarchist principles promoted a do-it-yourself outlook with a view to self-reliant individuals, attuned to the decentralization of state government. However, Judd's do-it-yourself principles did not conform to the conventional American values associated with the suburban home. Rather, his approach reveals how the political agendas underlying the do-it-yourself movement were stimulated by the rise of a youthful counterculture and by the new left thinking of the 1960s. I argue that the rustic furniture constructed by Judd himself as well as by local carpenters in Marfa was in sympathy with the craft revivals and the simpler living environments championed by the countercultural trends of the time. I discuss how Judd's highly manipulated do-it-yourself furniture production paralleled social conditions wherein the realities of actual production processes had become hardly legible.

Chapter 3, "The Interrelationship of Furniture and Sculpture," examines the development of Judd's furniture in relation to his artwork in the 1980s and the 1990s. The condensed version of this chapter was published under the title "Furniture and Artwork as Paradoxical Counterparts in the Work of Donald Judd" in *Design Issues* (Summer 2011). Judd's furniture production entered a new phase as he began to commission skilled, professional furniture makers to fabricate his objects in the U.S. and abroad, and showed his furniture in galleries after 1984. In this chapter, I shed light on how Judd's furniture and artworks were paradoxically interlinked at many levels: they shared similarities in terms of their underlying philosophies, formal concerns, materials, production processes, installations,

marketing, and, to some extent, critical reception, despite the ambivalent remarks Judd made about these links in his writing during the 1980s and 1990s. Other than in terms of utility, Judd's furniture and art share similarities since they were created side by side and based on the same empiricist philosophy. I show that the putative division between Judd's furniture and art is stipulated more in hindsight, after his works left private workplaces and residences and entered the public domain of the marketplace and gallery.

Chapter 4, "Total Work of Art," explores the ways in which Judd remodeled his residences and workplaces and how they became integral to his own everyday conduct and lifestyle.[33] Users' accounts of Judd's furniture will also be investigated. Beginning in the late 1960s, Judd renovated old buildings by cleaning up their spaces to achieve an effect of spatial wholeness and by assigning a specific function to each space. Judd's preoccupation with empirical knowledge, the immediacy of perception and on the decentralized self-managing preference for a simple lifestyle informed the renovation process. Analyzing his writings of the 1990s alongside his interior designs, this chapter explores Judd's ideal of spatial wholeness, an aim that should be understood in the context of his highly considered ways of connecting art and life.

Chapter 5, "Art into Life: Judd and Scott Burton," reexamines Minimal artists associated with theater practices and pays close attention to usable sculptures by Scott Burton (1939–1989), who has been seen as one of the leading post-Minimal artists of the New York art scene. Although his artistic career was very brief, Burton received significant attention for his creation of functional art and his involvement with public art projects. Through his practice in the theater, Burton came to design furniture-sculpture objects after 1973 and became engaged with public art projects during the 1980s. I compare Judd and Burton in terms of their different approaches towards the concept of furniture and early modernist furniture design. Burton's interests in involving audiences in his projects made his functional

33 "Lifestyle" is "A term originally used by Alfred Adler (1870–1937) to denote a person's basic character as established early in childhood which governs his reactions and behavior," and it generally meant "a way or style of living" in the 1960s and 1970s. Later in the 1980s and 1990s the term also came to be increasingly related to "a particular way of living" and associated with marketing tactics "designed to appeal to a consumer by depicting a product in the context of a particular lifestyle." *Oxford English Dictionary*, 2nd ed., s.v. "lifestyle." I use the term to signify a way of living based on certain values of the individual in my attempt at illustrating how Judd's philosophy and design principles were linked, and generated his everyday conduct with its strong sense of the here and now.

sculptures more visible to the public outside of the art world and presented the possibility for generating a new design and art discourse. Although there has not been much critical attention to this subject, I analyze the subtle tendency in which design and art discourse shifted from an emphasis on the uncertainty of the meaning of the real in art during the 1970s and the 1980s to a closer attention to the social and personal nature of audience participation and involvement in usable artwork in later decades.

In the Conclusion, I discuss how Judd's furniture making began with do-it-yourself principles in the midst of a counter-cultural climate and later migrated toward an international production scheme during the postmodern, global cultural conditions of the 1980s and 1990s. Judd's increasing aestheticization of renovated spaces, his focus on the design integration of the room as a whole, total work of art, suggests that his initial impulse toward decentralized simplicity evolved as he merged his designs into a concept of living environments as instruments of everyday conduct. He was not engaged in achieving social revolution in a conventionally Marxist sense, but rather promoted anarchist, piecemeal changes made in negotiation with the realities of a capitalistic society.

Furniture designed by Judd and Burton merges into the realms of everyday life—for Judd, his furniture is integrated with his empiricist and anarchist philosophies and with his own everyday behavior, whereas Burton's furniture pieces, often located in public domains, offer general audiences an actual involvement with his usable art in situ. Neither artist's furniture is about realizing a utopian unity between art and design, nor does it call for a radical political change in society. Rather, it is about a the gradual social change toward better recognition and function of the nature and values of everyday life as they are discovered through the subjective experiences of being 'on site'—an assertion that one's physical presence and active mental engagement with furniture in a certain spatial environment truly matters. The existence and action of artists at a local site provides hope toward the construction of a better functioning society.

CHAPTER 1

JUDD'S DECENTRALIZED POSITION AND HIS MOVE TO MARFA, TEXAS

Minimalism and Politics

The political dimensions of Judd's works have rarely been discussed in the art historical discourse on Minimalism. Yet, throughout his career Judd frequently wrote about his political positions, about his opposition to state authority, to the industrial war machine, and to capitalist enterprises imposed on citizens. Although Judd did not openly call himself an anarchist, his political views, his works, and the conduct of his life were deeply inspired by anarchist philosophy. In the past decade, David Raskin has made significant contributions toward illuminating Judd's political position as reflected in his artworks.[1] Minimalist works had no immediate impact on the course of contemporary politics, but scholars, critics, and some of the artists themselves made observations about these objects' social implications. Dan Graham's "Homes for America," which was published with editorial modifications in *Arts Magazine* in 1966, was an early writing which indirectly touched upon Minimalism by analyzing the values associated with the American middle-class home as it was backed by the growing construction industry and developers. (fig.9) Graham criticized suburban, standardized, mass-produced housing developments built for the sake of economic efficiency and devoid of any environmental awareness:

[1] David Raskin's dissertation, "Donald Judd's Skepticism" closely investigated the relationship between Judd's political ideas and his artworks in conjunction with Judd's interest in pragmatist philosophy; later a summary of this work was published as "Specific Opposition: Judd's art and politics," *Art History* 24, no.5 (November 2001): 682–706; and his latest publication, *Donald Judd* (New Haven and London: Yale University Press, 2010) discusses convincingly Judd as a citizen. Raskin reports extensively Judd's political involvements throughout his career.

Both architecture and craftsmanship as values are subverted by the dependence on simplified and easily duplicated techniques of fabrication and standardized modular plans. Contingencies such as mass production technology and land use economics make the final decisions, denying the architect his former 'unique' role. There is no organic unity connecting the land site and the home. Both are without roots—separate parts in a large, pre-determined, synthetic order.[2]

The economic logic was enforced at the expense of individual decision making and control over housing:

[Tract houses] were not built to satisfy individual needs or tastes. The owner is completely tangential to the product's completion. His home isn't really possessable in the old sense; it wasn't designed to 'last for generations'; and outside of its immediate 'here and now' context it is useless, designed to be thrown away.[3]

Although Graham did not make any explicit connections between the Minimalists' formal vocabulary and the economical strategies of postwar, mass-produced housing units, some of the serial Minimalist works and the pre-fabricated housing units adopted a similar permutation system for maximum design variations, as Graham's photographic juxtapositions (deleted from *Arts Magazine* but shown elsewhere) subtly implied. (fig.10/fig.11) The slightly differentiated colors and decorations of the exteriors may have compensated for the homeowners' desire to achieve stylistic individuality in their dream homes, whereas the Minimalists' serial methods appeared to be similar to this pervasive mass-production strategy in postwar consumer culture.

With reference to his serial objects, Sol LeWitt described his rather mechanical, even automatic art-making process as follows: "The idea becomes a machine that makes the art."[4] Although his seemingly systematically configured geometric pieces suggest a rational orientation, there is a certain irrational aspect to LeWitt's self-

2 Dan Graham, "Home for America," *Arts Magazine* 41, no.3 (December/January 1966-1967): 22.
3 Ibid.
4 Sol LeWitt, "Paragraphs on Conceptual Art," *Artforum* 5, no.10 (June 1967); reprint in *Sol LeWitt*, ed. Alicia Legg and others (New York: The Museum of Modern Art, 1978), 166.

exhausting system, devoid of any scientific reason or logic whatsoever. Reviewing LeWitt's 1966 solo show, Robert Smithson described LeWitt's serial pieces in terms of "entropy"—a process going in the opposite direction of the rational course of progress and development in modern society:

> LeWitt's first one-man show at the now defunct Daniel's [sic] Gallery presented a rather uncompromising group of monumental "obstructions." Many people were "left cold" by them, or found their finish "too dreary." These obstructions stood as visible clues of the future. A future of humdrum practicality in the shape of standardized office buildings modeled after Emery Roth; in other words, a jerry-built future, a feigned future, an ersatz future very much like the one depicted in the movie "The Tenth Victim." LeWitt's show has helped to neutralize the myth of progress. It has also corroborated Wylie Sypher's insight that "Entropy is evolution in reverse." [5]

This analysis was right in that LeWitt made no attempt at "idealizing technology." [6] In Smithson's view, LeWitt's work was calling attention to the emptiness of technological utopia at a time when standardized office buildings were soaring in the Manhattan skyline; when the suburbia of the mass housing complex was spreading out of the city with an irrational, destructive speed; and when the United States' space missions were competing with the USSR with national prestige at stake during the 1960s.

Mel Bochner also noticed that "technology" was mocked by some works of contemporary art. He reviewed the exhibition entitled "Art in Process" held in 1966 at the Finch College Museum in New York. The show included works by artists such as Judd, LeWitt, Robert Morris, and Dan Flavin who were all later seen as leading artists of the Minimalist movement: "These artists, who are dissimilar in most aspects, all avoid the false utopianism which is implicit in much work being done today. Their art makes no projection to a glorious future. If anything, there is a faint pessimism." [7] For Bochner, the "faint pessimism" was manifest in the avoidance of any metaphor in the geometric, serial configuration of their objects.

5 Robert Smithson, "Entropy and the New Monuments," *Artforum* 4, no.10 (June 1966): 27.
6 Sol LeWitt, quoted in Smithson, "Entropy," 27.
7 Mel Bochner, "Art in Process—Structures," *Arts Magazine* 40, no. 9 (September/October 1966): 39.

He saw that those works were significant in that they were meant to be perceived as things in themselves: "His [Judd's] work appears objective and detached. It is its own reality. His galvanized sheet-iron wall relief, sprayed with transparent red lacquer, refers to no object already existent."[8] But, since nothing could be totally objective, Bochner raised a further question about "how objective is any fabricated reality. Even objectivity is an appearance."[9]

Reality could be deceptive in a modern society in which the detailed facts about the fabrication processes and the distribution methods of mass products were increasingly complicated and hidden to consumers. The mute, geometric forms of Minimalist works indeed triggered social doubt about the blind belief in technological progress and the multi-national corporations forming in developed countries at the time. Artists emerged in the 1960s who were aware of the presence of the powerful political and economic authority affecting their art making and their survival as artists in the growing art capital of New York City. Some artists who took politically mute positions in their artwork were rather realistic in that they saw that art was fundamentally not an effective and practical means to change actual politics and existing power structures in society. But the apparently apolitical nature of Minimalist art objects would be seen as affirming political and capitalistic authority by some among the following generation of artists who directly accused the art market and the art museum of being subjugated to the capitalist economy.

In their concern with the status of art objects as commodities, certain leftist scholars and artists have criticized the pristine Minimalist objects quietly sitting in museum spaces. Soon after Judd won mid-career success, as evidenced by his one-man shows at the Whitney Museum of American Art in New York in 1968 and the National Gallery of Canada in Ottawa in 1975, his artwork and writings on contemporary art came under attack. Karl Beveridge and Ian Burn accused him of accepting a capitalist production scheme in their open questions to "Don Judd" in the leftist magazine Fox.[10] As a discourse on institutional critique[11] took

8 Ibid., 38.
9 Ibid.
10 Karl Beveridge is a Canadian artist and Ian Burn is an Australian artist. In the 1970s they both were affiliated with Art & Language, a group of conceptual artists who made collaborative works. Beveridge and Burn called attention to the development of institutionalized forms of art and culture in the United States during the sixties, while seeing Judd's works as a part of the empowering status of fine art objects in cultural organizations; Karl Beveridge and Ian Burn, "Don Judd," *Fox* 2 (1975): 139.

shape during the early 1970s, Judd's pristine, precisely fabricated objects quietly, yet boldly occupied art museums and were increasingly conceived as part of a traditional, high art cultural establishment, given their marketability and fine object status.

Some art historians and critics with left-wing leanings continued to view Judd's works as being apolitical and to view Judd himself even as being non-*engagé* in his aesthetic devotions, which went against the focus on institutional critique as it evolved during the decades of the 1980s and the 1990s. Brian Wallis, an art historian, critic, and then adjunct curator at the New Museum in SoHo, moderated a symposium entitled "The Crux of Minimalism: Style or Politics?" in 1987. The symposium was an attempt to reinterpret Minimalism as more of a socially conscious movement responding to the political upheavals of the anti-Vietnam War protests and human rights activism of the sixties. Richard Artschwager, who is affiliated with both Pop Art and Minimalism, was invited to the panel to represent a revisionist version of Minimalism in contrast with the presumably aesthetic one represented by the works of Judd. Contrary to Wallis's intention, however, Artschwager denied any direct political association in his art, while stressing his personal background of training and experience in furniture-making workshops as a major influence in his artworks. Eric Gibson, who reported on the symposium in an issue of *New Criterion*, was not convinced by the revisionist attempts of the panel. He noted that Minimalism was indeed radical aesthetically, but not radical in a politically activist sense.[12] Left-leaning analyses of Minimalism, focused on a critique of commodification in art, tended to dismiss the fact of art as social production integral to larger cultural phenomenon; such analyses often overlooked the complexity and subtle implications embedded in Minimalist works.

Anna Chave's essay "Minimalism and the Rhetoric of Power" (1990) threw a

11 Institutional critique was one of the tendencies in advanced art during the 1970s. It is characterized by the artists' critique of the systems of the art market and art museum which are dominated by a capitalistic logic and operated under the predominating power structure and hierarchy of society.

12 This left-leaning premise was summed up by Gibson's response to attending the symposium "The Crux of Minimalism: Style or Politics?" which was held at the School of Visual Arts in February 26, 1987. The panel speakers were Artschwager, Maurice Berger, Yvonne Rainer, James Welling, and Haim Steinbach, as reported by Gibson; Eric Gibson, "Was Minimalist Art a Political Movement?" *New Criterion* 5, no.9 (May 1987): 60, 64.

new critical light on the discourse of Minimalism. She argued that the hard-edged factory production of Minimalism was socio-politically indexed to a masculinist power base, manifested in U.S. corporations taking over world markets and the aggressive foreign policy of the United States (as manifest in the war in Vietnam) during Minimalism's heyday. She argued that there was a social implication of masculine superiority in Minimalist rhetoric:

> The language used to esteem a work of art has come to coincide with the language used to describe a human figure of authority, in other words, whether or not the speaker holds that figure in esteem. As the male body is understood to be the strong body—with strength being measured not by tests of endurance, but by criteria of force, where it specially excels—so the dominant culture prizes strength and power to the extent that they have become the definitive or constitutive descriptive terms of value in every sphere: we are preoccupied not only with physical strength and military strength, but with fiscal, cultural, emotional and intellectual strength, as if actual force were the best index or barometer of success in any of those spheres.[13]

Chave observed how certain "powerful" Minimalist works were received by viewers. Judd's objects made with the pristine surfaces of industrial materials may potentially attract someone who is enthusiastic about the machinery of consumer luxury products, say, such as the metallic surfaces of automobiles. But in other cases these artworks may be experienced as perpetuating "abuses of power against the hapless viewer." [14] Chave's analysis suggests the Minimalist paradox: industrially made, anti-art looking Minimalist works quickly became empowered, highly sought after fine art objects embraced by art museums and the market establishment following their initial challenge to viewers and cultural institutions.

There was an inevitable contradiction entailed in Minimalist geometric objects in their virtual attack on, yet lingering attachment to the fine arts' conventional ties with economically-privileged classes and with the social establishment attached

13 Anna C. Chave, "Minimalism and the Rhetoric of Power," *Arts Magazine* 53, no.14 (January 1990): 55-56.
14 Ibid.

to cultural institutions. Chave's essay opened a new political and social scope in the discourse on Minimalism of the following decades. The short life of the vanguard, anti-aesthetic gestures of Minimalism might have been due to the logic of power entailed versus the power situation in which the art operated; institutional and capital authority prompted the same kind of aggressive manifestation of power among Minimalist objects. What is odd and ironical about the Minimalists' rebellion against conventional art forms is that their open defeat by the existing power structures came by following the same logic of power, while mostly insisting on the artists' right to control the fabrication process and the way in which their works occupy museum spaces under the name of Art. The pristine, geometric box is hardly personified, but the stubborn, mute presence of a box emerging from the manual labor of the factory and sitting in the space of the art establishment evokes, to me, a hunger strike—a quiet but defiant protest against authority by occupying the entrance of a cultural or political institution. However, the hunger strike is not usually an effective tactic to change the course of politics. It is a desperate, final political gesture by an individual at the cost of his or her own health and life; physical defeat is its premise, but spiritual victory is its hope.

Responding to Chave's acute social observations regarding Minimalism, David Raskin further investigated the political dimension in Judd's artwork. In his essay "Specific Opposition: Judd's Art and Politics" (2001), Raskin made a balanced argument intertwining Judd's art and politics; Judd's preoccupation with positivist philosophy and U.S. anarchist doctrines was addressed in conjunction with the artist's concept and formation of artworks. Raskin argued that the wholeness of Judd's art objects was linked to his anarchist, anti-hierarchical, political views and to an empiricist approach of comprehending the physical world instantly, without divisions of form and color.[15] Raskin closely examined Judd's involvement with actual political activities while noting that his fundamentalist, art-as-art premise prevented his art from serving as a political vehicle. His argument illuminates the fact that Judd's political activism during the late 1960s and early 1970s at the local community level coincided with his "artistic decentralization," in Raskin's words:

> In checking hierarchy, Judd believed that art acquired the singleness, the unified *aesthetic* power, that was lacking in most Western art.

15 Raskin, "Specific Opposition," 684.

> Judd's demand for artistic decentralization paralleled his efforts in politics to eliminate top-down systems of government. During the late 1960s and early 1970s, he was actively involved in three local democracy efforts: Artists Against the Expressway, a newspaper entitled the *Public Life* and Citizens for Local Democracy. …
>
> In successfully opposing the project [construction of the Lower Manhattan Expressway], Artists Against the Expressway enlisted the help of community residents and local democracy organizations, including the Citizens for Local Democracy, sponsor of the *Public Life*, which was devoted to community politics… Judd became active in this protest group and read its newspaper …[16]

As Raskin explains, the *Public Life* was a publication of the Citizens for Local Democracy which supported Jeffersonian democracy operated on a basis of townships.[17] Using a number of Judd's political statements, Raskin effectively demonstrated how Judd was inspired by a Jeffersonian doctrine beginning in the 1960s. But, interestingly, as he observed, Judd's anarchistic political views shifted from an emphasis on local democracy to individualism in the early 1970s. The shift seemed to come from both personal and social influences in response to the cultural climate of the post-Vietnam era when the previous optimistic belief in forming a new society faced new dilemmas and increasingly seemed unrealistic. Raskin explored Judd's association with anarchist doctrines from several aspects: Jeffersonian anti-urbanism, local activism, pacifism, capitalist logic, and individualism. However, he concluded that Judd was rather sporadic in his adaptation of anarchist philosophy in his writings, and was more a part of the "Reformist Left," using the words of Richard Rorty, who characterized Judd's generation according to the "anti-communism and pacifism of many leftists who were teenagers in the 1930s and 1940s."[18]

Raskin's essay revealed the subtle interrelationship among Judd's "Reformist Left" position, pragmatist philosophy, artworks, and political actions during the late 1960s and 1970s. The remaining pages of this chapter reinforce Raskin's

16 Ibid., 690.
17 Ibid., 692.
18 Ibid., 702–03.

ideas about Judd's political position in the larger social context of the time in conjunction with the American tradition of embracing the individualist tenets of anarchism and the decentralizing trends of revived anarchism in the 1960s and 1970s. Close attention will be paid to the ideas for large-scale permanent installations that Judd developed in the late 1960s and his subsequent decision to move from the art capital of New York City to the nondescript, border city of Marfa, Texas, in his search for an extensive area in which to realize his artistically and politically-invested visions. As such, this chapter will describe Judd's anarchistic philosophical and political tenets as undercurrents in his furniture productions and interior designs which are discussed more fully in later chapters.

Anarchism as a Philosophy, a Way of Life

Besides his actual political involvement with local actions in the late 1960s, Judd avidly gathered the philosophy of anarchism.[19] Judd owned extensive works by anarchists and anarchist-inspired critics and writers from the dawn of the movement to the present day in his libraries at La Mansana de Chinati (The Block), Judd's primary residence in Marfa. (fig.12) The Donald Judd Library is now digitalized, which provides a view of each bookshelf and the collection. Mikhail Bakunin (1814–1876), one of the Russian founders of anarchism, is well represented in Judd's book collection which includes: *From out of the Dustbin: Bakunin's Basic Writings, 1869–1871* (English translation, 1985) and *Statism and Anarchy* (English translation, 1990) by Bakunin; *The Political Philosophy of Bakunin: Scientific Anarchism* (1953) compiled by G. P. Maximoff, *The Doctrine of Anarchism of Michael A. Bakunin* (1955) by Eugene Pyziur, and *Michael Bakunin* (1937) by E.H. Carr. Within anarchist discourse Bakunin is aligned with a collective, revolutionary social outlook as opposed to the individualistic anarchist approach represented by Pierre Joseph Proudhon (1809–1865) and William Godwin (1756–1836), for example. But Judd also had extensive works by

19 Judd was a very literate artist. He assembled a huge library with an encyclopedic scope and an emphasis on art and architectural history. My arguments on Judd's anarchistic political thinking are linked to certain sources that Judd owned. He was likely inspired by some of the anarchist writings in question during the 1960s; he evidently also obtained books in later decades that corresponded to his interests and ideas from the 1960s. I cite such texts in what follows with a view to establishing a philosophical grounding for Judd's political motivations and actions.

fig. 12 La Mansana de Chinati (The Block), Marfa, TX view of the South Library, Image Courtesy JuddFurniture.com/Judd Foundation

Friedrich W. Nietzsche, whose critique of the Christian establishment and idea of the "superman" inspired the individualist doctrine of some radical anarchists.

Judd located Bakunin's books in the South Library (Main Library) at the Block, where he encyclopedically organized historical, philosophical, and cultural readings from Greek and Roman classics to books on nineteenth-century art and literature. The library is geographically categorized so that Russian philosophical sources are placed along with books on Russian geography, history, architecture, and art. The way in which Judd organized this Main Library illustrates how he comprehended culture as a whole in terms of diverse aspects: literature, politics, history, and art, specifically germinated and simultaneously unfolding within particular regions.

In his North Library (Secondary Library), next to the Main Library, Judd placed more contemporary anarchist writings. These are primarily source books: *Essential Works of Anarchism*, edited by Marshall S. Shatz in 1971, *Anarchism* (1978) edited by J. Roland Pennock and John W. Chapman, *Anarchism* (1962) by George Woodcock, and *Anarchy in Action* (1988) by Colin Word, to name a few. Judd paid close attention to literature focused on anarchist activities in the United States. He collected the writings of Emma Goldman (1869–1940), the first female speaker on anarchism in the United States, who authored: *Living My Life* (1931), *Anarchism and Other Essays* (1910), and *My Disillusionment in Russia* (1925).[20]

Believing in a new society to come, Goldman protested against capitalism and the wage system. She considered the convention of marriage to be an economic treaty, and she was opposed to a relationship tied to the authority of law or religion. Goldman admired Peter Kropotkin (1842–1921), whom she called "the most outstanding exponent of anarchist communism."[21] Goldman was an exponent of anarchist communism, but she was foremost devoted to affirming the freedom of the individual and committed her life to the cause of humanity. Unlike her anarchist comrades, who often criticized artists as being associated with bourgeois consumerism, she saw that it was natural and necessary for artists to embrace beautiful things for their creative spirit, even though the consumption of fancy items represented a middle-class luxury.

Judd was also interested in how anarchist thought evolved in subsequent decades in the United States. He owned *Native American Anarchism: a Study of Left-wing American Individualism* (1932) by Eunice Minette Schuster, *The Black Flag of Anarchy; Anarchism in the United States* (1968) by Corinne Jacker, and *The American as Anarchist; Reflection on Indigenous Radicalism* (1978) by David De Leon. Judd's extensive holdings of anarchist literature indicate that he was versed in the different directions of collective, versus individual, approaches to anarchism under their shared doctrine of canceling centralized authority through each individual's moral actions at both the private and public levels of life.

In her *Native American Anarchism*, Eunice Schuster analyzed the primacy of individual freedom in the U.S. tradition of anarchism. She characterized anarchism as "a philosophy, a way of life."[22] Anarchism, as a philosophy tuned to one's life and the living environment of all classes, stood for the right of individuals to struggle against the religious, state, and economic authority of the nation: "Anarchism would apply to the whole of life. And as such a philosophy, we must interrogate it, and on the basis of the evidence which has already been presented, we may suggest what significance it may have had in American history."[23]

While exploring Judd's furniture design and his living environments, this book

20 The dates of books given here are the dates of their first publication and not necessarily of the edition Judd owned.
21 Emma Goldman, *Living My Life*, Vol. 1 (1931; reprint, New York: Da Capo Press, 1970), 168.
22 Eunice Minette Schuster, *Native American Anarchism; A Study of Left-Wing American Individualism* (1932; reprint, New York: Da Capo Press, 1970), 7.
23 Ibid., 179.

particularly invokes anarchism as a philosophy that prompts a self-managing lifestyle in our society.

Judd on Politics in His Artworks

Even though Judd basically denied any direct relationship between his artworks and politics, his powerful rhetoric in defense of the integrity of his art was not always theoretically consistent through the 1970s and 1980s. His ambivalence with respect to the political dimension in his artworks was evident in his writings as early as 1970. In the September, 1970 issue of *Artforum*, in a feature entitled "The Artist and Politics: A Symposium," Judd admitted that his "work had political implications, had attitudes that would permit, limit or prohibit some kinds of political behavior and some institutions."[24] Judd stated that his works were about his response to the political climate of McCarthyism during the 1950s, which tended to lead artists to the introverted safe zone associated with the isolated individual at the mental and creative level.

Judd felt that his own increasing isolation was partly due to a growing sense of his incapacity to deal with the turbulence of politics. In contrast to his powerful initial sentence about the "political implications" present in his artworks, Judd moved in subsequent sentences towards a defense of art from politics due to his disillusion with the utopian social causes he had witnessed during the late 1960s:

> So my work didn't have anything to do with the society, the institutions and grand theories. It was one person's work and interest; its main political conclusion, negative but basic, was that it, myself, anyone shouldn't serve any of these things, that they should be considered very skeptically and practically.[25]

For Judd, throughout his career, art and politics were fundamentally separate entities because each has its own internal logic which functions independently. In his defense of the creative freedom of the individual artist, for example Judd disagreed with the political activities prompted by the Art Workers Coalition.[26]

24 Donald Judd, "The Artist and Politics: A Symposium," *Artforum* 9, no.1 (September 1970): 36.
25 Judd, "Artist and Politics," 37.

He was alert to the group's censorship of fellow artists as potentially giving rise to another kind of dictatorship, perhaps reminiscent of the red-hunt which swept through the U.S. during the 1950s.[27] Negotiating between his positions as an artist and as a citizen, Judd somehow found a meeting point between his political position and artwork. Judd believed that "good work" was political at a metaphorical level. He thought that the formal vocabulary of artwork could manifest a decentralized anarchistic philosophy and promote action against an autocratic government however, as is evident in the following statement from 1973:

> Most people, including artists, don't want to act and that suits the various governments. Artists can and should object as artists but the real action is as a citizen among citizens. Art isn't politics or science or whatever and usually can't be used as such. But somehow it is implied in good work that the artist wouldn't support the present oligarchy and the present war.[28]

Revived Anarchism in the 1960s

A historian of anarchism, George Woodcock, pointed out that anarchist practices were revived in North America during the 1960s not in the form of an organized movement, but rather as a central element in the various directions of New Radical ideas.[29] In the United States the anarchist-inspired New Radicals were "a movement of dissident middle-class youth."[30] According to Woodcock, the central elements of anarchism that were revived in the 1960s were: "the rejection of the state, the abandonment of the comfortable in favor of the good life, direct action, decentralization, the primacy of the functional group, participation."[31]

26 In the appendix of his dissertation, Raskin reported on Judd's initial involvement in and prompt distancing of himself from the Art Workers Coalition due to his disagreements with its political perspectives and actions. Raskin, "Donald Judd's Skepticism," 174–87.

27 For instance, Dan Flavin's use of fluorescent tubes was denounced by the group because the maker of light fixtures supplied something to the Vietnam War. Donald Judd, "Imperialism, Nationalism and Regionalism (October 1975)," in *Judd, Complete Writings 1959–1975*, 222.

28 Donald Judd, New York, a letter to Irving Sandler, 24 January 1973, in reference to a panel at the College Art Association; reprint in *Judd, Complete Writings 1959–1975*, 217.

29 George Woodcock, "Anarchism Revisited," *Commentary* 46, no.2 (August 1968): 56.

30 Ibid., 57.

In short, suburban comfort and affluence were denied by anarchists in favor of a commitment to a simpler way of life based on a self-managed, democratic, local community. Since anarchists were opposed to the preexisting hierarchy, their tradition of moral values naturally merged with the civil-rights movement of the 1960s.[32] In his widely read essay, "The Black Flag of Anarchism," published in the *New York Times* on July 14, 1968, the social critic and novelist Paul Goodman argued that the on-going student protests throughout the world could be characterized as anarchist because: "They believe in local power, community development, rural reconstruction, decentralist organization, so they can have a say. They prefer a simpler standard of living. Though their protests generate violence, they themselves tend to nonviolence and are internationally pacifist." [33]

Comparable to this profile of the new student left, Judd was a pacifist and a "decentralist" who preferred simple living environments; and, as a prolific writer, he voiced his political views throughout his career. Although Judd insisted on a separation between art and politics, he didn't hesitate to proclaim his political opinions in printed media such as *Arts Magazine* or *Kunst & Museumjournaal*, and in his own exhibition catalogues. Judd's pacifist position emerged in these writings from time to time, stimulated by the almost constant involvement of the United States in major wars.[34] Although Judd expressed anti-war sentiments and an opposition to governmental authority and control (i.e., statism) in those writings, he rarely made direct connections between his artworks and these political messages.

In one of his early political statements, Judd and his then-wife Julie Finch listed their names on an anti-war advertisement by the War Resisters League, published in *Aspen Times* on August 29, 1968. (fig.13) They urged the withdrawal of United States troops from Vietnam, urging the country instead to devote itself to a "rebirth" by disarming police in the cities and granting equal opportunities to the

31 Ibid., 56.
32 Ibid., 58.
33 Paul Goodman, "The Black Flag of Anarchism," *New York Times*, 14 July 1968, 13.
34 Raskin investigated Judd's pacifism through his involvement in a number of activities such as belonging to the War Resisters League (WRL) from the late 1960s to the end of his life in 1994; organizing its fund-raising exhibitions; participating in rallies against wars and nuclear affairs; and addressing anti-war messages in his writing. Raskin observed that Judd's pacifism was not casual but not equivalent to the level of a professional activist's commitment, either. Raskin, "Judd's Skepticism," 120-38.

black community. He also went out on the street for political purposes, proudly participating in an anti-Vietnam war parade, for example: "I marched in the first Fifth Avenue parade and I hate group activities (Ad Reinhardt was the only artist I recognized)."[35] Later, responding to the Gulf War, Judd and his daughter Rainer Judd joined a demonstration held in New York on October 20, 1991, against the United States' foreign policy in the war against Iraq.[36] Simultaneously, he propagated his anti-war message through his text "Nie wieder Krieg" (Never Again War) in *Kunst & Museumjournaal*.[37]

Pacifism is not necessarily entailed in anarchism, but Judd's anti-war position drew upon the pivotal anarchist doctrines of the rejection of central authority. He expressed his anarchist tenets of pacifism in 1970: "Most of the emotions and beliefs given to institutions should be forgotten; the bigger the institution the less it should get; I never understood how anyone could love the United States, or hate it for that matter; I've never understood the feelings of nationalism."[38] Later, in 1991, during the early phases of the Gulf conflict, Judd continued to write about his views of a nation collapsing through its own warfare:

> World War II, in so far as it was about anything, was about the somewhat conflicting natures of the large central systems. The present threats and wars are the death throes of these systems, which will fight each other over minor distinctions as they collapse, to prevent collapse, and especially as they collapse. They all have ideas of the future, based on central authority, joined to ideas of the past created for the nation. None of this hangs together, which is good reason not to die for it.[39]

Likewise, after the Gulf War in 1992, in an exhibition catalogue for a solo show in Japan, Judd continued to put forth anti-war messages and to warn of the danger of the United States' huge military expenditures creating a vicious cycle of war and violence in the world:

35 Judd, "Artist and Politics," 37.
36 Donald Judd, "Treat Art as Art Only; Discussion with Donald Judd," interview by Seung-duk Kim, trans. Tatsumi Shinoda, BT 45, no.667 (1993): 196.
37 Donald Judd, "Nie wieder Krieg," *Kunst & Museumjournaal* 2, no.5 (1991): 19-22.
38 Judd, "Artist and Politics," 37.
39 Judd, "Nie wieder Krieg," 20.

> The Americans are looking for a substitute to the Cold War to justify three hundred billion a year for the military, Iraq was only good for one year. ... The enormous American military makes Russia question disarmament and presses Germany and Japan to rearm, after fifty years, as in the war against Iraq.[40]

Judd also saw the Gulf War as a cultural and religious conflict between west and east, and he warned about the tie between the United States government and Christianity leading to the oppression of others' beliefs. He was against economic, religious, or bureaucratic oppression of any sort of local community, tradition, or indigenous religion. With respect to Native Americans for example, Judd stated:

> The Hopis never fought the United States, only the Spanish once, but their children were taken away to distant American schools and taught Christianity. The schools in the area though are probably still American. This is aggression and shouldn't happen. It happens everywhere.[41]

However, Judd was not agitating for a Marxist revolution. The anarchist revival of the 1960s generally rejected capitalism; but its rejection of capitalism differed from socialism. David E. Apter rightly pointed out that, "Anarchists may be closest to socialists in their common critique of capitalist society, but they are diametrically opposed in the matter of solutions." Anarchist thinkers and writers saw capitalism as "a system and socialism as a form of bureaucratic tyranny."[42] Judd recognized that the modern system of capital and commerce is a given and that the artist had no choice but to deal with it.[43] He rather thought that political change would move forward on the grounds of its own logic, stimulated by individuals conducting a more moral life, not by a collective campaign or through the offices of a given leader.

40 Donald Judd, "Art and Internationalism Prolegomena," in *Donald Judd*, ed. Kyosuke Kuroiwa and Mikiko Matake (Osaka, Japan: Gallery Yamaguchi, 1992), 11-12.
41 Ibid., 10.
42 David E. Apter, "The Old Anarchism and the New – Some Comments," in *Anarchism Today*, ed. David E. Apter and James Joll (Garden City, N.Y.: Doubleday, 1972), 8, 12.
43 Raskin also noted that Judd embraced certain aspects of capitalist business; Raskin, "Judd's Skepticism," 23-26.

Both Woodcock and Goodman affirmed that anarchist theory did not support a "revolution" in the Marxist sense. Woodcock wrote in 1968, "The liberalization of a society is, in fact, an evolutionary and not an apocalyptic process, and can only be attained by concentrating on piecemeal changes."[44] Likewise, Goodman pointed out in the same year:

> In anarchist theory, 'revolution' means the moment when the structure of authority is loosed, so that free functioning can occur. The aim is to open areas of freedom and defend them. In complicated modern societies it is probably safest to work at this piecemeal, avoiding chaos which tends to produce dictatorship.[45]

Judd similarly believed in working out the logic of preexisting situations or conditions instead of calling for a drastic social revolution. He saw politics and institutions operating by their own logic: "the organization of society, was something itself, that it had its own nature and could only be changed in its own way."[46]

Judd did not entirely believe in government financial support for art projects on the grounds that it violates the creative freedom of artists and the autonomy of artwork. In other words, in a capitalistic society, artists are expected to support themselves. The sales of their works would guarantee both the financial and creative independence of artists. He also complained that artists tend to be treated as unimportant, that they were often summoned up during the last phase of architectural projects, for example, when there is not much room for original input. Judd wrote, "At the least the United States government should not be involved in grants and commissions ... [T]he most destructive aspect of the bureaucratic commission ... [is that the] artist is asked last to participate."[47]

44 Woodcock, "Anarchism Revisited," 59.
45 Goodman, "Black Flag of Anarchism," 13.
46 Judd, "Artist and Politics," 37.
47 Donald Judd, "A Long Discussion Not About Master-Pieces but Why There Are So Few of Them Part II," (1984/85); reprint in Donald Judd, *Donald Judd, Complete Writings 1975–1985*, (Endhoven, Netherlands: Van Abbemuseum, 1987), 84. There are several books by Herbert Read in Judd's library at the Block in Marfa. Having observed meetings of governmental committees for the arts, Read eloquently discussed the limitations of governmental support for cutting-edge art projects in *The Philosophy of Modern Art* (1952), a book owned by Judd.

Inspired by optimism about artists' communal solidarity during the 1960s, in 1970 Judd put forth an idealistic proposal for an organization run by artists through their own funding to defend themselves from unfair deals: "There should be an artists' organization. ... The organization should have its own money; there could be a self-imposed tax by members on all sales, part from the artist's portion, part from the dealer's."[48] However, in 1975, he would stress instead the artist's unique status and financial independence gained through sales of his own works. Then there was a hint of business conviction, and of the financial realities Judd increasingly faced as he continued to hire fabricators to make his objects, often on a large scale and in quantity:

> Art is done by people who like it and are good at it and they are few. ... It's not the same as some useful activity done by thousands of people. I don't see why art should be a guaranteed career. I think an artist should be as independent of the surrounding society as possible and should be ready to be poor, as artists have been in the United States until recently. Naturally it's better to make a living from art and it takes money to make work.[49]

Judd's rhetoric was opposed to capitalism, while at the same time, he accepted that the business of art is inevitable in modern society. Judd openly admitted that art is a business in a number of his writings, perhaps most straightforwardly in 1977, in his essay on the dealer "Leo Castelli" in the 20th Anniversary catalogue of the Castelli gallery:

> The sale of art is usually an artist's main contact with the society and of course it's the artist's living. It's very important then that the business be honorable; not perfect perhaps, but not disgraceful. It is a disgrace to work for nothing, to have your desire to make art used against you; it's a disgrace to be cheated, to be played with and to be patronized. Leo and I have had some difficulties but the business has remained normal and decent.[50]

48 Judd, "Artist and Politics," 37.
49 Judd, "Imperialism, Nationalism and Regionalism," 223.
50 Donald Judd "Leo Castelli," *Leo Castelli Twenty Years* (New York, 1977); reprint in *Judd, Complete Writings 1975–1986*, 11.

Later Judd became increasingly sensitive to the sway of commerce over the amount and scale of his art productions. With a defensive and pessimistic tone, in 1984 Judd noted that good art should avoid being submissive to commerce: "Art of a high quality should be part of the opposition to commerce but art is close to being forced underground by it…"[51]

Judd gradually tried to further his own countering response to the commerce of art by developing his permanent art installations from the late 1960s to the end of his life in 1994. But, Judd's battle against the dominance of the museum system and the art market over the individual artist's creative endeavors turned out to be a self-imposed financial burden towards the end of his life.[52] Judd finally had to cope with economic reality as a given social system operating on its own logic, outside of the artist's ultimate control.

Moving from New York City to Marfa, Texas

In the late 1960s and the early 1970s, cultural institutions in New York, such as The Museum of Modern Art [MoMA] and Metropolitan Museum of Art, came under attack by various artists who demanded changes. Artists protested racial and gender inequalities at art museums which underrepresented minority and female artists in their exhibitions and collections. But Judd was not enthusiastic about such demonstrations because he saw art being used for political purposes: "Why is the Modern [MoMA] so interesting? Why be so eager to demonstrate, to use a tactic that was originally used for a much more serious purpose ?"[53] Led by his anarchistic individualist doctrine, Judd sought out his own solution for fighting against the bureaucratic and capitalistic ventures of governmental and cultural institutions.

For Judd, large cultural institutions such as the National Gallery in Washington D.C. represented "fascist architecture," and he was critical of the museum's

51 Donald Judd, "A Long Discussion Not About Master-Pieces but Why There Are So Few of Them, Part I" (1984); reprint in *Judd, Complete Writings 1975–1986*, 52.
52 Melissa Susan Gaido Allen wrote about the financial situation of Chinati Foundation when Judd died; she reported that there was only $400 left in his bank account. Melissa Susan Gaido Allen, "From Dia to The Chinati Foundation: Donald Judd in Marfa, Texas 1979–1994" (M.A. thesis, Rice University), 1995.
53 Judd, "Artist and Politics," 37.

exclusion of Russian art and contemporary art.[54] Judd was not only anti-large-government, but also anti-large-museum, due to such museums' bureaucratic way of compartmentalizing art forms and separating them from their cultural context:

> No one agrees, except on the status quo, and they are not going to think enough even to intelligently disagree, much less agree on something new and constructive.
> This is why art has to be bottled up in museums, why everything has to be separated. Art disagrees with God and Country but the museums allow it to exist as Culture, isolating it from God and Country, which it might bite, that is, the museums prevent art from having any effect on the society and any common occurrence. This is one reason why there is a special museum and concert hall architecture.[55]

Judd came to detest the business orientation of art galleries and the ways in which his works were installed poorly and on a temporary basis at museums due to the priority given to cost efficiency.[56] In order to prevent the control of the state and the art market over artworks, Judd developed the idea of permanent installations; i.e. the installation of artworks by himself and other artists, such as Dan Flavin, John Chamberlain, Carl Andre, Claes Oldenburg, and Richard Long, in situ forever.[57] In her dissertation, "Donald Judd and the Marfa Objective," Melissa Susan Gaido Allen describes the development of Judd's large-scale permanent installations in Marfa with the financial support of the Dia Art Foundation between 1979 and 1984.[58] The realization of permanent installations was Judd's

54 Donald Judd, "On Russian Art and Its Relation to My Work," *Art Journal* 41 (Autumn 1981); reprint in *Judd, Complete Writings 1975–1986*, 18.

55 Donald Judd, "In Addition," in Donald Judd, *Donald Judd, Architektur* (Munster: Westfalischer Kunstverein, 1989), 208–09.

56 Donald Judd, "On Installation," in *Documenta* 7 (Kassel: Paul Dierichs, 1982), 164–67.

57 Melissa Susan Gaido Allen's Ph.D. dissertation, "Donald Judd and the Marfa Objective," is an impressive, comprehensive study of Judd's permanent installations in Marfa and focuses, with extensive visual documents, on Judd as an architect. Her work is based on her own long-term eye witnessing of the history and development of the Chinati Foundation and Judd Foundation and the changes in the installations over the period of time before and after Judd died. Melissa Susan Gaido Allen, "Donald Judd and The Marfa Objective" (Ph.D. diss., University of Iowa, 2005), 66–102.

58 The Dia Art Foundation was established in 1974 by Philippa Pellizzi (née de Menil) and Heiner Friedrich and funded by the family fortune of the de Menils. In 1979 the Dia Art Foundation ↗

solution to ending the cycle of artworks being circulated hand to hand to enhance market values, while artists could neither profit from this cycle nor influence its unfolding once the artwork left the studio.

Judd believed in the efficacy of the artist's individual action in society, and for him this belief was ultimately fulfilled by his commitment to permanent installations. The concept was gradually formed and materialized as Judd bought a nineteenth century, industrial, cast iron building on Spring Street in the SoHo neighborhood of New York in 1968, and renovated the vast spaces into his residence and studio. Artworks and furniture were carefully placed on each floor of the building. The spatially balanced design became a model for Judd's large-scale, permanent installations of artwork and furniture, which evolved subsequently in Marfa, Texas, in both indoor and outdoor spaces, and later in Eichholteren in Switzerland. Judd noted his passion for maintaining artworks in situ: "Permanent installations and careful maintenance are crucial to the autonomy and integrity of art to its defense, especially now when so many people want to use it for something else." [59] His was a piecemeal gesture against the dominance of an art market operating under the premise that art is an easily handled and traded commodity. In order to realize his ambitious vision of permanent installations, Judd had to deal with financing his projects through resources from sales of his own works as well as a massive contribution from the Dia Art Foundation.[60]

Judd took one step further toward social decentralization by moving his main workplace and residence out of New York City, the economic center and pivot of the cultural establishments of the United States. By the early 1970s he was increasingly disturbed by the authoritarianism of the city at all levels, from local politics, to the art market, and the art community in the city. He confessed, "I left [New York] legally because it was so awful. I don't like being lectured by

↘ signed an agreement to support Judd's large-scale permanent installations in Marfa.

59 Judd, "On Installation," 167. Allen discussed the careful coordination required in installations of Judd's artworks at museums and Judd's dissatisfaction with how his artworks were mishandled when they traveled; this led toward his development of the idea of the permanent installation. See Allen, "Judd and Marfa Objective," 71–76.

60 A troubled relationship developed between Judd and his patrons at the Dia Art Foundation in the early 1980s. See Michael Ennis, "The Marfa Art War," *Texas Monthly* 12, no. 8 (August 1984): 138–42, 186–92. After Judd won a legal battle against the Dia Art Foundation, he established his own Chinati Foundation named after a nearby mountain. It has been open to the public since 1986. Following Judd's death, the Chinati Foundation resumed a tie with the Dia Art Foundation.

doctrinaire artists, who are fortifying their work with politics, about situations I've lived with all my life and learned about angrily detail by detail." [61] Meanwhile, Judd was looking for open, under-populated, undeveloped, remote land as a site for large-scale permanent installations.[62] Mexico was considered as a potential location for this venture, but Judd found that it was inconvenient for art objects to cross the international border due to complications at customs. As an alternative, he found the town of Marfa, with a population of just over 2000, in southwestern Texas to fulfill his purposes, saying "it was the best looking and most practical" site he could find.[63]

In order to reach the town of Marfa, one has to ride three hours by car from the nearest public airports in Midland or El Paso. (fig.14) The layout of the center of Marfa is a flat, simple grid with one main intersection at South Highland Avenue (Highway 67) and San Antonio (Highway 90). A few blocks north from the central intersection, the pink-walled, charming classical building of the Presidio County Courthouse stands at the focal point of Highway 67, which leads to Presidio and Mexico. The railway runs parallel to Highway 90 through the center of town. Nonstop freight trains, trucks, and cars pass through the inner heart of the city during day and night. The city has a simple, symmetrical and compact layout free of large architectural developments. There is a sense of an expansive landscape without any focal point. Judd and his two children spent the summer of 1972 in a small house in town, and the following year he bought the abandoned World War I

fig.14 Map of Marfa in Texas, cortesy of Marfa chamber of commerce, www.marfacc.com/maps.php

61 Judd, "Imperialism, Nationalism and Regionalism," 222.
62 Allen pointed out the new trend toward land art in the art world at the time of Judd's search for a site for large-scale installations; Allen, "Judd and Marfa Objective," 76–80.
63 Donald Judd, "A Portrait of the Artist as His Own Man." *House & Garden* 157, no.4 (April 1985); reprint with a shorter title, "Marfa, Texas," in *Chinati Foundation* 2 (November 1996): 21.

airplane hangar, which was moved to Marfa before WWII, on the edge of town and gradually turned them into a residence for himself and his two children. Judd became a resident of Texas in the mid-1970s, and his children went to a local school.[64]

Seeking the possibilities of smaller communities was part of the larger movement of anarchist action in the late 1960s, as summarized by Woodcock:

> Today it is likely that more people than ever before are consciously engaged in some kind of decentralist venture which expresses not merely rebellion against monolithic authoritarianism, but also faith in the possibility of a new, cellular kind of society in which at every level the participation in decision-making envisaged by nineteenth century anarchists like Proudhon and Kropotkin will be developed.[65]

Judd's anarchistic distrust of central government continued, and he seemed never to lose his decentralized vision of politics in his later life. R.H. Fuchs, a friend of Judd, recalled what Judd told him in the 1980s: "Texas should really secede from the United States and proclaim itself a second republic; and then the southwest [of Texas] should secede from Texas. The world would best be made up of nothing but small countries ... like Switzerland and The Netherlands—then all of those stupid power problems wouldn't exist."[66] Judd's aspiration for a republic of Texas germinated during the 1960s, and perhaps his decentralized position was best embodied in an early flag design. In his *American Flag in Negative Colors of the Spectrum*, Judd undermined governmental authority by rendering the colors of the American flag in reverse. (fig.15) Judd moved to Marfa with this flag foremost on his mind, and began to shape his own way of life at his first rented, small house in the town. (fig.16) It was not a utopian move to a promised land, but rather a pragmatist, decentralist action in search of a solution, negotiated in view of the unfolding national, economic, and cultural conditions of the 1970s.

64 Later, the children moved back to New York City because they wanted to enter a high school there. They could also spend time with their mother, Julie Finch.
65 George Woodcock, "Not any power: reflections on decentralisation," *Anarchy* 104, (October 1969); reprint in *A Decade of Anarchy 1961–1970*, ed. Colin Ward (London: Freedom Press, 1987), 76.
66 R. H. Fuchs, "The Ideal Museum," *Chinati Foundation* 1 (August 1995): 6.

fig.16 Lujan House, Marfa, photograph by author, 2006.

CHAPTER 2

DO-IT-YOURSELF FURNITURE MAKING IN MARFA, TEXAS

The Do-It-Yourself Cultural Phenomenon

Judd's furniture making developed gradually around the time he obtained large spaces in 1968, when he bought the five-story cast iron building on Spring Street in SoHo, a do-it-yourself hub for artists who were illegally living and working in industrial spaces during the 1960s and 1970s. In this chapter, I will propose that the underlying model of Judd's working principles was the self-managing do-it-yourself approach toward repairing and constructing furniture and living environments that flourished in that period. After he and his children moved to Marfa, Texas in 1976, Judd developed increasingly various kinds of furniture, while incorporating standardized materials and adopting simple construction techniques in his furniture pieces.

Do-it-yourself, as a cultural phenomenon, has been all along paradoxically bound up with the opposite value and logic of that which is done-by-another. The phrase, do-it-yourself, was used in both political and cultural contexts with mixed implications, ranging from the democratic virtue of self-reliant individualism to the materialistic domination of consumer culture. Judd's do-it-yourself attitude was an ambivalent one; it did not fit into the ideals commonly attached to the do-it-yourself ethos in the popular imagination, namely American middle-class family values epitomized by a sweet home with a perfect lawn. Rather, Judd's approach reveals how the political agendas underlying the do-it-yourself movement were stimulated by the rise of a youthful counterculture and by new left thinking. Judd's own do-it-yourself credo was born of his aesthetic aspirations and fueled by his distrust for state politics and cultural institutions. On the one hand, Judd's rustic furniture production in Marfa reveals doubt about the strategic and progressive use of technology in modern mass-production processes. On the other hand, the rustic

furniture indicates Judd's involvement with two related yet contrasting methods of artistic production, do-it-yourself and done-by-order or done-by-another. I will discuss the contradictory nature of the do-it-yourself cultural phenomenon in which Judd's early furniture production can best be understood.

Judd was better known for done-by-order work than as a do-it-yourselfer, as he typically commissioned fabricators to make his artwork. In the art world, for a time he became rather notorious for having his art pieces made by others after he first commissioned the Bernstein brothers to produce a metal piece for him in 1963. Judd might seem far removed, then, from the idea of do-it-yourself, which is literally defined as "The action or practice of doing work of any kind by oneself, esp. one's own household repairs and maintenance, usu. as opposed to employing someone else to do it. Also *transf.* and *fig.* Freq. *attrib.* or as *adj.* Abbreviated as *D.I.Y.* Hence, do-it-him'self, do-it-your'selfer, do-it-your'selfism, and various other nonce derivatives."[1]

I treat the ideas and activities of do-it-yourself as part of a socio-cultural phenomenon defined by a concept opposite to employing someone else to do it for you. Technically speaking, the actions of do-it-yourself and done-by-another are contrary values. Unlike the hands-on method of do-it-yourself, work that is done-by-another implies control and manipulation over others to realize your projects, thus implying a hierarchical relationship, as between employee and employed. But do-it-yourself and done-by-another will also emerge in what follows as two sides of the same coin.

In reality, how far one commits to completing do-it-yourself projects on one's own generally becomes a matter of degrees of action. The idea of do-it-yourself germinated from the independent spirit of self-motivated individuals, but easy-to-follow manuals or professional hands-on support were available for less skilled amateurs in the do-it-yourself culture industry.[2] Even skilled do-it-yourselfers have to depend on standardized materials, machinery, or equipment supplied by manufacturers. At this practical level, both the do-it-yourself and the done-by-

1 *Oxford English Dictionary*, 2d ed., s.v. "do-it-yourself."
2 See the relationship between do-it-yourself home activities and the development of manufacture and retailing of tools for home renovation projects in Carolyn M. Goldstein, *Do It Yourself: Home Improvement in 20th-Century America* (New York: Princeton Architectural Press, 1998), 45-64. This exhibition catalogue cleverly provides a concise history and social analyses of the do-it-yourself culture and industry in the United States.

another procedures participate in the same economic logic and process of home interior decoration and renovation. They have coexisted side-by-side in society, even as the do-it-yourself practices and methods spread and were adopted in various realms: popular youth culture, liberal politics, and the home improvements industry.

Born in 1928, Judd primarily grew up in the suburbs, which played a dominant role in the development of the do-it-yourself home furnishing and renovating industries in the postwar United States.[3] Like Judd, most of the Minimalist artists came from the do-it-yourself generations. Young and adult do-it-yourselfers in the 1960s and 1970s were often raised in postwar housing situations and were familiar with the basic home improvement projects, tools and materials provided by the do-it-yourself industry. In *Do It Yourself, Home Improvement in 20th-Century America*, Carolyn M. Goldstein pointed out that the return of soldiers from Second World War caused a high demand for suburban housing, while do-it-yourself home projects boomed throughout the 1950s in the United States.[4] The do-it-yourself home improvement craze meshed with certain conformist values of the 1950s: the cherishing of "domesticity, of leisure, and of independence."[5] It also propagated an American dream of suburban affluence filled with the latest home gadgets and embodying an optimistic view of technological development in modern life.

The mass media of do-it-yourself magazines, beginning in the 1910s and, later, of television programs like *This Old House*, which debuted on PBS in 1979, propagated not only techniques of "how to," but also the fantasy of a beautiful home with the latest electronic devices, achieved through successful renovation models which could be easily followed by aspiring do-it-yourselfers.[6] *The Whole Earth Catalog*, first published in 1968 by Stewart Brand, became an unofficial manual that spread the communal spirit of the counter-cultural youth movement during the late 1960s and the 1970s. Promoting the independence of individuals to think and act responsibly, the magazine introduced ideas and tools adopted

3 Donald Judd answered an interviewer's question regarding his favorite place while he was growing up: "We always lived in suburbia, which I hated from the very beginning. My favorite place was my grandparents' farm in Kansas City, where I spent summers"; Donald Judd, "Donald Judd: The Interview," *Interview* 24 (April 1994): 96.
4 Goldstein, *Do It Yourself*, 35–36.
5 Ibid., 37.
6 For the role of mass media in do-it-yourself home activities from its pre-war outset to the 1970s, see Goldstein, *Do It Yourself*, 13–28, 94–95.

from do-it-yourself principles for individuals to help restore the environment and build communities. After the do-it-yourself craze of the 1950s, there was a rising interest in the craftsmanship of the past, and the historical preservation movement became instrumental as well during the 1960s.[7] The ambitious do-it-yourself projects of creating brand new houses or boats during the 1950s and the early 1960s waned thereafter, while the renovation and preservation of old houses or historical buildings came into prominence. For instance, the *New York Times* often reported on the renovations of old buildings for modern living without losing their historical touches.[8]

Judd's taste for rustic, aged, handmade furniture was not unique during the 1960s. He extensively collected pieces of antique, vernacular, and Arts and Crafts furniture. Peter Ballantine, a fabricator of Judd's plywood pieces, met Judd in 1968 and recalled that, back then, the artist already owned antique furniture, much of which was from Africa and was purchased from nearby shops in SoHo.[9] Judd also loved Arts and Crafts furniture designers, such as Gustav Stickley, whose furniture he collected and used in his dining area and living rooms at La Mansana de Chinati (The Block) in Marfa.

As antique, craft furniture was rediscovered, do-it-yourself kits for making antique-looking furniture boomed in the late 1960s and early 1970s, with projects for Shaker chairs and grandfather clocks being popular, for example. The look of old or authentic furniture appealed to nostalgic consumers' yearning for items made long before the troubled era of the 1960s. This trend of nostalgia for the past was also stimulated by the counterculture, which questioned the technocratic society and the consumerist orientation of modern life.[10] Surrounded by mass produced commodities while they were raised, many middle-class baby-boomers seemed to cherish handmade, authentic objects and to enjoy remodeling buildings based on past styles.[11] As part of this trend of looking back, naïve and aged-looking furniture would at times be fabricated using contemporary production

7 Ibid., 84–89.
8 For example, E.S. Bent, "Red Tape Entangles 2 Rescuing a House," *New York Times*, 2 June 1968, R 1; Rita Reif, "A 1760 Barn for 1968 Living," *New York Times*, 22 March 1968, 42.
9 Peter Ballantine, interview by author, New York, 14 April 2006.
10 See Theodore Roszak, *The Making of a Counter Culture, Reflections on the Technocratic Society and Its Youthful Opposition* (Garden City, N.Y.: Anchor Books, 1969).
11 Goldstein, *Do It Yourself*, 87.

techniques.[12] Although Judd did not explicitly express any nostalgic feelings toward the past with regard to his furniture design, he participated in this popular cultural climate in favor of old-looking furniture when he fabricated naïve style furniture beginning around the mid-1970s in Marfa.

fig.17 Lauretta Vinciarelli, Desk, 1977, plywood, fabricated by Peter Ballentine

At first, Judd constructed some of his furniture himself, but as he had limited technical skills the job was increasingly taken over by his father, a sophisticated Sunday carpenter, as well as by local handymen, skilled collaborators, and professional furniture fabricators. He was in part inspired by what he saw around and within his close network of friends and family. For instance, Lauretta Vinciarelli, an architect and erstwhile girlfriend of Judd, designed a large desk made of plywood for herself that was fabricated by Ballantine in 1977.[13] (fig.17) Judd liked her desk's formal simplicity and functionality, with its open and wide shelves designed to store rolled architectural plans or books on both sides of table. Judd designed a comparable desk made of planks for his children in the following year of 1978 in Marfa. (fig.18) Judd was neither a designer nor a cabinet maker in the conventional sense, though his early furniture grew out of his practices of art making and his concerns with space in conjunction with do-it-yourself principles. According to Judd, his grandfather Clarence Judd had built houses in Missouri, and Judd's father worked with wood and had hoped that his son would be interested in woodworking.[14] But Judd never liked craft woodworking; he lamented, "it was so boring. I didn't like the details." [15]

In due course, as he began to own a number of properties after 1968, Judd hired various carpenters and fabricators to furnish his own residential spaces

12 Ibid., 90–93.
13 Lauretta Vinciarelli, interview by author, New York, 22 April 2008. Vinciarelli met Judd in 1976 and they were together for about ten years. They spent time in the Spring Street building in New York and the Block in Marfa. Vinciarelli worked on several architectural projects in Marfa including a design of a garden for the Walker House in 1979 (unrealized). Judd purchased her drawings of a proposal for a public garden project (1975–1977) in Italy.
14 Judd, "DJ: Interview," 98.
15 Ibid.

fig.18 Donald Judd, Children's desk, 1978, pine, fabricated by Donald Judd, *A good chair is a good chair*, Ikon, 2010. Images/Courtesy Ikon, photography: Stuart Whipps

with artwork and furniture. During the 1980s, by which time Judd had achieved financial success, he had over thirty people working for him on renovation projects with old buildings in Marfa, Texas. For the most part, the carpenters in New York and Marfa who initially produced Judd's wood furniture in the 1970s and the 1980s were not formally trained as cabinet makers in the strictly traditional sense.[16] They were rather talented carpenters or handymen, coming from the do-it-yourself generation, and they often made both artwork and furniture for Judd, as he requested it in the regular course of his art-making and home improvement projects. In other words, Judd's wood furniture was initially fabricated by amateur do-it-yourselfers (including Judd himself) who had not been conventionally apprenticed under professional furniture makers.

16 Ichiro Kato worked for Jim Cooper since 1980, and they fabricated both Judd's wood artworks and his furniture. According to Kato, Cooper is a so-called "original resident" of SoHo who also belongs to the "do-it-yourself generation." Cooper is a talented craftsman and self-taught cabinetmaker. As Kato explained to me, when Cooper bought a property in SoHo, there was a table saw left in the building, so Cooper decided to use it and made some furniture for himself and eventually for his neighbors. After graduating from Musashino Arts University in Japan, where he majored in industrial design, Kato went into the furniture industry. He learned furniture-making processes at different furniture factories in Japan. Kato thinks that a cabinet maker like him, that is, with a college degree, was very rare back then. He is more flexible and open about using various tools from foreign countries and about working with artists compared to other traditionally trained Japanese cabinet makers. Ichiro Kato, interview by author, New York, 20 May 2006.

Anarchist Promotion of Do-It-Yourself

Politically speaking, anarchist principles promoted a do-it-yourself outlook by self-reliant individuals linked to an ideal of decentralized state authority. Goodman and Woodcock stressed the importance of do-it-yourself philosophy and activities applied to all levels of society. In his discussion on learning by doing, Goodman saw do-it-yourself as a self-organizing method operating according to its own logic among the individuals of a community, not as a tool for agitating for a movement or for revolution. Thus he wrote, "It is inauthentic to do community development in order to 'politicize' people, or to use a good do-it-yourself project as a means of 'bringing people into the Movement.' Everything should be done for its own sake." [17] Likewise, Woodcock stressed the significance of do-it-yourself as a key to co-operation at all levels of society:

> The factor of free co-operation in fact permeates every sphere of life, even though it is hidden under authoritarian structures which impoverish society by discouraging and destroying popular initiatives, by doing things for people instead of letting them do [them] for themselves. 'Do-it-yourself' is in fact the essence of anarchist action, and the more people apply it on every level, in education, in the workplace, in the family, the more ineffective restrictive structures will become and the more dependence will be replaced by individual and collective self-reliance ... The more we build and strengthen an alternative society, the more the state is weakened.[18]

In a 1976 book of essays, *Housing: An Anarchist Approach*, Colin Ward also advocated the anarchist principle of dwellers' control over the design, construction, and operation of their housing, as a path toward the social well-being of individuals generally.[19] Judd, who owned this book, was effectively following Ward's idea of tenants' control over their living environments when he renovated his first rented, small house in Marfa where he began to live with his children in

17 Goodman, "Black Flag," 13.
18 George Woodcock, *Anarchism*, 2d ed.; quoted in *For Anarchism, History, Theory, and Practices*, ed. David Goodway (London: Routledge, 1989), 15.
19 Colin Ward, *Housing: An Anarchist Approach* (London: Freedom Press, 1976), 8.

1972. (fig.16) Allegedly, the family who rented the house to Judd was unhappy because Judd renovated the house without the owner's approval.[20] This suggests that Judd believed in the anarchist do-it-yourself principle of the dweller's right to remodel his own living environment and so to deny the owner's authority and control over the tenant.

As he moved to Marfa and became a resident of Texas, Judd was not interested in fabricating a middle-class, suburban home. He was separating from his wife Julie Finch, who did not wish to move to Texas, and he was virtually a single father with two small children, Flavin and Rainer. He chose to live in a house located in the poorest neighborhood on the edge of town. Evidently, Judd was at odds with conformist values and the ideal of fatherhood implied by the common do-it-yourself home activities typical of complacent U.S. suburbia.

Do-It-Yourself Rustic Furniture Made in Marfa

Judd's furniture production in Marfa was mostly shaped by and developed under the given conditions of space, available materials, tools, fabricators, and available budgets in conjunction with his preference for simplicity of form and structure. As an example, Judd made a low bed with two sides divided by pieces of wood so that each child had an individual space in one of the rooms at Lujan House. (fig.19)

In order to give them each an area of their own notwithstanding the one room, I designed a bed which was a closed platform of one by twelves with a central, freestanding wall, also of one by twelves. The

Fig.19 Donald Judd, Children's bed #8, 1977, pine, 82.5 x 94 x 12 in. (209 x 239 x 142 cm). fabricated by Donald Judd, Image Courtesy Judd Foundation/Judd Furniture

20 Lee Donaldson, a former fabricator of Judd's Cor-ten steel pieces, and his family were among those Judd invited to a party at his rented house, called Lujan House. Donaldson explained that Mr. Lujan, the owner of the house, was upset about what Judd had done to the house without permission. Lee Donaldson, interview by author, Marfa, Tex., 5 June 2006.

bed was designed so that the lumber yard could cut the few different lengths to size and I could then nail them together in place. I liked the bed a great deal, and in fact the whole house, for which I made other furniture. Later, in a large place in town, I designed desks and chairs for the children using the same method of construction.[21]

Judd also said the following about his early furniture production in Marfa made with standardized pine boards:

I'm not much of a carpenter so it had to be relatively simple: I designed a desk, a bed, a chair for the children. Slowly, I started to build furniture as it was needed. At first it was plain planks. I figured it out so I could tell the lumberyard what I wanted—four pieces, five feet long, three pieces, two feet long—and they would cut them for me. They wouldn't do too many and they wouldn't do anything fancy. They would just chop it up. For a long time the basic module was the width of the wood: 1x12s, 2x12s. For some racket of the lumberyards, the twelve inches were really eleven inches.[22]

In his early do-it-yourself furniture production in Marfa, Judd followed the logic and economy of the lumber industry while fulfilling the simple and rational constructive requirements of his furniture. He was taking part in a kind of anarchist do-it-yourself action of designing and furnishing his own living environments, while coping with the given basic, conditions of local material and talent in a small community. Judd's wood furniture made in Marfa would mostly be constructed by the brothers Celedonio and Alfredo Mediano, as well as Anselmo Hernandez, and Ramon Nuñez back then. They were not trained as professional cabinet makers, but rather as good carpenters or handymen who collaborated with Judd on his furniture production, renovations, and a number of other tasks at his residences and permanent installations in Marfa.

The do-it-yourself rustic furniture made in Marfa represented fruitful collaborations between Judd and these local carpenters. Judd tended to provide

21 Donald Judd, "On Furniture," *Donald Judd: Möbel, Furniture* (Zurich: Arche Verlag AG, 1986); reprint in *Judd, Complete Writings 1975–1986*, 108.
22 Donald Judd, "Donald Judd's 'Real' Furniture," *XXIst Century* 1, no.1 (Winter 1991/92): 76–77.

minimal instructions about his furniture designs to his collaborators. As Alfredo Mediano and Ramon Nuñez recalled, their experiences of making furniture for Judd always began with a simple drawing. Judd's drawings usually show a basic form with metric measurements added for the sake of precision. Then, for instance, Judd told them to purchase multiple boards of standard widths with a given length, according to the sizes of the spaces where the furniture would be placed.[23] It was mostly the carpenters' responsibility or challenge to determine the details of joints and to obtain pieces of wood that would please Judd's particular taste. Finding an excellent quality of wood was the primary concern for Nuñez, who worked for Judd from 1988. Judd never went with Nuñez to buy wood at the lumberyard in Fort Stockton, 90 miles from Marfa.[24] He always bought the first grade of yellow pine for Judd since its surface is noticeably better than the second grade. Alfredo Mediano, who worked for Judd from around 1978 until the late 1980s, went further, to locations in El Paso or Odessa, in his search for fine, straight boards.[25] Judd was extremely particular about obtaining identical-looking pieces of wood. He preferred to use straight wooden planks with a fine, even surface and without irregular, animated patterns on them—difficult traits to find at lumberyards since wood is a natural material rife with imperfections. Judd did not incorporate the uniqueness of each wood plank into his furniture design; he was interested not in creating uniquely, sculptural pieces of furniture, but in simple objects without excessive detail, akin in a way to his artworks.

Making Judd's furniture was a continuous process of trial and error for the Mediano brothers because Judd did not direct them as to details of fabrication. Alfredo Mediano recalled that outdoor furniture was particularly difficult. Since wood dowels—whose appearance Judd liked—tended to become dislodged once it rained, they used galvanized screws hidden by wooden dowels on the surface.[26] Generally, Nuñez felt that Judd's furniture was not so difficult to construct so long as he could obtain the proper fine wood. According to Nuñez, typically the

23 Ramon Nuñez, interview by author, Marfa, Tex., 5 June 2006.
24 Now, Nuñez has to acquire yellow pine by order further away, in San Antonio because he has to repair and make furniture for in-house use at the Chinati Foundation; Nuñez, interview.
25 Alfredo Mediano recalled that white pine was used for indoor furniture, whereas yellow pine was adopted for outdoor furniture at the Block because the white is softer and easier to work with, while the yellow is tougher and better for outdoors; Alfredo Mediano, interview by author, Marfa, Tex., 7 June 2006.
26 Mediano, interview, 7 June 2006.

furniture was made off-site, often in Judd's workshop at one corner of the main crossroad in Marfa (now a city hall), and then brought to each designated space. Large tables, such as the ones in the library or Arena at the Chinati Foundation, were made in three or four parts and then assembled on site. (fig.20/21) Since the largest furniture, made of solid planks, was extremely heavy, once it was installed it was not moved easily.[27] This furniture especially was not portable in the sense that ordinary furniture is. It became rather site-specific objects akin, in that respect, to his artworks installed permanently in given spatial settings.

fig.20 Arena, Marfa, interior view with large tables, chairs, and bench by Donald Judd, photograph by author, 2005

Judd tended to prefer to keep the visibility of external joints to a minimum, with both indoor and outdoor furniture, but often there had to be metal hinges placed behind the visible, external surfaces in order to create extra support. Lacking such refinements, some of the early plank chairs are too fragile to support leaning on their backs. Former fabricators of Judd's wood furniture, Jim Cooper and Ichiro Kato in New York, pointed out that a primary principle of woodworking is to follow the basic nature of wood; for example, one side of a plank shrinks whereas the other side stays the same. This is basic knowledge all woodworkers have to follow when they construct furniture. A structural weakness in Judd's unprofessionally-made wood furniture, fabricated by carpenters in Marfa, was caused by a violation of this

fig.21 Arena, Marfa outside view, photograph by author, 2005

27 Marianne Stockebrand, a director emeritus of the Chinati Foundation, also pointed out that those large pine tables were basically immovable once they were installed; Marianne Stockebrand, interview by author, Marfa, Tex., 5 December 2005. According to Nick Terry of the Chinati Foundation former staff, a large pine table designed by Judd requires ten men to lift it up to move. Nick Terry, interview by author, Marfa, Tex., 5 December 2005.

fundamental woodworking rule.[28] Gaps formed between the planks of some of the furniture as it warped quickly. The roughly made, pine plank, indoor and outdoor furniture could not last forever—especially the outdoor furniture, which is exposed to the harsh heat and wind of south Texas.

Naïve Style Furniture

The simple, rustic, fragile plank furniture designed by Judd and made by local carpenters in Marfa was specifically intended to be naïve in style.[29] It continued to be made in the same manner throughout the 1980s, even after Cooper advised Judd on technical improvements with respect to the vulnerable structure of his rustic chairs. The humbly made plank furniture was never meant to be sold, but a similar design of furniture with improved structure and professional carpentry has been sold to the public. Alfredo Mediano remembered that Judd knew that the plank furniture would warp and become distorted, but he liked it when that happened and normally did not do anything to prevent it.[30] When Mediano had to repair rustic furniture, Judd wanted Mediano to avoid a brand new look in his repairs. Judd saw his early do-it-yourself furniture as a deliberately ingenuous style invented through his collaboration with local carpenters in Marfa.

Judd even sent the Mediano brothers to New York to fabricate some pieces of furniture for the Spring Street building in the early 1980s. Judd wanted to have exactly the same kind of furniture made in Marfa for his Spring Street building as well.[31] In other words, Judd knew that the rustic do-it-yourself furniture could

28 Jim Cooper recalled that he was unable to persuade Judd to improve a structural defect of his rustic wood furniture and put in place a more durable and marketable furniture production; Jim Cooper and Ichiro Kato, interview by author, New York, 9 May 2006.
29 To clarify the meaning of these terms: "naïve" means "natural and unaffected; artless; innocent. Later also: showing a lack of experience, judgment, or wisdom; credulous, gullible." In the field of art, it refers to "a painting, etc.: produced in a bold, straightforward style that avoids sophisticated techniques. Also: produced by a person without formal training." In science, it also refers to "a person or animal: not having previously had a particular experience or been the subject of a particular experiment; lacking knowledge of the purpose of an experiment; unconditioned. Of a test or experiment: using such subjects." *Oxford English Dictionary*, 2d ed., s.v. "naïve." I use the terms "naïve style furniture" in order to suggest the intentional display of a lack of woodworking knowledge in Judd's do-it-yourself furniture fabricated by local carpenters in Marfa under the supervision of the artist.
30 Mediano, interview, 7 June 2006.

only be created by the Mediano brothers' minds and hands—the particular talent and skill that Judd had discovered locally in Marfa. The brothers came with their basic woodworking tools and stayed in New York for sixteen days, fabricating a dining table and chairs and a table for the kitchen using lumber locally obtained in New York. According to Mediano, Jim Cooper invited the brothers to his workshop. Alfredo and his brother wanted to visit Cooper's workshop, but Judd did not allow them to go because he did not want them to be introduced to new tools and new techniques.[32] Judd told them "no" because he thought their furniture was perfect in its own right and should not be done any other way.[33] Alfredo Mediano told me that he and his brother knew that some of the chairs they made were fragile and would collapse if a sitter leaned back in them. They wanted to reinforce their furniture with metal joints, but Judd preferred that they primarily use wood dowels, an old and simple wood joint method. Mediano had a power tool to make biscuit joints, for example, but Judd did not allow him to use that technique because he thought it was too fancy for this naïve style furniture.[34] (fig.22-a, b) There is, in short, a denial of modern machinery and advanced technology behind the operation of making simple do-it-yourself furniture that Judd developed in Marfa.

fig.22-a Dowel joint

fig.22-b Biscuit joint

Machinery and Technology Questioned

In his essay, "Do-It-Yourself: Constructing, Repairing and Maintaining Domestic Masculinity" (1997), Steven Gelber observes that the culture of do-it-yourself became an embodiment of idealized American manhood during the 1950s. The

31 Mediano, interview, 7 June 2006.
32 Mediano, interview, 7 June 2006.
33 Mediano, interview, 7 June 2006.
34 Alfredo Mediano, interview by author, Marfa, Tex., 8 June 2006. Biscuit joints use a piece of wood in a shape of a leaf or a biscuit, applied between sections of two parts of wood with concaves in the shape of biscuit, cut out by a special mechanical tool in order to place the biscuit.

spread of the suburbs stimulated the do-it-yourself home projects carried out through the leadership of the father on the weekends when he was away from his place of employment. Gelber suggests that the term "do-it-yourself" became part of the very definition of the suburban husband by the end of the 1950s. He argues that do-it-yourself activity can be seen as a restitution of the "traditional direct male control of the physical environment through the use of heavy tools in a way that evoked pre-industrial manual competence." [35] He discussed how prior models of masculine identity waned with the rise of white-collar employment, while men's ability to fix things in their own domestic environments gave do-it-yourself "an aura of masculine legitimacy." [36]

In the 1960s, do-it-yourself home projects continued to be commonly practiced in many households, while there was a growing emphasis on fine home workshops loaded with mechanical instruments. As reported in the *New York Times* of March 19, 1961, more than thirteen million households boasted home workshops, and nearly twelve million were equipped with power tools.[37] The trend of having home workshops was both a result and a cause of the simplified construction processes of mass produced housing structures and the ongoing supply of superior new tools and standardized, easy-to-handle materials, such as plywood, after the war.[38] Gelber pointed out that—even though an increasing number of women were willing to cope with tools and household repairs as do-it-yourself practices were widely exercised in American suburbs—"the big tools never lost their aura of masculinity." [39] In the late 1960s, the masculine desire to dominate modern mechanics still prevailed. However, a form of reaction against it emerged in elements of the counterculture movement which embraced the past, craftsmanship, and a simple way of living, as opposed to the pervasive conformity of the American middle class and suburban affluence.[40]

35 Steven M Gelber, "Do-It-Yourself: Constructing, Repairing and Maintaining Domestic Masculinity," *American Quarterly* 49, no. 1 (1997): 2.
36 Ibid.
37 Richard Strouse, "The Self-Made Industry," *New York Times* 19 March 1961, SMA 44.
38 Ibid.
39 Gelber, "Do-It-Yourself: Domestic Masculinity," 4.
40 In chapter ten of his book, David E. Shi discusses the simple way of life sought by the youthful generation during the 1960s and how it developed into the environmental consciousness of 1970s and 1980s in the United States. David E. Shi, *The Simple Life, Plain Living and High Thinking in American Culture* (New York: Oxford University Press, 1985).

Although Judd used an industrial, in a sense masculine-coded formal vocabulary with his pristine artworks, he was not enthusiastic about catching up with the latest power tools or machinery, typically sought after by the serious do-it-yourselfers. Judd owned the old-fashioned wood-working tools of the 1950s, possibly obtained from his father or grandfather, though Peter Ballantine never saw Judd use them.[41] There is a hint of Judd's admiration for mechanical devices, for instance, in the kitchen of the Spring Street building, which was equipped with a commercial meat slicing machine and an industrial scaled kitchen sink. But these were rather old, low-tech industrial objects meant to serve large-scale functions in his open-plan kitchen, which now looks more like a late nineteenth-century kitchen used to prepare meals for a big family.[42] As it happened, there was no artist's shop at the Spring Street building until the late 1980s when Judd set up a very basic woodworking workshop for his furniture production—otherwise, Judd hired fabricators to make his works outside of his residence.[43]

There is a workshop at the Chinati Foundation where I interviewed Nuñez. It is the place to repair and construct rustic furniture for private use at the Foundation. (fig.23) The workshop is equipped with the minimum tools needed to fulfill simple tasks of woodworking. Often artists' fully equipped workshops enabled the construction of three-dimensional art objects at a single location. In

fig.23 Ramon Nuñez at the workshop of Chinati Foundation, Marfa, photograph by author, 2006.

41 Ballantine, interview, 14 April 2006.
42 In fact, although they are no longer in place in the SoHo building, Lauretta Vinciarelli remembers that there were all kinds of convenient, modern electrical appliances common to households, including a coffeemaker and a toaster, at Judd's kitchens at the Spring Street building and at the Block in Marfa while they were together between 1976 and the mid 1980s. Vinciarelli saw that Judd was rather practically-minded, and not strictly anti-technology; Vinciarelli, interview.
43 Jeff Jamieson, a fabricator of Judd's wood furniture after 1989, worked with his business partner Rupert Deese at a small workshop equipped with basic, simple woodworking machinery, such as table saws, in the basement of the Spring Street building until 1994, before he moved to California. Thus, Judd's woodworking workshop at the Spring Street residence was mainly occupied by other fabricators, not by Judd himself; Jeff Jamieson, telephone interview by author, 13 November 2007.

contrast, it seems that Judd had no interest in putting all the necessary facilities and equipment to fabricate his artworks and his furniture in one centralized place. Basically, his fabricators in New York City, such as the Bernstein brothers and Peter Ballantine, had their own workshops and worked independently, away from Judd's studio.[44] Thus, as both a father and an artist, Judd was separating himself from mainstream, male do-it-yourselfers.

"Made by machine is a myth," said Rob Weiner of the Chinati Foundation, commenting on Judd's works.[45] The furniture that Judd designed appears to consist of simple, geometric, rigorous forms; the visibility of joints is kept to a minimum and the edges are sharply defined. As such, this furniture does not evoke the warmth associated with traditional craft works at first glance. However, Judd's wood furniture was actually constructed by fairly conventional, old, wood joining techniques, such as dovetails, wood dowels or interlocking joints. Judd was not technologically-oriented in his design of furniture; he was not eager to invent a new method or to use advanced materials to fabricate his furniture. In this sense, Judd deviated from the exemplary industrial designer, who is usually preoccupied with the latest and most cost-efficient material and technology with a view to serving a large public.

In his wood artwork as well as his furniture, Judd suppressed any conventional handicraft aspects. But he was not interested in championing the widely-held belief in the supremacy and marvel of modern technology during the 1960s, either.[46]

44 As an exception, during a brief period between January and September of 1981 Ballantine used an entire ground floor of the Spring Street building as a workshop in order to make a large plywood piece that was too large to fabricate at his own nearby workshop. Peter Ballantine, email correspondence with author, 7 May 2008.

45 Rob Weiner, interview by author, Marfa, Tex., 15 December 2005.

46 Historically, the term "technology" is a modern invention, as is the concept behind it. Technology is derived from the combination of the Greek words *techne*, "art, craft," and *logos*, "word, speech," and was first used in English in the seventeenth century in a discussion of applied arts. By the mid-century, it was broadly defined as "the means or activity by which man seeks to change or manipulate his environment." It has been rooted in the rational, scientific application of reason to techniques, and associated with inventions and innovations of machines, materials, or tools in modern industry to meet the needs of modern civilization. *Encyclopedia Britannica*, Online Academic ed., s.v. "technology." http://www.britannica.com/EBchecked/topic/ 585418/technology. Like the term technology, "craft" basically indicates human intellectual activities: "Strength, power, might, force," and more specifically "Skill, skillfulness, art; ability in planning or performing, ingenuity in constructing, dexterity," "Human skill, *art* as opposed to nature," or "A work or product of art." Unlike the concept of technology, however, the definition of craft includes the non-rational ↗

Moreover, according to Judd, his "paintings were handmade, but none of the three-dimensional work is meant to look handmade, including the wooden ones which I made in as matter-of-fact a way as I could. Wood being what it is tends to look more manipulated than metal. I kept down the handi-craft aspect. Other artists play it up."[47] In a 1971 interview, Judd discussed the low-level technology he used in his art:

> In the first place, I use an old-fashioned technique—basically a late 19th-century metal-working technique. I don't romanticize technology like Robert Smithson and others. I think generally you are forced into more modern technologies, but the technology is merely to suit one's purpose. It's not something mysterious or something that sanctions the work.[48]

Judd did not see his works as following a linear course of development: "I don't have too great a sense of progress—of change, either. I like to work back and forth. There seems to be a lot more variety in my work than is casually apparent."[49] In fact, some of the works Judd conceived early on were realized decades later, when he was able to afford fabricators to make them. The ideas could be simply executed once there were sufficient materials, skilled labor, and money. This is a very rational, practical, socially-minded, and economical way of creating objects. Judd basically applied available materials and pre-existing techniques to both his artwork and his furniture designs. There is no praise for industry, machinery or technology implied in his furniture productions. Again, such a conception of machines is quite different from the typically optimistic approach found in popular do-it-yourself magazines for male subscribers. It is instead in sympathy with an anarchist understanding and practical use of mechanics to serve the necessary functions of a self-sufficient individual's conduct in everyday life.

↘ connotation of "Occult art, magic." The term, "handicraft" includes such meanings as "Manual skill: skilled work with hands," "A manual art, trade, or occupation," or "A handicraftsman, artizan [sic], workman." *Oxford English Dictionary*, 2d ed., s.v. "craft" and "handicraft."
47 Donald Judd, "An Interview with Don Judd by John Coplans," *Artforum* 9, no. 10 (June 1971): 45.
48 Ibid.
49 Ibid.

Lewis Mumford's Promotion of "Democratic Technics"

Judd's ideas about the roles and functions of modern machinery and technology are in some respects comparable to those of Lewis Mumford (1895–1990). Mumford, one of the most influential critical voices in the U.S. of the 1960s, is known for his architectural and urban planning criticism. Even though he did not claim to be an anarchist, Mumford was deeply influenced by Kropotkin's idea of a decentralized society in which citizens manage themselves at their workplaces.[50] Mumford propagated a libertarian vision of democracy and a pragmatic use of technology for transforming the direction and totality of one's life.[51] In 1989 Judd wrote that Mumford was one of the most undervalued writers; he thought that Mumford's observations about the way people live and design their living environments should be discussed more.[52] Judd had Mumford's major books in his libraries in Marfa: *The Conduct of Life* (first edition 1951), *Condition of Man* (first edition 1944, later edition 1973), *Myth of Machines* (first edition 1967), *Techniques and Civilization* (c.1934), and *The Lewis Mumford Reader* (1986; copies of which can be found on the bookshelves at the Block and at Casa Pérez, one of the houses at Judd's ranches), along with books by architectural and design historians such as Sigfried Giedion (1888–1968) and Manfredo Tafuri (1935–1994).[53] Judd evidently based his critical views toward modern technology, design, architecture, and city planning in part on these works.

Mumford conceived of the machine as a mere tool, an extension of the human hand and a vaunted contributor to individual creative output, as opposed to the "megamachine" of the authoritarian power system of society which oppresses the enrichment of one's personality in a democratic community. In his "Authoritarian and Democratic Technics" (1964) Mumford uses the term "democracy" to refer

50 Peter Marshall, *Demanding the Impossible: A History of Anarchism* (London: HarperCollins Publishers, 1992), 577.
51 Ibid., 578.
52 Judd, "In Addition," 208.
53 Books in English by Tafuri such as: *History of Italian Architecture, 1944-1985* (c.1989), *Theories and History of Architecture* (c.1980), *The Sphere and the Labyrinth: Avant-gardes and Architecture from Piranesi to the 1970s* (c. 1987) and Giedion's *Mechanization Takes Command, a Contribution to Anonymous History* (1948) are found at Judd's library at the Block; the publication dates given above are those of United States editions, and not necessarily of the exact copies Judd owned.

to bounded small groups and communities in which people knew each other. He defined "democratic technics" as "the small scale method of production, resting mainly on human skill and animal energy but always, even when employing machines, remaining under the active direction of the craftsman or the farmer," whereas "authoritarian technology" was associated with the totalitarian bureaucracy, military armies, and standardized mass production.[54] Likewise, Judd opposed the domination of a capitalistic regime in the art and furniture markets and of a large government which effectively controls individuals' everyday activities at all levels of society.

Regarding his furniture production, Judd admitted that his furniture is expensive because of the hand-made process of construction and not readily available in the furniture market because of its limited editions and made-to-order production.[55] As his assistant and friend Rob Weiner recalled, Judd had tried to make his furniture more affordable to a wider public by introducing a more mechanical fabrication process, but he gave up because he was unwilling to compromise on the quality of his furniture.[56] Judd complained about low priced, mass-produced furniture and its large distribution system which "monopolizes against diversity" and propagates "a slogan of the Pentagon," that is "'free enterprise" backed by the open market strategy of the United States foreign economic policy as well.[57]

In his 1989 essay "In Addition," Judd quoted the following text from Mumford's *Roots of Contemporary American Architecture* :

… Modern civilization has produced the totalitarian state, the extermination camp, and nuclear weapons capable of wiping mankind off the face of the earth. No small part of the modern is brutally contrary to all that our Victorian ancestors lauded; it must be identified with the regressive and the anti-human. Even in countries like the United States, with a long tradition of freedom and self-respect, new varieties of compulsions and conformities,

54 Lewis Mumford, "Authoritarian and Democratic Technics," *Technology and Culture* 5 (Winter 1964): 2–3.
55 Donald Judd, "It's Hard to Find a Good Lamp," in *Donald Judd, Furniture Retrospective* (Rotterdam: Museum Boymans-van Beuningen, 1993), 15.
56 Weiner, interview, 15 December 2005.
57 Judd, "It's Hard to Find a Good Lamp," 17, 19.

expressed in business as well as government, overpower our rational purposes and make mock of them: witness the American motor car, that rolling neurosis. Modern architecture, therefore, not merely gives expression to the best aspects of modern civilization: it also gives full representation to its worst elements—its purposeless materialism, its lubricious desire for publicity, its denial of the organic and the personal, its deference of human needs to those of the evergrowing, ever-expanding machine.[58]

Both Mumford and Judd championed decentralization in politics and believed in the empowered spirit and action of individuals in their lives and living environments. In his *Condition of Man*, Mumford also argued that the decentralization of power at all social levels would be achieved by a morally-committed individual, actively engaged with the whole process of regeneration of society: "The task for our age is to decentralize power in all its manifestations. To this end, we must build up balanced personalities: personalities that will be capable of drawing upon our immense stores of energy, knowledge, and wealth without being demoralized by them." [59] Like most liberal anarchists who were at odds with the totalitarian governments of communism, Mumford was opposed to the authoritarian aspects of Marxism; "the dominant forces of the nineteenth century, including the authoritarian communism of Karl Marx, remained on the side of big organizations, centralized direction, and mass production: with no thought for the worker except as a unit in the megamachine." [60]

Although Mumford rejected the "megamachine," he did not promote going back to the lifestyle of the pre-machine age. Rather, he proposed social regeneration through more human control over machines and architectural designs.[61] Judd and Mumford both assimilated the liberal tenets of anarchism; they both saw art as a high act of human expression.[62] Mumford saw modern art as proclaiming "the autonomy of the human spirit," as a "revolt against the

58 Lewis Mumford, *Roots of Contemporary American Architecture*, 2d ed. (New York: Grove Press, 1959); quoted in Judd, "In Addition," 211.
59 Lewis Mumford, *The Condition of Man* (1944; reprint, New York: Harcourt Brace Jovanovich, 1973), 419.
60 Lewis Mumford, *The Myth of the Machine* (New York: Harcourt, Brace & World, 1967), 255–56.
61 Lewis Mumford, *Roots of Contemporary American Architecture* (New York: Reinhold, 1952), xiv.
62 Lewis Mumford, *The Lewis Mumford Reader*, ed. Donald Miller (New York: Pantheon Books, 1986), 352.

machine."[63] For Mumford, art assumed a significant role in the regeneration of modern man and society:

> With the expression of a true work of art the goodness of life is affirmed, and life itself renewed. The work of art springs out of the artist's original experience, becomes a new experience, both for him and the participator, and then further by its independent existence enriches the consciousness of the whole community.[64]

Likewise, Judd thought that art has its own integrity primarily when created by an individual as free as possible from any kinds of authority. Art was not strictly a political tool for Judd, but an artist's existence and creations could nonetheless represent crucial and effective resistance to state control over individuals. Judd stated late in his career, "Society is basically not interested in art.... Art has its own integrity," and he continued that the only way artists can shake up society is by their very existence, because art is done by individuals and it does not serve society.[65] As a professional independent artist in a society run on the basis of capitalist logic, Judd basically did not expect to win critical acclaim and financial support from the government, corporations, or the public.

Mumford affirmed the independent spirit of do-it-yourself, while critiquing the do-it-yourself industry for promoting and marketing machines: "The do-it-yourself movement prematurely got bogged down in an attempt to sell still more machines; but its slogan pointed in the right direction, provided we still have a self to do it with."[66] Although he used hired hands, Judd probably did not think of his furniture making as equivalent to what Mumford thought of as the "megatechniques" of mass production under the large corporation system. In fact, Judd's do-it-yourself rustic and fine wood furniture was primarily dependent on a kind of cottage industry construction process completed by human hands through specific modes of craftsmanship; initially, he worked with rather small local workshops in Marfa and in SoHo.

63 Ibid., 350.
64 Ibid., 353.
65 *Donald Judd's Marfa, Texas*, pro. and dir. Chris Felver, 25 min., Arthouse, Inc., 1998, videocassette.
66 Mumford, "Authoritarian and Democratic Technics," 8.

Filling the Gap between Amateur and Professional

The handmade furniture fabricated by local carpenters in Marfa was inseparable from the growing phenomenon of things being done-by-order, another side of do-it-yourself. There is a trace of manipulation and control over the production process and final result, but it emerged in part in the form of collaboration, allowing input from the carpenters. Judd's do-it-yourself furniture paralleled the social conditions in which the production process of manufactured items is complicated and not easily legible to consumers. In this cultural climate, it was difficult to discern the line between professional and amateur contributions in the home do-it-yourself industry.

There had been an on-going concern to fill this gap on the part of the do-it-yourself industry. The do-it-yourself industry and magazines propagated a consensus among the serious do-it-yourselfers that the more they were equipped with professional tools, the more likely they were to achieve a high level of craftsmanship comparable to the work of professionals.[67] This tendency intensified by the early 1970s, when *Popular Mechanics* publicized the serious do-it-yourselfer's perfect workshop and called for subscribers to compete to publicize their own workshops in the magazine.[68] It seems to have been a myth that the gap between the amateur and the professional could be leveled by the magic of the latest tools and the alchemy of the ideal workshop because craftsmanship, in a traditional sense, is not obtained simply by buying new equipment. Technically speaking, sophisticated craftsmanship is normally founded both on talent and skill and gained through long hours of practice and apprenticeship. However, the history of the American craft tradition is young compared to furniture-making conventions in Europe, for example, and that may have contributed to propagating the illusion that amateurs could easily achieve a professional level of work.

In do-it-yourself magazines, the term craftsmanship mostly did not suggest difficult, specially acquired techniques, but rather something that is simply handmade as opposed to being mass produced. A number of do-it-yourself publications

67 Goldstein, *Do It Yourself*, 48–53.
68 Harry Wicks, "A Craftsman's Shop That Lets You Work Like a Pro," *Popular Mechanics* (January 1972): 162.

often featured easy to follow step-by-step instructions for all levels of do-it-yourselfers. Publication of furniture-making manuals with detailed instructions, including measurements and diagrams, such as *Construction of American Furniture Treasures* (1975) by Lester Margon, enabled advanced do-it-yourselfers to construct exact replicas of early American furniture.[69] The basic approach of antique furniture-making manuals is grounded on the practical idea that craftsmanship is not about an exquisite, mystical skill won through a long apprenticeship to a master, but rather something that one can achieve on one's own by carefully following the right instructions and using the correct tools.

At a political level, in the anarchistic conception of society, the phenomenon of do-it-yourself had a positive impact in breaking the conventional boundary between professionals and amateurs. The anarchist writer Colin Ward supported the "self-build movement" as a way of promoting dwellers' control over the design, construction, and maintenance of their housing. He acknowledged that there is a gap between the architect and the self-builder of houses, but he thought this gap should be filled by his anarchist doctrine of "self-help," which challenges the rigid, institutional system of governmental regulations, planning, and building permits:

> In fact, a great gulf exists between the existing theory and practice of self-build, and the imaginative architect's idea of what it could be, not to mention all those bright ideas floating around in the schools of architecture and in those innumerable 'underground' manuals on homes, houses and shelter. The gap is there, because without any specific intention to do so, an absolute veto on innovation and experiment has been imposed by the sources of land, finance and permission to build: in other words by public authorities and institutional lenders. In the hard days to come this gap has got to be bridged.[70]

69 Lester Margon, *Construction of American Furniture Treasures*, 2d ed. (Mineola, N.Y.: Dover Publications, 1975).

70 Ward's view was particularly based on the housing situation in England where a self-builder was "surrounded by a thicket of legal obstacles and by the deepest suspicion by public authorities who would see it as normal and virtuous for them to build houses and let them at 'reasonable' rents of one-fifth of the economic rent"; Colin Ward, "Self-Build and the Architect," *Architects' Journal* 2 (April 1975); reprint in *Housing: Anarchist Approach*, 70.

Ideally, self-motivated individuals could virtually take full control of their own living environments, legally and otherwise, fueled by the anarchist vision of the freedom and integrity of human life. Modern machinery and products are not especially harmful to human life, from an anarchist viewpoint, as long as their "functioning is transparent" and "repair can be undertaken readily and simply by the user."[71] Since the return to a so-called primitive means of production made no sense in postwar American society, despite the nostalgia for the past rife in the late 1960s and 1970s, Judd negotiated between craft and manipulated help in his furniture production. Although he embraced simple handmade furniture and collected Arts and Crafts furniture, he betrayed no hint of nostalgic feeling for the American past. With decentralized vision, Judd designed furniture for his family while making the most of the technical support of his local community, and dismissing a popular pursuit of the fully equipped workshops of American suburbia.[72]

Marxist and Other Critiques of Do-It-Yourself

In contrast to the anarchist advocacy of do-it-yourself home construction and renovations, the Marxist scholar Theodor Adorno did not have a totally positive view of do-it-yourself as a popular phenomenon. In his essay "Resignation," first published in 1969, he wrote about the "do-it-yourself syndrome" taking part in the culture industry, and he criticized its "pseudo-activity."[73] In analyzing the relationship between theory and action at the time, Adorno saw the do-it-yourself approach of producing goods and repairing things as nonsense because it merely catered to individual concerns while making use of amateur craftsmanship.[74] Adorno was not so negative about do-it-yourself methods in politics, however, because they could aid in realizing the potential spontaneity of the small group. But he did not approve of political activism falling to the level of the riot; that

71 Colin Ward, *Anarchy in Action* (New York and London: Harper & Row, Publishers, 1973), 107.
72 After addressing housing needs during the 1950s, in the 1960s do-it-yourself magazines such as *Popular Mechanics* began to focus more on family leisure time, with entertainment from the latest motor vehicles, cars, campers, boats, and water skis, besides instructions on how to fix and renovate houses.
73 Theodor W. Adorno, "Resignation," *Politik, Wissenschaft, Erziehung. Festschrift für Ernst Schütte* (Frankfurt, 1969); trans. Wes Blomster in *Telos* 35 (1978): 166.
74 Ibid., 167.

would represent a "pseudo-activity, resulting in mere theater," in Adorno's words.[75]

In fact, Adorno was not the first to investigate the link between material culture and the do-it-yourself industry. In 1958, Albert Roland pointed out in his essay "Do-It-Yourself: A Walden for the Millions ?" that the average craftsman-hobbyist relied heavily on all kinds of do-it-yourself kits.[76] And he acutely observed the psychological effects of do-it-yourself: "What counts most here, we feel, is the satisfaction of having built something, and being able to show it off to friends." [77] Roland further analyzed the consumer orientation of do-it-yourself culture:

> From all we have been saying, do-it-yourself appears as the domestic answer to some important needs of our economy of plenty. It is not, though at first glance it may seem so, a return to artisan production. It has developed rather, in a spontaneous, haphazard way, as a mechanism of distribution of goods and of "canned" services in the home. As such, it is another result of the shift from a production-oriented to a consumption-oriented culture. ... But a close look at today's craftsmen-hobbyists and handymen show that even for the great majority of them do-it-yourself is essentially a means of taste-exchanging consumership.[78]

For Roland, as for Adorno, do-it-yourself represented a refusal to be involved with political activism or participation, and instead meant a withdrawal into the individual's home workshop.[79] This analysis points to certain emotional issues that emerged when, during the early 1970s, the boom of do-it-yourself came to be diagnosed as an obsession instead of a hobby.[80] The craze was in part stimulated by do-it-yourself industries using the marketing strategy of promoting the consumer's psychological fulfillment with respect to domestic upkeep. In reality, the perfect

75 Ibid.
76 Albert Roland, "Do-It-Yourself: A Walden for the Millions?" *American Quarterly* 10, no. 2 (1958): 159.
77 Ibid.
78 Ibid., 162.
79 Ibid., 164.
80 For instance, Marian Denby Freedman, a do-it-yourselfer, reported how do-it-yourself projects at her home turned out to be an obsessive habit, taking an emotional toll and exacting enormous labor, while causing her to sacrifice her social life. Marian Denby Freedman "'Do It Yourself' Addiction Causes Pain and Joy," *New York Times*, 23 January 1972, R 1, 6.

family teamwork and togetherness prompted in do-it-yourself home projects was likely highly fictitious during the 1960s and 1970s. At the advent of the postwar do-it-yourself fever, in the 1950s, gender roles played out in home improvement advertisements in which the father and son relationship was fundamental to family collaboration.[81] Such gender roles were questioned in the 1960s as a result of the feminist movement, and do-it-yourself magazines began to feature women's involvement with broader, ambitious projects using power tools.[82] This direction confirmed the tendency in which the wife or husband was responsible for her or his own projects independently. Thus, do-it-yourself home projects turned out to be more about the division of labor than the moral symbolism of family ties. Ironically, the family bonds could even be strained by the demands of the renovation projects, whose aim was partly raising the value of the family's biggest investment, their house. In other words, the house was treated as a blue-chip investment; if the value of the remodeled house increases, the homeowner can sell it for an extra profit and potentially afford to move into upgraded housing in a better neighborhood. The house, in this sense, is viewed not as a family's permanent home, but rather as a transferable asset in the market.

Collaboration between Judd and His Fabricators

Unlike Andy Warhol (1928–1987), Judd did not seriously consider establishing his own well-equipped "factory" once his works were made at workshops outside of his residences. One of Judd's fabricators, Peter Ballantine, has pointed out that Judd's working method was rather hands-off. Judd hardly visited Ballantine's workshop, which was close by his Spring Street building in SoHo. Ballantine thinks that it was clever of Judd to avoid being influenced by technological knowledge in his art-making and to keep an "arm's length" relationship with his fabricators.[83] In fact, Judd had relatively little concern for how things are built and, again, he was not a gifted craftsman or a designer in the conventional sense. As Nuñez recalled, Judd traveled almost constantly: "most of the time he [Judd] was gone." [84] Judd would stay at one of his favorite ranches for a couple of weeks and then be gone for two

81 Goldstein, *Do It Yourself*, 67–82.
82 Ibid.
83 Peter Ballantine, interview by author, New York, 20 January 2006.
84 Nuñez, interview.

to three weeks, a month, or a month and a half. Only then would he come back to check on the progress of his art and design works being created in Marfa.

Proceeding from Judd's simple drawings, fabricators often had to work hard to figure out how to put things together into coherent objects while Judd was gone. Achieving the desired effects conjured up by a rough drawing often consumed a lot of time and experimentation. For instance, Lee Donaldson talked about how he and Raoul Hernandez invented a specially designed screw to create joints for some of Judd's metal artworks.[85] Searching for a quick rusting process to create brown-tinted Cor-ten steel surfaces, Donaldson unsuccessfully experimented with applying tomato sauce on surfaces of metal instead of the usual method of spraying water.[86] This try-and-try-again experimentation was commonplace and integral to arriving at the desired final outcome among Judd's fabricators. As another example, according to Alfredo Mediano, he and his brother came up with a method for producing and maintaining outdoor furniture on their own, without being closely supervised by Judd.[87] They figured out that the old-time wood maintenance technique of using turpentine and linseed oil was a simple and easy way to treat outdoor furniture twice a year, before the rainy season and winter time. (fig.24) Judd particularly liked this old wood maintenance technique the Mediano brothers adopted since it caused the wood surfaces to retain their natural dark colorations as time passed.

This seems to have been one of the successful outcomes in the arm's length working relationship between Judd and his fabricators, who were do-it-yourselfers when it came to their furniture making. It is no wonder that once Judd found a fabricator who was skilled and devoted enough to make his works, he relied on that person as long as he could. This was also true, for instance, of LeWitt's wall-

fig.24 Donald Judd, Table and benches outside Arena, Marfa, photograph by author, 2005.

85 Donaldson, interview.
86 Donaldson, interview.
87 Mediano, interview, 7 June 2006.

drawings. Initially, they were meant to be done by anyone, as a radical gesture against art conventions, but eventually the same team of draftsmen tended to be summoned and hired to finely execute the wall-drawings whenever and wherever his exhibitions took place. Thus, the twin reasoning and practice of do-it-yourself and done-by-another turned out to entail long-term collaborative teamwork.

Judd played a role as the head of a team, but the relationship between him and his fabricators was not very rigid with respect to the actual construction processes, since he was not that involved. Ichiro Kato, an accomplished cabinetmaker and woodworker, also observed that his working relationship with Judd was akin to sailing a boat by the wind: Judd allowed Kato to explore several directions, though Judd was always responsible for the final destination.[88] Judd's working relationship with his fabricators created a free-functioning space in which the authoritative lines between artist and fabricator, employer and employee often became ambiguous, even though the ultimate control remained with Judd. In some cases, the relationship between Judd and his fabricators was intense and challenging. Their collaborative process was dependent on mutual respect and a deep understanding of Judd's specific aesthetics and often involved an open-ended working method.[89]

Judd's Open-Ended Control

Judd deliberately made his carpenters fabricate a naïve style of furniture in Marfa. But, does his rustic furniture really look as if it were made in the past? The wear and warping of his wood furniture generally expresses some age. However, it does not suggest nostalgia in as much as it does not entail any historical stylizations or any local characteristics, and its rigid geometry evokes nothing similar to folk furniture. The geometry of Judd's do-it-yourself chairs made of wood planks does not have any conventional crafted warmness. They appear somewhat clumsy and

88 Kato, interview, 9 May 2006.
89 Lee Donaldson, a fabricator of Judd's rusted steel pieces and some prototypes of furniture in Marfa, described his working relationship with Judd as follows: "I and Don talked at a different level." Although Donaldson left Judd because of disagreements, he feels thankful for the memorable and challenging working experience with Judd. Donaldson and Raul Hernandez, another fabricator of Judd's art and furniture in Marfa, both recalled how they tried to guard the rusted metal pieces they fabricated for Judd from being touched by visitors during the Open House. The two saw that Judd was very committed to making artworks and often the issue of cost came later. Raul Hernandez and Lee Donaldson, interview by author, Marfa, Tex., 5 June 2006.

chunky because of their actual weight, and their lack of detailed parts, such as arms or grips, is foreign to the portability and handiness of ordinary furniture. In particular, the outdoor benches and chairs are by now distorted and have many gaps between their parts. This suggests something gone wrong with their fundamental structures, that is, a violation of the nature of wood, as noted by Cooper and Kato. With those works of furniture, each wood plank strays apart from the next, and they hardly cohere as a whole unit. If made by an amateur do-it-yourselfer, this would indicate a basic mistake, but it was instead a deliberately manipulated effect produced by a professional in a done-by-other operation.

The way in which Judd was involved with do-it-yourself furniture making reflected some specific characteristics of U.S. cultural and political phenomena during the late 1960s and the 1970s. Compared to ordinary furniture made by do-it-yourselfers, Judd's rustic furniture is unique in its own right and logic and in the way in which it was made and maintained. It was a particular choice of Judd to violate basic wood working rules and allow gaps and warping to remain in his furniture even though they are normally seen as deficiencies. It is fairly common to praise the coloration and shine of antique wood furniture or the simple formal beauty of folk furniture, whereas it is unusual to embrace the structural errors of do-it-yourself furniture, especially from a skilled woodworker's perspective. The rustic furniture made in Marfa does not last forever—the outdoor furniture ages especially quickly because of the severe weather conditions in South Texas. Judd must have known that fact, but left the furniture the way it was, as long as he could, with only occasional repairs. When the condition of a piece of furniture worsened to the level of not being functional, it was replaced by a new piece. After all, furniture is supposed to be used and worn-out—that is its fundamental reality in everyday life. In fact, the Judd Foundation had to reconstruct an outdoor table and bench at the Block because the previous one was too dilapidated. Interestingly, this conflicts with Judd's ideal of creating permanent installations to maintain the autonomy of fine artworks eternally. Rather, the eventual dissolution of each object is a tangible reality with Judd's outdoor do-it-yourself furniture. It demonstrates that the human attempt to develop complete control over the nature of wood is impossible.

The uncertainty about whose hands and whose contributions produced Judd's furniture parallels the socio-cultural phenomenon of do-it-yourself, which propagated the illusion that amateurs could attain a professional level of skill

and even a degree of sophisticated craftsmanship. Mumford's and Judd's doubts about technology and the mechanics of industry were countered, in Judd's case, by his spontaneous control over production processes following a do-it-yourself principle, which politically was a reaction against the dominant capitalistic logic and mechanization of the mass manufacturing system. Judd's control over the fabrication process of his rustic furniture was never a total one, but rather a free-operating one in the respect of letting individual fabricators largely try out their own techniques. Technically, once the production process became hands-off, Judd could control whether to play up or play down the level of craftsmanship, as we saw in his wood rustic furniture primarily fabricated in Marfa. This caused the deceptive effect that Judd's do-it-yourself furniture is not all that it appears, as it obscures the actual hands on approach of do-it-yourself as a popular cultural phenomenon. The rustic furniture was not completely made by naïve amateur hands, but by deliberately controlled professional manipulation. Neither was it, however, created through an absolutely oppressive rule in the sense of Mumford's "megamachine"; rather, it was produced mostly through a fluid relationship of mutual respect between Judd and his fabricators.

The anarchist struggle to reform and regenerate an entire society via the independent spirit of do-it-yourself was inevitably entailed with its internal counterpart of done-by-other—the other side of the do-it-yourself coin. In the way Judd's furniture design unfolded in Marfa, there was a self-managing drive to control the living environment through the free operations of individuals. However, Judd's outdoor furniture would be virtually destroyed with the passing of time and the power of nature. The truth about the rhythm of time and nature free from absolute human control is embedded in Judd's do-it-yourself furniture; that very fact stands against the pervasive fiction of the amateur's assimilation of professional values, as promoted by the cultural phenomenon of do-it-yourself in the 1960s and 1970s.

CHAPTER 3

THE INTERRELATIONSHIP OF FURNITURE AND SCULPTURE

Furniture Springing from Art Practices

Judd's furniture production entered a new phase during the 1980s as he began to commission professional furniture makers and workshops and made an effort to find qualified craftsmanship abroad. The furniture making, which began in the midst of a counter-cultural climate, working with small local workshops primarily in Marfa and SoHo, was expanded through an international production scheme during the 1980s and the 1990s. In addition to the rustic do-it-yourself furniture, which continued to be fabricated in Marfa, Judd was increasingly productive in designing different types of furniture using various materials and construction methods. In the late 1980s, Judd set up a woodworking workshop in the basement of the Spring Street building for his wood and plywood furniture production.

Besides the naïve style furniture, Judd's later furniture (i.e. that from 1982 to 1994) was professionally made not only in the United States, but also in Switzerland, Germany, the Netherlands, Ireland, and England. Judd had to work with different fabricators in various nations so as to gain access to specialized skills.[1] Interestingly, this international impetus coincided with a firmer tie between his furniture and his artworks, as his furniture came to be made in a sophisticated manner instead of the main focus of producing deliberately naïve, rustic, do-it-yourself style of previous years. The unskilled, tactile quality prominent in his early furniture is absent from both his professionally-fabricated furniture and his precisely-made art pieces. In this chapter, I will investigate the interrelationship between Judd's furniture and art with a view especially to practical aspects: the

1 Judd mostly found various fabricators through his associates, according to Robert Weiner, telephone interview by author, 25 October 2007.

fabrication processes, the predominant formal configurations, his marketing strategy, and his installation schemes, keeping in mind Judd's own ideas and writings.

Why does the interrelationship between Judd's furniture and artwork matter? The two fields of production have been conventionally divided in modern western cultural institutions and art historical discourse. The status of "fine art" is said to be higher than that of functional objects because the fine arts are commonly recognized as originating from the creative acts of individuals granted absolute freedom of expression. In contrast, the "decorative arts" have been seen as being on a lower plane, in part due to a perceived limit on creative freedom, entailed by functional obligations, and the need for objects to serve in daily use. This hierarchy is of course a cultural and social invention, and certain key early modernist movements—such as the Bauhaus, De Stijl, and Constructivism—saw such a hierarchy as irrelevant to their renewed visions of the modern world. This chapter will examine the ways in which Judd dealt with this lingering hierarchy in the postmodern era of the 1980s and 1990s. Countering Judd's own, as well as received ideas of the higher status of art over functional objects, the two pursuits would be tightly intertwined and developed side by side at the philosophical, formal, production, and marketing levels of the artist's practices. As such, it is useful to consider Judd's furniture and artwork as counterpoints within his entire output throughout his life instead of diminishing the significance of his functional objects, as has been the predominant practice in the discourse to date.

Having studied empirical philosophy, Judd was preoccupied with presenting a matter-of-fact effect in his art objects, and elicited the viewers' immediate comprehension of things instead of attempting to prompt a metaphysical process that may be entailed in perceiving artwork.[2] Judd's furniture can provoke a kind of empirical experience comparable to that posed by his artwork. Judd once responded to a question about his interest in the viewer's experience of either

2 Raskin investigated Judd's philosophical background as it was inspired by empiricist David Hume and Charles Sanders Peirce and considered how it was reflected in his art pieces that provoke a viewer's active response to objects as material facts that test prior knowledge. Raskin writes, "If art were permitted no escape from the here and now, neither were its viewers. Since Judd's untitled objects convey little beyond sensory information, he left fully open the question of why they are art; yet given their gallery context, the works have no escape from the 'habits of mind' that transform experience into comprehension. Judd's art attempts to disrupt these habits, generating a situation in which the viewer tests her sense-data against preconceptions"; Raskin "Specific Opposition," 684-87.

looking at or understanding his works: "That's the division between thought and feeling. You have to do it all at once. You have to look and understand, both. In looking you understand; it's more than you can describe. You look and think, and look and think, until it makes sense, becomes interesting."[3]

In "The Foundation of Knowledge," Moritz Schlick, a German philosopher of logical positivism, summed up how the individual's direct observations could be the foundation of knowledge: "In any case no matter what world picture I construct, I would test its truth always in terms of my own experience. I would never permit anyone to take this support from me: my own observation statements would always be the ultimate criterion. I should, so to speak, exclaim 'What I see, I see!'"[4] Empirical knowledge operates by the method of induction, which uses "guessing" to generate principles without depending on previous assumptions.[5] And this knowledge should be "immediately perceived" because the nature of observation is not aimed at a metaphysical process; rather, the empirical experience of the present moment has more validity with respect to the reality of the physical world than something written or memorized in the past.[6] Rudolf Carnap discusses the kinship between positivism and materialism in their denial of metaphysics and the preeminence:

> Consequently, the positivist and materialist constitution systems do not contradict one another. Both are correct and indispensable. The positivist system corresponds to the epistemological viewpoint because it proves the validity of knowledge by reduction to the given. The materialist system corresponds to the viewpoint of the empirical sciences, for in this system all concepts are reduced to the physical, to the only domain which exhibits the complete rule of law and makes inter-subjective knowledge possible.[7]

3 Donald Judd, "Discussion with Donald Judd," in *Donald Judd*, ed. Roland Wäspe (St. Gallen, Switzerland: Kunstverein St. Gallen, 1990), 54.
4 Moritz Schlick, "Über das Fundament der Erkenntnis" (The Foundation of Knowledge) Erkenntnis 4 (1934); reprint in *Logical Positivism*, ed. A. J. Ayer (New York: Free Press, 1959), 219. The book *Logical Positivism* is found at Judd's library at the Block.
5 Ibid., 220.
6 Ibid.
7 Rudolf Carnap, "Die Alte und die neue Logik" (The Old and the New Logic), Erkenntnis 1 (1930-31); reprint in Ayer ed. *Logical Positivism*, 144.

fig.26 Donald Judd, Untitled, 1966, Painted steel, 48 x 120 x 120 inches (121.9 x 304.8 x 304.8cm). Whitney Museum of American Art, NewYork; gift of Howard and Jean lipman 72. 7a-j, Installation view from the exhibition *Full House: Views of the Whitney's Collection at 75 (June 29 – December 3, 2006)*, photography by Sheldan C. Collins

This here-and-now, empirical approach of immediately perceiving Judd's artwork and furniture in the same space reinforces their essential physical similitude, regardless of one's prior knowledge about the cultural hierarchy between art and non-art objects. Like his art, Judd's skillfully made furniture poses an immediate question about its specific identity—i.e., "Is this furniture?" "Is this a bench or a table and a bed or a bench?"—because some of his furniture pieces are oversized and appear to be finely made, rigid cubic forms to be looked at, comparable to his art. In a sense, Judd approached his furniture and art in the same way, by configuring them on the basis of material fact.

Being preoccupied with a pragmatist philosophy and with presenting the defined volume of an object in space, Judd generally preferred somewhat open structures in both his artwork and furniture design. Specifically speaking, most of Judd's works are not enclosed boxes; however they are opened-up, straightforward structures that one can look through. They often self-evidently reveal the way they exist in space. Judd frequently used transparent or translucent materials such as Plexiglas in his art pieces. In some pieces, one can see through to the interior. Structurally and visually, there is nothing hidden in his see-through art objects. This formal feature in his art is generally shared with his furniture design.

Judd began to make his so-called "stacks" in 1965. (fig.25) The basic formula of the "stacks" is a box or an open grid, lined up on the wall vertically and serially

fig.28 Donald Judd, Bookshelves, 1966, pine, fabricated by Donald Judd and his father R. C. Judd, *A good chair is a good chair*, Ikon, 2010, Image Courtesy Ikon, photography: Stuart Whipps

such that one can clearly comprehend the volume of each unit from the bottom to the top from almost any viewpoint. Similarly, in a work from 1966, Judd made a freestanding "stack" in which units of an oblong, square grid are simply lined up horizontally on the floor. (fig.26) Each metal unit of the open grid structure creates a concrete sense of spatial volume which can be looked through as viewers walk around the piece.

Prior to formulating the "stack," Judd constructed a small table in 1958-59 made of found pieces of wood from the street. (fig.27) Reminiscent of children's simple play with blocks, the table has no joints. It could be assembled any place, just like Carl Andre's sculptures made of identical units of objects installed on site. The table's legs are now missing and other small wood parts are piled together on top of on one of the long large desks, lined up in a row at Judd's Art Studio, a former Safeway grocery store in Marfa.

Interestingly, Judd applied comparable organizational principles of "stacks" to the bookshelves he made in 1966 with his father. (fig.28) This early furniture project, consisting of multiple units of bookshelves, entails oblong frames which could be stuck up against a wall, depending on the size of the available wall space. In other words, the way in which the bookshelves are arranged could define the space of the wall similarly to the way his "stacks" could define space as art pieces.

Some pieces of early furniture by Judd were designed for specific sites, as too

were some art pieces meant for permanent installations. Often, the placement of furniture was permanent in Judd's residences; for example, a low bed on the fifth floor of the 101 Spring Street building was nailed to the floor and integrated into a permanent installation with other artworks and furniture.[8] The sheet metal chairs with arms, fabricated by the Bernstein Brothers in 1971, were initially designed specifically for the interior of the Spring Street building, but they were removed since Judd thought they didn't fit well in the space. By contrast, Judd's oversized tables, beds, and benches made of solid and thick planks were too heavy to be easily moved around. As such, unlike ordinary portable pieces of furniture, the over-sized furnishings tend to exist site-specifically within his residences, where both functional objects and artworks were carefully chosen and arranged by Judd himself.

Ambivalence of "Furniture is Furniture" in Judd's Writings

When first designing his commissioned furniture, Judd would directly derive his formal vocabulary from his own art forms. In 1986 Judd recalled that when he was commissioned to design a coffee table in 1970–71, he modified a piece of his artwork to produce the table, though this would not result in a successful object, by Judd's account.[9] While explaining that this coffee table had given him a bitter lesson—that is furniture should not mimic his artwork—Judd excluded the table from the chronology he prepared for the 1993 catalogue. (fig.29/fig.30) This anecdote helps illuminate his struggle to draw a strict line between his art and furniture. The story of Judd's first piece of commissioned furniture evinces an agenda concerning the formal and structural resemblances between Judd's artwork and functional objects which formed an undercurrent in his output throughout his life.

Reexamination of Judd's early exhibition reviews and essays, such as "Specific Objects" (1965) and "Twentieth-Century Engineering" (1964), casts new light on

8 Judd often used "found measurements" in both his art and furniture; for instance, the dimensions of the plywood art pieces made in 1973 and of the pine dining table placed at the 101 Spring Street building were derived from the width of a window of the building; thus, the pre-existing space was taken into account when Judd designed site specific furniture pieces, Ballantine, interview, 20 January 2006.

9 Judd, "On Furniture," 107.

his design-oriented perspective on contemporary art at the dawn of Minimalism. It is worth noting that in his writings of the 1960s Judd had been positive and open about the vagueness of the line between art and non-art objects, favoring the physical, singular thing-ness of works by Constantin Brancusi and by certain Dada and Neo-Dada artists. In his essay "Specific Objects," published in 1965, Judd stated:

> There are precedents for some of the characteristics of the new work. The parts are usually subordinate and not separate in Arp's sculpture and often in Brancusi's. Duchamp's ready-mades and other Dada objects are also seen at once and not part by part. Cornell's boxes have too many parts to seem at first to be structured. Part-by-part structure can't be too simple or too complicated. It has to seem orderly. The degree of Arp's abstraction, the moderate extent of his reference to the human body, neither imitative nor very oblique, is unlike the imagery of most of the new three-dimensional work. Duchamp's bottle-drying rack is close to some of it. The work of Johns and Rauschenberg and assemblage and low-relief generally, Ortman's reliefs for example, are preliminaries. Johns's few cast objects and a few of Rauschenberg's works, such as the goat with the tire, are beginnings.[10]

Additionally, by writing that, "Art could be mass-produced," Judd pointed to the possibilities for the mechanical processes of making art and for the use of new materials, including industrial ones, such as "formica, aluminum, cold-rolled steel, Plexiglas, red and common brass."[11]

Prior to this famous essay, Judd wrote on the relationship between art and design objects. In an essay published in 1964 on the Museum of Modern Art exhibition, "Twentieth-Century Engineering," Judd supported the curator Arthur Drexler's perspective of paying attention to engineering projects and treating them not only as products of science but also as art objects, because "there are preferences of certain forms" besides fulfilling the objects' certain functions.[12]

10 Donald Judd, "Specific Objects," *Arts Yearbook* 8 (1965); reprint in *Judd, Complete Writings, 1959–1975*, 183.
11 Ibid.,187.
12 Donald Judd, "Month in Review," *Arts Magazine* 39, no.1 (October 1964); reprint with a new title, "Twentieth-Century Engineering," in *Donald Judd, Architektur*, 173. Arthur Drexler's ↗

Unlike his later, 1980s discussion about the separation between art and functional objects, Judd had initially stressed that the differences between art and functional objects were based on common, general assumptions. In other words, in this 1964 essay he suggested that the distinctions are a matter of degree. Significantly, he also pointed out that assumptions about differences were due to the emerging authority of scholarship and cultural institutions:

> Until lately art has been one thing and everything else something else. These structures [i.e.: dams, roads, bridges, tunnels, storage buildings and various other useful structures] are art and so is everything made. The distinctions have to be made within this assumption. The forms of art and of non-art have always been connected; their occurrences shouldn't be separated as they have been. More or less the separation is due to collecting and connoisseurship, from which art history developed. It is better to consider art and non-art one thing and make the distinctions ones of degree. Engineering forms are more general and less particular than the forms of the best art. They aren't highly general though, as some well-designed utensils are. Simple geometric forms with little details are usually both aesthetic and general.[13]

The "general" here seems to refer to some nameless sense of good design, as evident in Judd's hope that a virtually unknown engineer of bridges in New York City be more recognized: "Engineering, incidentally, is a fairly anonymous art, as Othmar Ammann's obscurity indicates. The Verrazano or one of his other bridges around Manhattan should be named after him." [14] In contrast, "particular" refers to the value of individually created art as opposed to the "general" and anonymous, but these are relative values for Judd. It is not entirely clear what Judd meant by a more "particular" element in art, but possibly something closer to the term "specific," a term he developed later in his discussion of the distinguishing feature of new art.

↘ promotion of the aesthetic dimension in industrial structures was a part of MoMA's continuing mission to discover the beauty of the simplicity and geometry of industrial tools and household goods, a mission initiated by prewar exhibitions such as "Machine Art," curated by Philip Johnson in 1934. See Sidney Lawrence, "Declaration of Function: Documents from the Museum of Modern Art's Design Crusade, 1933–1950," *Design Issues* 2, no.1 (Spring 1985): 65–77.
13 Ibid., 174.
14 Ibid., 173.

David Raskin pointed out that Judd's use of the terms "specific" and "general" was derived from the terminology of classical empiricism.[15] It is based on the empiricist contrast between "simple," materialist facts as the basis of knowledge, as opposed to "complex" or fictional conceptions developed at the mental level; Judd's use of the terms "specific" and "general" contrast the value of positive versus negative implications.[16]

Although in 1964 Judd's empiricist rhetoric contrasted the "particular" and the "general," he would not be entirely consistent, as in this case, when he assigned a positive value to a "general" functional object, the Verrazano Bridge, which he thought should be named after the particular engineer who designed it. Judd paid attention to the significant aesthetic values in design objects that are equivalent to artwork and suggested that the distinctions between them are relative, a matter of degrees. This position about art and non-art is integral to Judd's entire output—his artwork, furniture, functional objects, and interior designs—which makes it hard to draw strict lines between and among them.

Judd was not so interested in arguing over what constituted art versus non-art when he discussed design objects, Neo-Dada, or Pop Art during the 1960s. Rather, his numerous critical reviews written during his early career as an art critic focused on the external impact of the tonal and formal values of a given artwork regardless of its association with everyday objects or subject matter. Although Judd then embraced a "thing-ness" in new art akin to that of functional objects in everyday life, he did insist on a firm distinction between fine art and decorative art. And he publicly persisted in this hierarchical idea throughout his career.

When Judd began to fabricate and to sell his finely crafted furniture during the 1980s and 1990s, he verbally stressed the higher status of art over functional objects. In his writings, Judd kept referring to the postmodern trend of the aestheticization of functional objects and the supposedly loose boundary between art and furniture in the art world with a tone of irony: "In the long run any artifact will be art. In a thousand years the art of this century will be ceramic sinks and toilets because that's all [that] will survive the wars and the developers." [17]

As Judd launched into exhibiting his furniture in public in 1984, he verbally

15 Raskin, "Donald Judd's Skepticism," 76.
16 Ibid., 76–77.
17 Judd, "A long discussion Part II," 70.

kept his design works at a distance from the postmodern, optimistic currents that would embrace chairs and other kinds of furniture as an artistic medium. In 1986, Judd stressed a fundamental gap between art and functional objects, but in the same text he admitted that the artist's taste is reflected in his designs: "If you like simple forms in art you will not make complicated ones in architecture." [18] He made another contradictory statement in the same essay by denying any ties between his art and design objects: "I can now make a chair or building that is mine without trying to derive forms from my own works of art." [19] In other words, in Judd's mind fine art should not be brought down to the level of functional objects. Later, in 1990, he again made an ambivalent statement, "The category of beautiful object [sic] can include art and furniture," while adding, "but it's important that you call it 'art'. That distinction is important." [20]

For Judd, the division between art and design seemed crucial to keeping the integrity of the high status of artworks, but he was also careful about maintaining the socio-cultural and economical order entailed in such a division in the public realm of museums and the marketplace. He wrote about his furniture in 1993, "I am often asked if the furniture is art, since almost ten years ago some artists made art that was also furniture. The furniture is furniture and is only art in [the way] that architecture, ceramics, textiles and many things are art." Further, "We try to keep the furniture out of art galleries to avoid this confusion, which is far from my thinking. And also to avoid the consequent inflation of the price." [21] In short, for Judd art could never stoop to the level of the functional object, whereas furniture could only rise up to the realm of art to the extent that it was qualified and affirmed in its aesthetic value as judged by the artist.

In keeping with his privileging of formal qualities, Judd's geometrically shaped furniture, in particular his chairs are often accused of being dysfunctional inasmuch as they are uncomfortable, inhospitable and harsh-looking because of their straight, rigid surfaces and hard-edged designs.[22] Judd was aware of this

18 Judd, "On Furniture," 107.
19 Ibid.
20 Judd, "Judd, Interview with Griffiths," 48.
21 Judd, "It's Hard to Find a Good Lamp," 21.
22 Henry Wegmann, a collector and user of Judd's furniture in Switzerland who I met at the 2005 Open House in Marfa, told me that he owns Judd's chairs and uses them at his office, but whenever they have a meeting the youngest and lowest ranked persons present are usually destined to sit on Judd's chairs because no one feels comfortable sitting in them. In contrast, he thinks that Judd's desk ↗

criticism, but responded that his "furniture is comfortable" to him, as "A straight chair is best for eating or writing. The third position is standing." [23] Whether or not his chairs could provide actual comfort to Judd or to others, he admitted that aesthetic value was the key to his design principles. Judd's primary criterion for good furniture was that, above all, it should be something "pleasurable to look at." [24] Evidently, Judd's furniture design aspired to the realm of art in the sense that its formal appeal was based on the aesthetic priority he attached to simplicity of forms, carefully balanced proportions and color choices. As such, his own words notwithstanding, Judd's furniture often bears a physical resemblance to his artwork, as it tends to originate from Judd's overarching philosophical concerns, and to share the same or similar materials and structural forms.

For Judd, his insistence on the separation between his furniture and art objects entailed a moral significance that he accorded to securing the autonomy of each medium. At a socio-economic level, there might be a concern on Judd's part that a moral issue would arise if he appeared to be trying to deceive those who bought his furniture; one might buy a piece of furniture as a functional object and treat it as a more costly work of art or, conversely, buy a piece of furniture at a price high enough for a work of art only to use it as a functional object. Judd was also aware of the cultural and social hierarchy behind the division between fine art and decorative arts in western culture, resulting in the artist receiving more critical attention than the designer. He persisted in identifying himself as an artist and cautiously distanced himself from speculation that he functioned more as a designer in his art productions made by fabricators.

In her exhibition catalogue, *Design ≠ Art*, Barbara Bloemink pointed out the rationale behind Judd's carefully-maintained, low profile as a designer in the United States:

↘ functions very well, and he is happy with the desk designed by Judd; Henry Wegmann, conversation with author, Marfa, Tex., 8 October 2005; Madeline Hofmann at the Judd Foundation, who has been assisting in organizing Judd's furniture exhibitions for over ten years, also noticed that the public often responded to Judd's furniture as being uncomfortable looking and thus it has had little appeal to the general public; as such, most buyers of Judd's furniture are collectors of his artwork or people who already know about Judd through his artwork; Madeline Hoffmann, interview by author, New York, 16 May 2005.

23 Judd, "It's Hard to Find a Good Lamp," 21.

24 Ibid., 8. Judd complained that he couldn't find nice furniture that satisfied his vision when he moved to Marfa.

As a young, ambitious artist, Judd would probably not have wanted to diminish the reception of his art with any potential confusion with his furniture. In addition, Judd may have been concerned that people would purchase his design work and treat it as artwork—only less expensive—which went directly against his thesis that design was to be functional, while art was not.[25]

Viewers are not allowed to touch Judd's art pieces, whereas he felt his chairs should be in use, even though one might feel better looking at them instead of sitting on them. The potential confusion caused by Judd's furniture is due to a cultural perception depending on a certain socio-cultural context shaping prior notions of what art or furniture is supposed to look like.

Although artists have a right to declare what is art and non-art in their own oeuvres, they don't have absolute control over how others perceive their works. In fact, once Judd's furniture enters the private realm of its owners, the artist has no control over the positioning of his furniture as a functional object to be used or a work of art to be looked at. While Judd may have disagreed, it seems that if his furniture is appreciated as both art and as functional object, which proves that he successfully created something pleasurable to look at as he had intended in his furniture designs. Despite the artist's claim of observing the art/non-art hierarchy, the relationship between the two should be open to critical interrogation in his case. The lower price and lesser recognition accorded to Judd's furniture, as compared to his artwork, should not be considered as determining its lesser art historical importance.

The Fabricators of Judd's Artwork and Furniture

Judd's design objects, especially prototypes for private use, were often made by his art fabricators from early in his career until the end of his life. Jim Cooper and Ichiro Kato, who were both self-taught professional woodworkers of furniture and artworks, produced Judd's woodblocks from 1976 to 1981, before making furniture he designed.[26] According to Cooper, he first fabricated a piece of wood

25 Bloemink, "Donald Judd," 48.

furniture for Judd in 1982 at a time when the artist was rarely in New York City.[27] As Cooper recalled, when he visited Judd's Spring Street building, he happened to see a contact sheet of photographs of Judd's rustic chairs made in Marfa. Impressed by the design, yet immediately noticing structural problems with those "naïve style" chairs, Cooper proposed that he could fabricate a similar design of chairs with a more durable construction.[28]

By contrast with Judd's simple furniture made in Marfa, Cooper and Kato fabricated fine furniture endowed with structural endurance during the 1980s. This marked the beginning of Judd's career as a designer moving into the realm of a business operation. Judd, however, kept a low profile as a designer. From the beginning of the official debut of his furniture in the public arena, Judd generally tried to separate fabricators, exhibition venues, and dealers between his art and furniture.[29] But, in fact there were some exceptions that indicate an interdisciplinary approach from the 1960s on; and sometimes Judd's art and furniture co-existed in the same spaces at public displays during the 1980s.

Before Judd began to develop a number of pieces of do-it-yourself furniture in Marfa during the mid-1970s, a small number of prototypes, trial or unique pieces of furniture were made by Judd's art fabricators in New York. The Bernstein Brothers, known as fabricators of Judd's metal art pieces after 1963, made some early functional objects designed for the 101 Spring Street building, such as the aluminum chairs of 1971 and the steel sink of 1970–71. As a matter of fact, Peter Ballantine, who was a long-term fabricator of plywood artwork for Judd, was initially hired to construct the low bed on the fifth floor of the 101 Spring Street building.[30] Later in the early 1990s, some prototypes of steel furniture were made by Lee Donaldson and Raul Hernandez in Marfa, who were fabricators of Judd's Cor-ten steel art pieces. Some fabricators of Judd's artwork occasionally made pieces of furniture from the 1970s to the 1990s, but they were mainly for private use and produced in limited numbers as prototypes.

Judd adhered to the dominant social and economic system at the practical level of production. Once Judd made a contract with an art gallery, he was put

26 Jim Cooper, email correspondence with author, 24 October 2007.
27 Cooper and Kato, interview, 9 May 2006.
28 Cooper and Kato, interview, 9 May 2006.
29 Weiner, interview, 25 October 2007.
30 Ballantine, interview, 20 January 2006.

on the regular track of producing new works on a routine basis. Judd had to be an efficient manager and designer of his entire output, coordinating with his fabricators to complete works in a timely manner. There was a practical and economic cause behind Judd's usual separation, later in his career, of art and furniture fabricators as well. Ballantine explains that the division between art and furniture fabricators was a matter of convenience because Judd employed fabricators at small workshops with one or two craftsmen. If entire workshops were engaged with his furniture productions they would not be able to produce any new artwork, which would cause a serious problem in preparing for Judd's upcoming exhibitions.[31]

Judd separated major fabricators between his art and furniture for sale in the late 1980s. Ellie Meyer, who assisted Judd with his furniture business, recalled the period when she worked for Judd between the end of 1983 and October 1991 in Marfa as marking a slow transition toward establishing a firmer structure for furniture distribution, but also as a trial period of making various new furniture designs with different materials.[32] Wood furniture was produced in New York by Jeff Jamieson and Rupert Deese after 1989.[33] Jamieson and Deese (collectively, WPF [Wood and Plywood Furniture]) were previously assisting Judd and began to make Judd's furniture. Lehni A.G., a furniture factory in Switzerland known for its sophisticated techniques in bent sheet metal furniture, made Judd's art and furniture after 1984. However, Judd ceased doing business with Lehni A.G. in

31 Ballantine, interview, 14 April 2006.
32 Ellie Meyer, telephone interview by author, 26 February 2008.
33 Jeff Jamieson started to work for Judd on the occasion of his retrospective at the Whitney Museum in 1988 as Judd needed extra help for the show. Having learned about Jamieson's fabrication of Alvar Aalto's furniture for his personal use, Judd decided to commission Jamieson for his furniture productions. Jamieson's educational background is in art, including ceramics; he received his B.A. in art and was not trained as a cabinetmaker. Jamieson also made two plywood art pieces (prototypes or studies) for Judd that are now in Marfa. Jamieson and his business partner Rupert Deese worked together at a small workshop equipped with basic, simple woodworking machinery, such as table saws, in the basement of the Spring Street building until 1994, when Jamieson moved to California four months after Judd's death. He had been the sole fabricator of Judd's wood furniture after Judd passed away until 2006; Jeff Jamieson, interview, 13 November 2007 and email correspondence, 27 June 2008. Judd also worked with other wood workshops located abroad, such as Pro Raüm in Germany, where he made plywood furniture in the early 1990s. Jamieson recalls that he and Deese began to fabricate plywood furniture around 1991, but they never contacted other furniture fabricators with whom Judd was working; Jamieson, email correspondence with author, 2 December 2007.

1987, as he was beginning to divide his fabricators of art pieces and furniture. The sheet metal furniture began to be fabricated at Janssen C.V., in Holland in 1989, whereas aluminum art pieces were made at Menziken A.G. in Switzerland after 1988. In addition, some art pieces and prototypes of furniture were produced at Lascaux, Brooklyn in New York in the early 1990s. Almost a decade after Judd's death, Lehni A.G. resumed fabricating Judd's aluminum furniture in 2002 under the authorization of the Judd Foundation. The factory is the sole fabricator of Judd's aluminum sheet furniture still in production today.

Meanwhile, Donaldson and Hernandez explained that they approached fabricating Judd's art pieces and furniture in the same way since their basic configurations were alike.[34] In short, the fabricators who made both art and furniture for Judd did not find much of a distinction in the materials and techniques they used to craft furniture and artwork, and both received a similar level of careful refinement. Generally, once fabricators learned to work out the logistics of meeting Judd's expectations with only a minimum of supervision, the making of any of Judd's objects seemed to unfold naturally according to its own inner logic.

Furniture and Art Making Unfolded Side by Side

The formal resemblance between Judd's furniture and artwork was not only due to his approaching them with the same or comparable artistic and philosophical ideas, but also to their actual construction processes having been intertwined. A close analysis of the fabrication process for Judd's artwork and furniture and a comparison of the results show that both kinds of output share complementary physical properties as well as the basic formal characteristics of symmetry, geometry, and a clear sense of volume.

Seamless and Decorative Joints

Regarding construction methods, William C. Agee recalled, for example, that he could not persuade Judd that it was impossible to seamlessly join one-ton slabs of concrete for his outdoor pieces in Marfa.[35] Likewise, Judd had tried to eliminate

34 Hernandez and Donaldson, interview.

fig.31 Dovetail joint

the visibility of all joints and hinges from his do-it-yourself wood furniture; just he did with his art pieces made at the same time. In his simple plank furniture, made primarily for private use in the 1970s and afterward in Marfa, if there was a structural necessity for using a metal screw or a nail, a piece of wood dowel was inserted in order to hide the metal joints on the wood's surface. Similarly, in the 1970s Judd tended to design the way in which the nails and joints were placed on the sides so that a flat plane is presented to the frontal view without the visible disruption of a nail.[36] He generally pushed for an ever greater degree of perfection: "I used to want the slots in all the screws to be horizontal." [37]

The external visibility of joints in some of Judd's artwork and furniture changed over the course of time, however. Judd was open to older, elaborated and sophisticated joints, such as dovetails, while he was commissioning wood furniture from Cooper and Kato after 1982. (fig.31) In 1989, however, when Judd began to work with new furniture fabricators, Jeff Jamieson and Rupert Deese, he decided to eliminate decorative joints and to focus more on hidden joints in his wood furniture as in his plywood art pieces.[38] In short, Judd carefully avoided the visibility of craftsmanship in his plywood artwork; his plywood art pieces were

35 William C. Agee, "Donald Judd in Retrospect: An Appreciation," in Donald Judd, Sculpture (New York: PaceWildenstein Gallery, 1994), 9.
36 Thomas B. Hess, "Boxing Day," *New York*, 11 April 1977, 72.
37 Ibid. Ballantine had an argument with Judd about the precise uniformity of the direction of the tips of the screws because, in Ballantine's opinion, the uniformity of the screws seemed more decorative than functional; Ballantine, interview, 14 April 2006.
38 When Jamieson proposed simpler joints to Judd for his furniture constructions which would accentuate the formal unity of his furniture, Judd was concerned about the strength of the joints, but he agreed as Jamieson explained to him their structural durability; Jamieson, interview, 13 November 2007 and email correspondence with author, 27 June 2008. Meanwhile, Ichiro Kato remembers that Kato and Judd discussed details about choosing the joints of solid wood furniture. They came to an agreement on using the finest and most durable joints for solid wood furniture because they decided to make it in a limited edition at the time. Kato recalls that Judd was well informed about the technical and formal aspects of joints and happy with the appearances of those meticulous joints that Kato skillfully crafted. From a technical point of view, solid wood tends to warp significantly compared with the more artificial material of plywood. As such, old joint techniques such as dovetails provided the best structural strength to the solid wood furniture; Ichiro Kato, telephone interview by author, 24 April 2008.

always constructed with seamless joints, whereas he allowed decorative joints in some limited editioned wood furniture during the early production period in the 1980s.

By contrast with his early artwork and furniture, in which the metal screws were hidden, metallic screws were exposed as an apparently decorative feature in painted, aluminum sheet art pieces made in the mid-1980s. The regularly placed silver dots not only create rhythmical accents on external surfaces, but also help to visually integrate seemingly contingent and irregular color combinations into a singular whole. Moreover, the tip of each screw is uniformly directed vertically. This particular finishing touch seems to be only possible if human hands screwed them one by one with a close attention to detail, instead of mechanically doing them. In contrast to his aluminum sheet art pieces, in Judd's painted aluminum furniture the screws are mostly hidden from the frontal viewpoint. The metal sheets are folded once in his art pieces, whereas they are folded two or three times inward in his aluminum furniture, thus hiding the screws; in part, this invisibility is due to structural reasons, since the folds are needed to give enough strength to hold a sitter's weight. Thus, a decorative use of joints is evident in his painted aluminum sheet art pieces, whereas his aluminum furniture uses joints in a functional, hidden manner. This is a reverse case to the decorative joints used at a certain moment with the wood furniture, while the joints of the plywood art pieces were kept hidden and seamless. Hence, the contrasting features of the seamless versus the decorative joints in the art and furniture emerged side by side as a counterpoint in his different types of production.

Technical Differences

Although many fabricators felt there was not a huge technological gap between making Judd's furniture and his art, Jamieson, who fabricated Judd's wood and plywood furniture between 1989 and 2006, claimed that it took a "very different mindset" to make Judd's art or his furniture.[39] There are some differences in terms of materials and craft techniques between Judd's plywood art pieces and wood furniture. And the first use of untreated plywood in his artwork came much earlier, in the early 1970s, than his Finland-color plywood furniture,[40] which was made

39 Jamieson, interview, 13 November 2007.

almost two decades later. Moreover, the Finland-color plywood was never used to fabricate Judd's plywood art pieces.

Ichiro Kato, a fabricator of solid wood works, and Ballantine, Judd's fabricator of plywood artwork, used the same basic hand tools and machines. Each fabricator admired the other's highly specialized skills in making Judd's (ply-) wood objects. Ballantine thinks that Kato is a better traditional craftsman than he is, whereas Kato thinks Ballantine's precise craftsmanship is supreme.[41] On the one hand, wood furniture requires a finishing coat and a slightly gentle touch on the edges, so that it won't hurt its users. On the other hand, Ballantine's untreated plywood art pieces entail sharply cut edges meant to be looked at. The sharply defined geometric shapes intensify the visual experience of seeing Judd's plywood artwork. The wood and plywood chairs don't have as much of an acute, imposing visual intensity as the conspicuously large plywood art pieces do.

Technically, some plywood art pieces do require a level of exquisite and particular craftsmanship, perhaps more so than is entailed in the plywood furniture construction. For instance, there are finely curved, round elements with some plywood or metal pieces which demand sophisticated techniques to bend the solid, flat materials according to precise dimensions. From a technical standpoint, Judd's aluminum art and furniture seem to be more closely intertwined than his plywood works. The colorfully painted aluminum art pieces and furniture were developed at the same factory, Lehni A.G., in 1984, and most likely they used the same materials, similar techniques, and a common fabrication process, or so the results would suggest.[42] Interestingly, Gianfranco Verna, a long-time friend of Judd and

40 Finland-color plywood is multi-purpose plywood. Both sides of the panel are treated with smooth colored translucent film. It is commonly used for interior furnishing. Judd examined and chose various samples of Finland-color plywood in different colors and proportions.

41 Ballantine, interview, 14 April 2006; in fact, being college educated, Ichiro Kato is different from traditionally trained carpenters in Japan in his choice of hand tools: he is very open to using different kinds of hand tools, including ones from England and Japan, and he even makes his own tools; Kato, interview, 20 May 2006.

42 Madeline Hoffmann at the Judd Foundation responded to my question: "What are the differences in the production process, materials or fabricators between Judd's painted aluminum furniture and aluminum art pieces?" Hoffmann replied, "At one point, they were both made by Lehni in Switzerland. And, I trust she [Lehni] employed the same fabrication techniques for both. It was, after all the same factory. In 1989, the metal furniture pieces were then produced in Holland by a furniture fabricator and the art went to other places to be made. But, they were both based upon a similar production process, which did not change"; Madeleine Hoffmann, email correspondence ↗

owner of Annemarie Verna Gallery in Switzerland, documented how Judd found a way to make "a monumental sculpture out of heavy material" while getting inspiration from a piece of metal furniture he saw:

> To everyone's surprise, Judd hit upon a potential solution in observing a bookshelf on the opposite side of the room during the meeting. A long-established classic, Andreas Christen (1936–2006) had designed the shelf in question in 1964. To this day, it is still produced and sold by the Lehni company in Dübendorf near Zurich. It consists of aluminum sheet bent along the outer edge and held together with screws—a light and relatively thin material that obtains its stability through the bending of the edges. The machining and manufacture takes little effort. Judd was convinced that a large-scale work could be produced in a similar manner. He wanted to devise a form and a structure for such a work. Then another issue was finding a suitable factory. This fortunately did not pose a problem: My wife Annemarie suggested involving her longtime friend, Doris Lehni-Quarella (1944–1998). The friend, a photographer by profession, had inherited the Lehni tinsmith works from her husband Rudolf Lehni when he passed away in 1981. With energy and enthusiasm, she expanded the division of her company that dealt with the fabrication of furniture. The design of the furniture was almost exclusively handled by the artist and designer Andreas Christen, who supported our project with his counsel and experience.[43]

Verna explains that Lehni-Quarella provided an ideal creative environment for Judd to work at her factory while being extensively assisted by the factory's accomplished craftsman, Willi Bühler. Judd closely worked with Bühler and followed his technical suggestion to hold each metal unit together with visible screws. It is intriguing to find that Judd was influenced by a piece of furniture and a particular furniture maker in his search for making large metal artwork, while

↘ with author, 20 April 2006. Later, I contacted Ursla Menet at Lehni A.G., and asked her when Judd's art and furniture were developed at the factory. She responded that they were produced in the same year, 1984; Ursla Menet, email correspondence with author, 18 February 2008.

43 Gianfranco Verna, *Donald Judd in Schweiz: Ein Arbeits—und Freundschaftsverhältnis 1973–1994* (Freiburg: Kenstraum Alexander Bürkle, 2007), 14. English translation of Verna's essay is by Julia Thorson.

he also developed furniture pieces made of the same material and techniques. Menet at Lehni A.G. responded to my inquiry about the manufacturing process of Judd's furniture, "Everything is handmade." The most challenging part is the precise "quality control" of the surfaces and dimensions of the sheet metal and the need "to keep the exact the exact [sic] tolerances of the bent pieces. They have to be frequently checked and readjusted." [44] Thus, professionally fabricated art pieces and furniture were closely generated side by side.

Symmetry and Serial Variation

Judd's do-it-yourself furniture was primarily constructed in Marfa and was configured in accordance with the standard sizes of lumber. Besides the given dimensions, Judd in a way applied a given design scheme, namely symmetry to both his furniture and his artwork. "An artist or an architect can, of course, use both [symmetry and asymmetry] or use only asymmetry, but I long ago reached an agreement with what I consider the primary condition: art, for myself, and architecture for everyone, should always be symmetrical except for a good reason," Judd wrote in his essay "Symmetry," published in 1985.[45]

The dimension of a chair made of planks that is at the Arena of the Chinati Foundation is straightforward; the overall height is 30 inches, the length is 15 inches, the width is 15 3/4 inches, and the seat height is 18 inches. The measurements of the do-it-yourself furniture are not precise but differ slightly because of the individual nature of planks and the simple construction process. However, the overall height (30 inches) and width (15 inches) are the basic and fundamental proportions of all the wood chairs in the Arena. A professional fabricator, Jeff Jamieson was able to achieve more exact proportions with the same chair design by Judd: the overall height is 30 inches, the length is 15 inches, the width is 15 inches, and the seat height is 17 1/2 inches. The seat height of 17 inches was predetermined as a standard chair dimension. Thus, except for the regular seating height, Judd persisted with a symmetrical proportion of 2x1x1 (height x length x width).

Furniture fabricators such as Jamieson and Bühler exercised their sophisticated

44 Menet, correspondence, 18 February 2008.
45 Donald Judd "Symmetry" (1985); reprint in *Judd, Complete Writings 1975–1986*, 92.

THE INTERRELATIONSHIP OF FURNITURE AND SCULPTURE 93

fig.33-a, 33-b Judd Furniture chair #84-85 colored Fin-Ply (suite of 5, styles 1, 7, 6, 2, 10) view 1, 2, Image Courtesy JuddFurniture.com/Judd Foundation

techniques produced functional objects with the same kind of exact measurements as Judd's artwork. To take another example, a plywood desk Judd specially designed for Marianne Stockebrand is configured in a symmetrical way in its overall form and details; the length is 200 cm, the width is 100 cm, and the height is 75 cm.

In his series of sheet metal furniture, Judd adopted symmetry in a most systematic manner. The simple principle of symmetry can generate various types of pieces. Judd's basic module was 25 cm, and he multiplied this number in order to develop different configurations and a variety of furniture designs. He designed fifteen variations of sheet metal furniture as a set initially fabricated at the Lehni A.G. in 1984. Judd also applied the idea of making serial objects, which he had developed in his artwork, to his chair designs. (fig.32/fig.33-a, 33-b) In his series of chairs, Judd developed slightly differentiated configurations on their bottoms. Those variations appeal to formal and proportional interests instead of upholding functional ends. Hence, Judd's preoccupation with the subtle variations between each unit within a whole set of his serial artworks was reflected in his chair designs as well.

Single and Multiple Colors

Judd's sheet metal furniture has much in common with his aluminum artwork, which was developed almost simultaneously at the same factory. Judd did explore a greater degree of color variations and combinations with his painted aluminum art pieces than with his aluminum furniture, each piece of which was produced in a

fig.34 Judd Furniture Seat-Table-Shelf #57/#58, Image Courtesy JuddFurniture.com/ Judd Foundation

single color. (fig.34/fig.35)

Judd's use of multiple colors in his artwork entered a new phase around 1984. Painted metal sheets allowed Judd to explore an infinite variety of color combinations. He basically used color as a material. Judd liked colored Plexiglas because "the color is in the Plexiglas, right in the material." [46] Applying pigments to a metal (e.g. a painted aluminum sheet), in fact, represented a "compromise" to the material integrity of the object, in Judd's view, though he justified the practice as being at least a rational, non-metaphysical treatment of metal surfaces, like the production of cars.[47] In his painted aluminum art pieces, Judd tried to create a great visual impact from the combinations of different pigments while avoiding a traditional sense of harmony:

> In the sheet aluminum works I wanted to use more and diverse bright colors than before. As I will describe later, there are many combinations, some old as I listed, and some my own from earlier work. I wanted to avoid both of these. I especially didn't want the combinations to be harmonious, an old

46 Judd, "Discussion with Donald Judd," 54.
47 Ibid.

and implicative idea, which is the easiest to avoid, or to be inharmonious in reaction, which is harder to avoid. I wanted all of the colors to be present at once. I didn't want them to combine. I wanted a multiplicity all at once that I had not known before. This was very difficult.[48]

For Judd color was as important an element as space, with his primary concern throughout his artistic career being the viewer's empirical, actual experience of conceiving things in spaces. The lasting visual impact impressed in one's mind was what Judd aimed at through the bold presentation of the physical presence of objects, regardless of whether they are artwork or furniture. Judd tried to avoid including detailed formal elements and color combinations that might come between viewers and objects.

All experience is knowledge: subjective experience is knowledge; objective experience, which is science, is obviously knowledge. Color is knowledge. ... Color as knowledge is very durable. I find it difficult, maybe impossible, to forget. A considerable effort in the painted sheet, aluminum work that I made was to forget the colors and their combinations that I had liked and used in my first paintings, those in turn sometimes derived from Mondrian, Léger, or Matisse, or earlier European painters.[49]

But, at the same time, Judd could not deny his taste for certain colors. He noted his favorite pigments, which sounded industrial and chemical even in their names; "[a] group of colors, without an adjective like 'full,' that I especially like is of course cadmium red light, cerulean blue, chartreuse, and permanent green." [50] He applied his favorite colors in both his artwork and his furniture. While admitting his preference for certain colors, such as the red used in his early works, Judd seemed to be more comfortable in embracing his taste for certain colors with his furniture design. Judd frankly stated that color is a "fun" element in his furniture designs and took the liberty of adopting colors he liked.[51]

48 Judd, "Some Aspects of Color in General and Red and Black in Particular (1993)," in *Donald Judd, Colorist*, ed. Dietmar Elger (Ostfildern-Ruit: Hatje Cantz, 2000), 114.
49 Ibid., 98.
50 Ibid., 115.
51 Judd commented on the use of colors in his furniture designs, "There are some ugly colors but ↗

Each piece of aluminum furniture is in one pigment chosen from a palette of twenty colors used by Judd. The role of color in his artwork is to enhance the lasting visual impact of the physical wholeness of the object, and he pursued the same course with his furniture design.[52] There seems to be a turning point at which Judd's artwork and furniture seem to inspire and echo each other, as they share a similar principle of variety within one whole object or set of objects. As if corresponding to his explorations in color in his aluminum art pieces during the mid to late 1980s, Judd introduced a new series of Finland-color plywood furniture in 1991, made by WPF.[53]

Whether with single or multiple colors, his furniture and art pieces convey a rigorous and harshly perceived visual impetus through the vibrant materiality of industrial paints.

Marketing Judd's Furniture

Judd's first two furniture exhibitions were mounted in 1984. They were held almost simultaneously at private and public spaces, his home at 110 Spring Street (Nov.17–Dec.15, 1984) and the Max Protetch Gallery (Dec.7, 1984–Jan.5, 1985) in New York City. Additionally, Judd's new large-scale art pieces made of concrete and steel were also on view at Leo Castelli's two Galleries in SoHo. In short, there were four exhibitions featuring one artist taking place around the

↘ mainly most artificial colors are just fun"; Judd, *Donald Judd's Marfa, Texas*, videocassette.

52 While I have not been able to find a stated reason why Judd didn't design multi-colored aluminum furniture, it is likely that the formal unity of each piece of furniture could be easily fragmented if the different parts of the furniture, like the legs, arms, back and seat were painted different colors. This might also oppose Judd's preference for asserting the formal wholeness of physical objects in space. In addition, furniture could appear anthropomorphic if the vividly accentuated components of the legs or arms triggered figurative imagery in the viewers' imaginations. The possibility of a metaphorical reading in his furniture would not agree with Judd's preference for objects to be devoid of every implication except their physicality.

53 According to Jim Cooper, when he was making solid wood furniture for Judd during the 1980s Judd was reluctant to use plywood for his furniture because the same material had been reserved for his plywood art pieces, which reflected Judd's attempt to distinguish his furniture and artwork, but later Judd embraced plywood for his furniture; Jim Cooper, email correspondence with author, 17 October 2007. According to the checklist of Judd's furniture retrospective in 1993, the plywood furniture made with plain, natural wood surfaces such as birch plywood was initially made at Pro Raüm, Cologne in Germany in the early 1990s. Later, Jamieson and Deese (WPF) produced a variety of Finland-color plywood and natural birch plywood furniture.

same moment in the same neighborhood of New York City. Perhaps it was not unheard of during the 1980s, but such an opportunity was surely reserved only for the most established of artists. This plethora of shows also suggests the artist's ample productivity, achieved through his skilled professional fabricators, and demonstrates Judd's capability as the manager of an entire business operation. Judd carefully orchestrated which works were designated to which venues: pieces of wood furniture were handled by Jim Cooper, who curated the solid wood furniture exhibit at the semi-homey setting of 101 Spring Street; colorfully enameled aluminum furniture fabricated at Lehni A.G. in Switzerland was shown at the Max Protetch Gallery, which is known for representing both artists and architects; and art pieces on an ambitious scale went to the Leo Castelli galleries run by the internationally prominent Castelli (1907–1999), an influential dealer of contemporary art. Judd tried to separate his furniture dealers from his art dealers from the outset, in short, in promoting his furniture in the public arena.[54]

However, there were cases when some art galleries dealt with his furniture, and often Judd's new art and design works were shown around the same time in close proximity.[55] His design projects were represented by such art galleries as Paula Cooper Gallery in SoHo, Rhona Hoffman Gallery in Chicago, and Annemarie Verna Gallery in Switzerland in the 1980s as well as Protetch. It seems that Judd became stricter about the division between his furniture and art dealers toward the late 1980s, when he completely separated his fabricators of furniture for sale and his fabricators of art pieces. Hester van Roijen, a private dealer in the U.K., also consulted Judd to market his furniture in Europe starting in the late 1980s.[56] The dealers who specifically represented Judd's furniture were A/D Gallery in New York City, Ulrich Fiedler Gallery in Cologne, Germany, and a furniture store, Formatera, in Zurich, Switzerland.[57] Van Roijen also assisted Judd in

54 Weiner, interview, 25 October 2007.
55 I am grateful to Urs Peter Flückiger, Professor at the College of Architecture, Texas Tech University, for drawing my attention to the fact that there were cases when Judd promoted and sold his furniture through art galleries where he was represented.
56 On behalf of Judd, Hester van Roijen facilitated the fabrication and distribution of painted aluminum furniture and some pieces of wood furniture made in the U.K. and Ireland; Hester van Roijen, email correspondence with author, 9 April 2008.
57 Doris Lehni-Quarella at Lehni A.G. also facilitated marketing Judd's furniture between 1984 and 1987 when the factory produced Judd's furniture (the factory resumed fabricating Judd's furniture in 2002). Formatera, the furniture store in Zurich, began to sell Judd's furniture in the late 1980s or ↗

setting up contracts with David Gill Gallery in London, Downtown Gallery in Paris, and Carine Szwajcer in Brussels.[58] David Gill Gallery has been promoting contemporary decorative arts since 1987. Downtown Gallery is focused on modern furniture and functional objects.

Judd's furniture shows were held at the Ulrich Fiedler Gallery in 1992 and 1993.[59] By the mid-1990s, Fiedler owned both furniture and art galleries and he had dealt with vintage (1920s) photographs from the beginning.[60] A/D Gallery was opened in 1989 in the SoHo area and featured only furniture and functional objects designed by artists. The owner of the gallery was Elisabeth Cunnick who met Judd around 1988/89 and began to show and sell Judd's furniture at her gallery.[61] So, often these gallery owners who handled Judd's furniture had strong ties with artists and their products.

Although Judd played a role as a manager of his production lines, he was not a designer in the common sense of the term in the way in which he marketed his furniture. Judd did not apply for a design patent in order to protect his furniture designs from copies nor did he try hard to work with large, well-known modern furniture manufacturers, such as Knoll or Herman Miller.[62] Judd and

↘ the early 1990s because the artist wanted to separate his furniture dealers, but the store's business was not very successful. The store was closed around 2006 or 2007; Gianfranco Verna, telephone interview by author, 19 February 2008. While Judd was alive there were other galleries which briefly handled his furniture, such as PaceWildenstein Gallery in California, De Vera Gallery in San Francisco in the early 1990s, and an unidentified gallery in Spain, as Jeff Jamieson recalled; Jeff Jamieson, email correspondence with author, 7 April 2008.

58 Van Roijen, correspondence.
59 Judd was initially a patron of modernist design objects sold by the Ulrich Fiedler Gallery. After 1991/92, Judd acquired Bauhaus items and furniture by Gerrit Rietveld at the gallery, and Judd proposed that Fiedler mount his furniture show. While the owner of the gallery agreed to do so, the gallery no longer handles Judd's furniture; Ulrich Fiedler, email correspondence with author, 29 October 2007.
60 Ulrich Fiedler, email correspondence with author, 30 October 2007.
61 Elisabeth Cunnick, telephone interview by author, 7 November 2007. When the A/D Gallery closed its exhibition space, Jon Tomlinson Director of A/D Gallery, opened his own gallery Artware Editions with his business partner, Rebecca Kong in May 2006 in Greenwich Village in New York City, and his gallery succeeded in distributing both Judd's wood and aluminum furniture; Jon Tomlinson, email correspondence with author, 26 October 2007.
62 For instance, Isamu Noguchi applied for design patents on his numerous design objects and ideas, including ash trays, utensils, lamp shades, and even the mechanics of water fountains, based on his bitter experiences of having pervasive, cheaply-made imitations of his lamps and coffee tables appear during his early career as a designer.

Jim Cooper discussed attempting a venture into large scale manufacturing but never attempted it because objects in solid wood couldn't easily be adjusted "from artistry to industrial" modes of production, in Cooper's words.[63] Instead, in the beginning Judd's solid wood furniture was produced on an edition basis, and was manufactured in relatively small-scale workshops and factories and handled by dealers tied to the contemporary art world.[64] Metal furniture was also fabricated in limited editions of 100 in 20 colors initially at the Lehni A.G., but production became unlimited when Janssen began to fabricate metal furniture in the late 1980s.[65] When Jamieson and Deese started to make wood and plywood furniture for Judd, it was not on a limited edition basis, but a running number was signed on each piece of furniture.[66]

Judd created furniture with a greater variety of materials and designs throughout the 1980s and the 1990s than he had previously, and marketed it through rather

63 Jim Cooper, email correspondence with author, 18 October 2007.
64 A price list of Judd's furniture made for the show "Donald Judd: Sculpture and Furniture" in 1985 at the Rhona Hoffman Gallery indicates that all the wood furniture pieces are from editions ranging from 10 to 100 in a total. Later, in 1988, a wood furniture list compiled by Paula Cooper Gallery shows that all items also comprised editions from 10 to 80. Prior to the first furniture show in 1984, Judd and Jim Cooper decided to produce wood furniture on an editioned basis; Cooper, correspondence, 18 October 2007. Before the opening of the show Judd and Jim Cooper often met for furniture production, and Judd visited Cooper's workshop to sign the back of each piece of furniture; Cooper and Kato, interview, 9 May 2006.
65 See Erika Lederman, "Donald Judd, Furniture," *Art Monthly* no.184 (March 1995): 45. Hester van Roijen confirmed to me that Janssen made unlimited, painted aluminum furniture for Judd; van Roijen, correspondence. I am puzzled with the terminology applied to Judd's aluminum furniture since it is described in various ways by different persons. Ursula Menet at Lehni A.G. informed me that the factory "registered" and "stamped" each piece of Judd's furniture from 1984 to 1987 with text like "DONALD JUDD 84-001/100 LEHNI AG SWITZERLAND"; Ursula Menet, email correspondence with author, 26 February 2008. Gianfranco Verna referred to Judd's aluminum furniture as "limited editioned" when it was shown at Annemarie Verna Gallery in 1985. Gianfranco Verna, telephone interview with author, 8 April 2008.
66 Jeff Jamieson wrote how he and Deese set new prices on furniture other than the limited edition pieces when they began to make Judd's furniture in 1989: "My memory is that Rupert and I lowered prices on many pieces. We stopped the editions (at Judd's direction) and knew prices should come down. Wood for some pieces was still so expensive (Single bed Douglas fir). By making the whole line out of different materials (a single chair could come in common pine, Texas plus pine, hardwood or plywood) the prices had to reflect that. There were pieces newly designed just for plywood as well. We made some changes after learning how difficult it was to construct the shelf unit and how much lumber it used for example"; Jeff Jamieson, email correspondence with author, 7 April 2008 and 27 June 2008.

exclusive venues. Many kinds of furniture designed by Judd are still in production today. The Judd Foundation, which was established by his children in 1996 according to Judd's last wishes, holds the copyright for Judd's furniture designs, their production, and distribution.[67] Ramon Nuñez at the Chinati Foundation made a large table on demand for events at the 2005 Open House, co-organized by the Chinati Foundation and the Judd Foundation.[68] That simply made furniture was used in-house only, and Nuñez fabricates and repairs pieces of furniture at the Chinati Foundation in the same manner he did while Judd was alive. Thus, many of the different designs of Judd's furniture are available by ordering them through the Judd Foundation, except for some specially made prototypes and the do-it-yourself rustic pieces of furniture made in the "naïve" manner by local carpenters in Marfa. There are currently two furniture manufacturers: wood and plywood furniture is made by Jeff Jamieson in the United States and aluminum furniture is produced at Lehni A.G. in Switzerland.[69]

Judd handled his furniture as more of a small business operation as he developed some new designs especially for his family members and close friends. In some cases, his furniture functioned as a token of friendship in a local community.[70]

67 While Judd was alive, things were somewhat informally operated; the artist was occasionally involved with selling his furniture via his own office, but as Robert Weiner told me, after Judd died in 1994 the business of marketing his furniture was officially passed to the Judd Estate (later, Judd Foundation); Weiner, interview, 25 October 2007.

68 The annual open house was initiated by Judd in 1989 with 200 neighbors and the artist's friends attending. The number of guests grew to the point that it is now over 2,000. Visitors include neighbors and others from all over the world who enjoy free public viewings of the permanent installations, cultural entertainment, and symposia in Marfa.

69 In 2007, wood and plywood furniture production was transferred to a new fabricator, as Jamieson opted to discontinue fabrication for the Judd Foundation in 2006. Jamieson resumed to fabricate Judd's wood furniture in 2009.

70 For instance, Judd placed advertisements for cultural activities at the Chinati Foundation in a local newspaper, *Big Bend Sentinel*, run by Robert Halpern. When the Chinati Foundation owed $2000 to the news agency in 1992, Judd asked Halpern if he would like to have Judd's furniture to pay the debt, and Halpern agreed and chose a table-bench from a catalogue Judd showed. The furniture piece was made by Raul Hernandez using 2x12 pine obtained at a local lumberyard, and it now sits in Halpern's office in Marfa as a witness to the "friendship" between them; Robert Halpern, interview by author, Marfa, Tex., 5 June 2006. Shaw Skinner, a CPA in Alpine who worked for Judd from 1987 to 1994, asked Judd for permission to make a copy of Judd's library desk for his own office. Judd verbally approved the request and when he saw the new desk at Skinner's office Judd acclaimed, "Oh, this is familiar to me," per Shaw Skinner, interview by author, Alpine, Tex., 6 June 2006.

"I try to keep the prices as low as possible but because all of the work is done by hand, the cost of a chair still comes to $1500," said Judd to an interviewer in 1993.[71] This price for a chair is not an affordable amount for an average household. However, compared with the recent sharp rise in prices for Judd's artwork at auction houses, the prices for his furniture seems rational and even modest.[72] Aware of the logic of business in the art world, Judd must have realized that if each piece of furniture was manufactured with highly sophisticated craftsmanship and sold through editions at galleries it would be priced as a luxury item.[73]

It might seem that adopting galleries as the main marketing venues to distribute his furniture contradicts the spirit of Judd's intention to separate it from his art in public, official arenas of display and productions.[74] However, placing his furniture with galleries might have allowed Judd to avoid competition in the wider arena of the design market. Judd tried to maintain a rational price for his furniture as it is supposed to constitute "real" functional objects. As he stressed in 1991, "The main point is it's not art. It's not artist's furniture, it's real furniture. We do sell it now, though we don't make much of an effort to do so yet, which I think we should because people want it. And we try to keep the price down. It's still kind of expensive."[75] Judd was not eager to reach out to wide audiences. After all, he was not in agreement with the dominant process of mass-production and favored the small workshop operation for the creations of both his art and functional objects.

71 Judd, interview of Judd, in Allen, Appendix A: Dutch Interview, c.Mid-1993, "Judd and Marfa Objective," 196.
72 For instance, Dennis Dickinson, Director of 2D gallery in Marfa ordered a solid wood chair in 2002 (the chair is stamped "Judd 2002© C CP 5 376 WPF") through the Judd Foundation. It was fabricated by Jeff Jamieson, and Dickinson paid $1,100 for the chair. According to price lists provided by Rhona Hoffman Gallery and Paula Cooper Gallery, a limited editioned library chair made of solid Brown Elm cost $2,750 in 1985 at Rhona Hoffman Gallery, and later the same chair cost $3,000 in 1988 at Paula Cooper Gallery.
73 Judd's furniture continues to have a somewhat low-profile, but it is currently available directly via the Judd Foundation or through galleries, such as the Artware Edition Gallery in New York and the Gallery Yamaguchi in Japan.
74 When Jim Cooper was involved with the fabrication and sale of Judd's furniture in the 1980s, he had an agreement with Judd and a gallery that the selling price was generally three times more than the fabrication cost, and when a piece of furniture was sold at the gallery approximately one third of the sale went to each party: the fabricator (Cooper/Kato), the gallery, and Judd. They gave a discount to galleries and related dealers, as Jim Cooper recalled; Cooper, correspondence, 24 October 2007.
75 Donald Judd, "Judd's 'Real' Furniture," 77.

As a designer, Judd sought the highbrow market instead of the middle market geared to art crowds.[76] Judd's furniture is likely best appreciated by audiences who are familiar with his artwork.[77] Yet Judd did not identify his works with any class or hierarchical group, as he wrote, "I don't want my work to become part of the overstuffed fake elegance of the upper class; I don't want it to sit on the grey middle class wall-to-wall carpet; I don't want to join the lower-class either, who want only social realism, as does everyone else."[78] In short, the division between the art and furniture was a social necessity once the furniture left workshops for the public arena of the market, but they remained together in his own private environments in Marfa, Texas the place that became his primary working and living site in the 1970s.

76 As a comparable example, Isamu Noguchi didn't totally embrace the idea of reaching out to the public at large by selling his artistic forms of lamps on the mass market. Noguchi rather carefully chose high-profile, fashionable, established modern design venues, distributors or art galleries such as Bonniers, Bloomingdale's in New York, Wohnbedarf A.G. in Switzerland, and Steph Simon Gallery in Paris where he internationally distributed his lamps; see Nina Murayama, "Akari Chronology," *Design: Isamu Noguchi and Isamu Kenmochi*, (New York: Isamu Noguchi Museum and Fivetie, 2007), 99–103.

77 Early clients of Judd's furniture tended to be persons both Judd and Cooper/Kato knew, including artists, collectors, dealers, and designers; Jim Cooper recalled the following clients: "Chuck and Leslie Close, Lynda Benglis, Joel Shapiro and Ellen Phalen, Leo Castelli, Peder Bonnier, Larry Gagosian, Ronald Greenberg, Bill Katz, Hiroshi Murata, Ed Downe, Frank Benedict, Eric Silverman, Paula Cooper"; Jim Cooper, email correspondence with author, 24 October 2007. As Fiedler recalled, Judd's furniture shows at his gallery in 1992 and 1993 were neither very enthusiastically received by journalists nor a business success; Fiedler, correspondence, 29 October 2007. Gianfranco Verna also recalled that buyers of Judd's furniture shown at Annemarie Verna Gallery in 1985 were mostly those who knew about Judd's art. There was little media attention to the show, but it marked the slow start of Judd's furniture business; Verna, interview, 8 April, 2008. Elisabeth Cunnick remembers that clients of Judd's furniture included interior designers, and that Judd's furniture show in 1992 at A/D Gallery was well received compared to the previous one in 1989, a group show entitled "Library" which included a library table designed by Judd; Elisabeth Cunnick, telephone interview by author, 7 November 2007. Jeff Jamison also recalls that he and Deese produced 160 pieces of furniture during the period between 1989 and 1994. Almost all customers of Judd's furniture were connected to the art world. Although they came from many nations, a small majority came from the U.S.; Jamison, correspondence, 7 April 2008.

78 Donald Judd, "Two Cultures," *Lotus International* 73 (1992):123.

Installations of Judd's Furniture and Artwork

Being aware of the potential confusion between his art and furniture, Judd was known for his practice of not showing his art and furniture together in the same rooms of galleries or museums. As a matter of fact, Judd's policy was not so strictly enforced, and there were some exceptions during the 1980s. Both his art and furniture were on display at the same gallery and museum spaces or shown at nearby locations in New York City around the same time. Judd's retrospective at the Whitney Museum of American Art in 1988 included two wood benches and coincided with his design works being shown at the Paula Cooper Gallery in New York.[79]

Despite the fact that his furniture and artwork were often on view and available to reviewers at the same time, his furniture shows received little notice compared with his artwork, as Jim Cooper recalled in discussing the first furniture show in 1984 at the 101 Spring Street building in SoHo.[80] The presence of Judd's furniture could easily be ignored in art historical discourse, but perhaps it would have been harder to avoid if it had been shown together with his art pieces. As a matter of fact, during the early public showings of his furniture, Judd was not so adamant about separating his art and furniture in gallery spaces. Almost a year after his first furniture shows in New York City, his artwork and furniture were exhibited together in the same space at the Rhona Hoffman Gallery in Chicago from October 18 through November 16, 1985. The show was entitled "Donald Judd, Sculpture/Furniture." (fig.36) The owner of the gallery, Rhona Hoffman,

79 And later in 1993, a year prior to his death, when Judd's first furniture retrospective was held at Museum Boymans-van Beuningen and traveled to Villa Stuck in Munich, his prototypes of the new series of Finland-color plywood furniture were being exhibited at the initial site of Judd's first furniture show at the 101 Spring Street building. Robert Weiner curated the exhibition with Judd, and remembered that the show was organized to introduce these new types of Finland-color plywood furniture made by Jamieson and Deese (WPF); since it was held at Judd's private home, it was operated in an informal manner, and furniture was sold through Judd's office with some assistance from the art gallery; Robert Weiner, email correspondence with author, 16 October 2007.

80 According to Jim Cooper, Judd had an idea to show his furniture in 1982 and 1983, but there was a financial difficulty in realizing the plan. Jim Cooper suggested to Judd that he wanted to do it; the two signed a contract in which Judd would have provided the designs of furniture and Cooper/Kato would have been responsible for the materials and fabrications of furniture; Cooper and Kato, interview, 9 May 2006.

104 FUNCTIONAL ART IN A DYSFUNCTIONAL SOCIETY: DONALD JUDD'S FURNITURE

fig.36 Installation view of the exhibition *Donald Judd, Sculpture/Furniture* (1985) Rohna Hoffman Gallery, Chicago Image Courtesy Rohna Hoffman Gallery

recalled that at the time Judd didn't come to supervise or advocate for separate installations of his furniture and artwork.[81] Judd "certainly did know and he definitely approved" that they were shown in the same space as Hoffman remembers.[82] The installation views in photographs indicate that his furniture, such as a desk set, library chair, table bench, and bench, uniformly occupy floor space, whereas his art works are uniformly installed on the walls of the gallery. Both art and furniture are similarly treated as physical volume, presenting formal kinship and existing in space with a perfect sense of balance among the pieces.

About three years later, in 1988, Judd had a design show entitled "Donald Judd, Drawings, Furniture, and Sculpture" at the Paula Cooper Gallery. This exhibition was held at the gallery simultaneously with Judd's second retrospective at the Whitney Museum of American Art. At the time, Judd instructed Paula Cooper, the owner of the gallery, to install his sculpture and furniture in different spaces. Thomas McEvilley reviewed this exhibition and noticed Judd's intention to divide the two. But, he couldn't help noticing the similarity between them:

At the Paula Cooper Gallery Judd showed furniture, sculpture, and architectural drawings. Understandably, the installation tried to keep the first two categories separate. Many of Judd's boxlike sculptures of the '60s and '70s looked vaguely like furniture at the time. Now his furniture pieces—angular beds, chairs, and a drawing table, all of which appear to be uncomfortable—look vaguely like sculpture. The new sculptures

81 Rhona Hoffman, email correspondence with author, 13 July 2007.
82 To my question about Judd's express preference for separating the art and furniture, Hoffman replied, "Maybe he thought it was old hat or he simply changed his mind… [it was] his prerogative," underscoring the artist's right to make a decision about how to show his work. Hoffman also noted that the show was well received by visitors and some pieces of furniture were sold; Hoffman, correspondence.

THE INTERRELATIONSHIP OF FURNITURE AND SCULPTURE 105

fig.37 Installation view of the exhibition *Donald Judd* (October 20–December 31, 1988) Whitney Museum of American Art, New York, photography by Jerry L. Thompon

themselves—multicolored industrial beam assemblages—were located in the back room, mounted high enough on the wall so that they couldn't be confused with furniture.[83]

Interestingly, Judd's 1988 retrospective at the Whitney Museum of American Art included a piece of furniture, as shown in the installation photographs. (fig.37) In fact, the presence of furniture in the retrospective at the Whitney Museum was a surprise for Judd's fabricators and other persons affiliated with him who continued to strictly follow the artist's stated protocol of presenting his furniture separately from his art pieces—in some cases even after Judd died. Neither Peter Ballantine nor Jim Cooper could recall much about the pieces of furniture shown at this Whitney retrospective. Recalling the retrospective recently, Barbara Haskell, the curator did not recall having included any furniture.[84] The exhibition catalogue shows three photographs of Judd's furniture pieces: a library desk with two chairs (1982), a cube base chair (1984), and a bed (1987). It is somewhat puzzling that the presence of furniture at such a pivotal exhibition was little mentioned in the critical discourse and was largely forgotten.

83 Thomas McEvilley, "Donald Judd," *Artforum* 27, no.6 (February 1989): 125.
84 Barbara Haskell's recollection was that some pieces of furniture might have been borrowed, but not used in the end; Barbara Haskell, email correspondence with author, 5 November 2007.

Nevertheless, the inclusion of furniture at the Whitney show was planned as documented in files kept at the archives of the museum. There is a memo dated September 14, 1988 from Barbara Dary to Barbara Haskell, curator of the show regarding "Furniture for Donald Judd Exhibition":

> Since I do not yet know which pieces of furniture will be coming from Marfa for the exhibition I wanted you to be aware of a couple of things. As you know it was difficult to arrange for packing of the pieces that are definitely coming out of Marfa. ... Pick-up in Marfa is scheduled for Oct. 7th and there may or may not be room on that van for the furniture you may want to ship. If we need to send another truck into Marfa costs could go up considerably.[85]

This message indicates that there was a plan to exhibit Judd's furniture, and there was an attempt to orchestrate shipments from Marfa. However, evidently the choices about displaying furniture were uncertain at this point of about one month before the opening of the show, and more serious attention was being paid to art pieces than to furniture.

In fact, a drawing of the layout of the works found in the archives of the Whitney Museum doesn't indicate any pieces of furniture. Nevertheless, Judd's furniture was indeed exhibited along with his art pieces, as is evident from photographs and a review. Importantly, two benches were displayed at a pivotal spot at the entrance area. Phyllis Tuchman wrote about her encounter with Judd's furniture as she stepped into the fourth floor of the museum where Judd's retrospective took place:

> First, two oversized wood benches crafted to the influential 60-year-old's specifications greet you. Then, rather than encountering a panoramic vista of objects on display, you'll find an unorthodox installation.
>
> The work isn't presented chronologically nor tidily arranged by type or category. Instead, a series of four huge concrete cubes immediately blocks out

85 A note dated September 14, 1988 from Barbara Dary to Barbara Haskell, curator of the show regarding "Furniture for Donald Judd Exhibition," Whitney Museum of American Art Archive, New York.

everything else to your left. And to your right, a number of smaller, bright-red wood objects suggest someone with no sense of proportion orchestrated this show.[86]

By Tuchman's account, there was a doubly confusing effect to the installation amplified by the rather aggressive physical characteristics of the works: the largeness of the cubic concrete forms and the vibrant red color of the wood works, that challenged the visitor's first glance. In this disorienting setting, the presence of over-sized benches may have been too perplexing to comprehend at once.

There were not many exhibition reviews of Judd's furniture shows in New York during the 1980s and 1990s. Judd had firmly established himself by that time as a canonical artist of Minimalism, and his furniture design was taken as a secondary venture and mostly ignored. Yet a small number of reviews indicate that critics saw Judd's furniture in relation to his artworks, which were increasingly perceived as "beautiful" or "elegant" objects meticulously crafted with the finest, most visually appealing materials.

At the furniture show curated by Jim Cooper at the Spring Street building in 1984, a critic noted, "The wood furniture is no less rigorous than the artist's sculpture; meant to be useful, it is elegantly unsentimental."[87] In another review, Robert Mahoney reported on Judd's drawings, furniture and sculpture shown at the Paula Cooper gallery in 1988:

> The Couch/Bed creates a visually nice enclosure, but the ability of a body to hide in it creates potentials most beds don't. The Standing Desk and Stool/Stand looks rather too finely-polished for draft-work, and its underslits seem only to pull the grain out from underneath the wood. This motif—the underslit, the visual and functional transfer of the closure from Judd's boxes—has its most visually elegant but functionally paranoid expression in his Desk Set, where the perfect nothing-out-of-order desk is made nervous in its clean pride by the close underlayer of who knows that could be hidden there.[88]

86 Phyllis Tuchman, "The Shapes of Prose," *Newsday*, Friday, 28 October 1988, 15.
87 Pilar Viladas "Furniture designs by Donald Judd," *Progressive Architecture* 66 (January 1985): 28.
88 Robert Mahoney, "Low, Messy and Repressed," *New York Press*, 25 November 1998, 20.

108 FUNCTIONAL ART IN A DYSFUNCTIONAL SOCIETY: DONALD JUDD'S FURNITURE

Judd's art and furniture may have evoked a sense of confusion in many viewers, as suggested by such reviews. In the "please do not touch" context of an exhibition, Judd's furniture was treated and perceived more as artwork than as usable, functional objects. Above all, his furniture pieces were as exquisitely manufactured as his artworks, and there are formal resemblances in the overall structural principles of both. Elisabeth Cunnick, an owner of A/D gallery, recalled of Judd's 1992 furniture show at her gallery, "Before, people tended to think of Judd's furniture as sculpture"; since his beds were displayed without mattresses, "People thought it was beautiful but said it couldn't possibly be a bed. It looked too uncomfortable." [89] For that matter, the furniture still tends to be perceived more as beautiful than as functional. "His chair [in metal] is definitely a work of art," claims Gareth Williams, Curator of Architecture and Design at the Victoria and Albert's Museum.[90]

When Judd's furniture was put on display abroad, the exhibition generally followed the same logic as his installations of art, and viewers tended to perceive the furniture more as artwork. The installation for the furniture retrospective at the Museum Boymans-van Beuningen, Rotterdam in 1993 was designed by its curator Piet de Jonge. (fig.38) There were various pieces of furniture of different designs and materials. There was no chronological order, but a spatial one; all the pieces of furniture were symmetrically arranged. Interestingly, de Jonge decided not to have a label placed beside each object, believing that a piece of furniture presented a

fig.38 Installation view of the exhibition *Donald Judd, Furniture Retrospective*, Museum Boymans-van Beuningen, Rotterdam, 1993, MUSEUM BOIJMANS VAN BEUNINGEN Postbus 2277-3000 CG ROTTERDAM Museumpark 18-20-ROTTERDAM.

89 Elisabeth Cunnick, in Aric Chen, "Making More of Donald Judd," *Interior Design* 73, no.8 (August 2002): 204–05.
90 Gareth Williams, in Helen Kirwan-Taylor, "Art by Design," *Art Review* 2, no.2 (February 2004): 51
91 Piet de Jonge recalled of his installation: "it is a very seventies approach I suppose. Just show things as they are. All objects are more or less contemporaries of the viewer so he/she should be able

self-evident reality through its material physicality.[91] For his furniture shows at Ulrich Fiedler's gallery in 1992 and 1993, Judd instructed the gallery owner to install his furniture to look like interiors, with an ensemble of tables and chairs arranged in seemingly everyday situations.[92] Like his art pieces, Judd's furniture is never meant to be placed on a pedestal. However, in the peculiar context of an exhibition, the furniture was meant to be looked at instead of used, causing a feeling of doubt to arise about its actual identity as furniture.

Judd's furniture retrospective at the Museum Boymans-van Beuningen was mostly viewed by local writers and reporters in relation to Judd's own artworks as well as to Holland's early modernist designer and architect Gerrit Rietveld. In one of the exhibition reviews, Jaap Huisman noted that some of Judd's large pieces of furniture have imposing presences comparable to those of his artwork, whereas his chairs didn't have such a strong sense of existence.[93] This suggests that Judd's art and furniture could in some cases become mingled in the mind of the viewer. Inevitably, the furniture appears to be more about abstract, formal qualities once the viewer focuses on looking at it instead of using it. Likewise, John Pawson wrote about the 1993 furniture retrospective in *Blueprint*, the British architecture magazine:

> The furniture is like his boxes, in that it is unforgiving, and demands not only to be placed correctly in a space, and in relationship to the other things in it, but also needs to be perfectly made and kept pristine. The space that the chairs create around themselves is also important, as a visual repetition of the forms of the furniture itself.[94]

When Judd's sculptures and furniture were shown at the Museum of Modern Art, Oxford in 1995, Tony Godfrey reviewed the exhibition and posed the question about the relationship between Judd's art and furniture in terms of the aesthetic

to understand what is being shown. As a curator I was very much in favor of that attitude as well." As a curator of modern art, de Jonge also found it challenging to organize the artist's furniture show at the museum because he was not the curator of the applied art department; Piet de Jonge, email correspondence with author, 11 October 2007.

92 Fiedler, correspondence, 29 October 2007.
93 Jaap Huisman, "Meubels als een alphabet," *De Volleskiant*, 22 May 1993.
94 John Pawson, "Judd and the Art of Reason," *Blueprint* 99 (July/August 1993): 34.

value of the furniture and the do-not-touch display context:

> The chairs and tables present an ontological problem: we see these supposedly functional objects as having the presence of sculptures (a word, like 'Minimalism', Judd disliked) and hence read them as art rather than furniture—no visitor to the exhibition showed any inclination to sit on the chairs.[95]

In her discussion on Judd's furniture in du magazine in Germany, Helga Leiprecht also claimed a tie between Judd's art and furniture: "Every table is a 'specific object' forming each space into its own reality." [96]

Judd's adaptation of the empirical approach toward his art and furniture means that they exist as paradoxical counterparts; they resemble each other even as they test each other's identity. They are both against common assumptions about their conventional identities. Judd's art pieces deny the practice of "composition" in art and look like design objects, whereas his geometrical, hard-edged chairs appear too rigid and his oversized benches too large—they are at odds with ordinary furniture and resemble his own beautifully crafted artwork. Some of his furniture pieces have dual or multiple identities: bed/couch, bed/bench, or table/bench.[97] Thus, there is an additional puzzle for the viewer as to the exact functions of Judd's furniture, leading to a greater sense of the ambiguity of the objects.

Even though Judd mostly tried to divide fabricators, marketing venues, and the public display of his art and furniture toward the late 1980s, they remained closely linked and were generated side by side. Although the artist had of course a right

[95] Tony Godfrey, "Review: Donald Judd, Oxford and London," *Burlington Magazine* 137, no. 1105 (April 1995): 262.

[96] Helga Leiprecht, "Alphabet der Einfachheit," du (April 1995): 71–72. I thank Heike Bergdolt, landscape architect, for this translation.

[97] Brigitte Huck also points out the ambiguity of functions in Judd's own formal determinations: "Judd often combines different functions in a single piece: table and bench, for instance, or table, bench and shelf unit. He also repeats elements, producing bench-table-bench combinations arranged in a line or rectangle, and exploiting the repetitive potential. Repetition as one of the central elements in his furniture also means openness and freedom, in that the focus is on recurring and new elements. Donald Judd's furniture designs always comply with the demand for conciseness and for the definition of the object in terms of its form and material." Brigitte Huck, "The Furniture," in *Donald Judd, Furniture Retrospective*, 95.

to specify what is art and what is not in his production, that act of naming turned out to be more a matter of moral conviction and a way of facilitating the social status and function of creations after they left the workshop: i.e., of determining or influencing how things are priced, handled, traded, consumed, and received in particular social, cultural, and economic systems. Judd's furniture continued to be produced after the artist died, whereas his art pieces would not be fabricated legally any longer.[98] Technically speaking, it is possible to reproduce Judd's pre-existing art pieces as long as qualified craftsmen and the same materials are available.

The moral dilemma attached to the producing of more of Judd's artwork bears on the paradoxical counterpart between Judd's art and furniture production and marketing. Judd tried to take a maximum of control over this paradox in his creations. Although, legally and morally, Judd made no attempt to push his empirical approach so far as to challenge the assumption that privileges fine art over decorative art, he did undermine the rigid socio-cultural division at the levels of production, marketing, and public display. In the end, Judd resolved this paradox only in his own private living environments and the permanent installations where his furniture and artwork could successfully coexist without specific labels or price tags within Judd's singular vision of spatial wholeness.

98 Once artists' works leave their studios, they inevitably come to serve, to a certain degree, the ends and visions of the patrons or institutions who own the artwork. See Susan Hapgood's "Remaking Art History," *Art in America* 78, no.7 (July 1990): 114–22,181, regarding the issue of reproducing artwork. Judd had a problem with his collector Count Giuseppe Panza di Biumo, whose unauthorized reproductions of the artist's works for the purpose of exhibition made him furious. Donald Judd, "Una Stanza Per Panza," *Kunst Intern* 4, no.7 (November 1990): 3–22. More recently, Anna Chave's essay "Revaluing Minimalism: Patronage, Aura, and Place" further touches on critical aspects of the patronage and quality of aura in Minimalist objects and installations. Analyzing Minimalist works on the east and west coasts, she observes an underlying formal structure entailed in Minimalist objects and spatial environments that emanates an awe-inspiring appeal to patrons who seek their own spiritual connections to Minimalist works, even as these works are shaped by institutional anticipation of their patrons' visions. Anna C. Chave, "Revaluing Minimalistm: Patronage, Aura, and Place," *Art Bulletin* 90, no.3 (September 2008): 466–86.

CHAPTER 4

TOTAL WORK OF ART AND SOCIAL ECOLOGY

Private and Public Spaces as Counterparts

In his later career, during the 1980s and the 1990s, Judd was increasingly aware of the interrelationship between his creations and his life; as he acknowledged, "Art is made as one lives."[1] But, meanwhile, he continued to maintain his hierarchical view that the creative process of art is distinguished from ordinary, everyday conduct:

> It [art] must be as decisive as acts in life, hopefully more so, and is made despite the same acknowledged ignorance. But the assertions of art depend on more organization and attention than is usual in living. The force of it depends upon the long process. The construction, the developments, and the many decisions are necessary so that it be clear and strong.[2]

In this chapter I will discuss how Judd's deliberate processes of orchestrating his installations and furnishing in both private and public spaces were generated from the totality of his everyday behavior and experiences. Marianne Stockebrand points out that, technically speaking, Judd's residences are not permanent installations; they are Judd's private living spaces, including kitchens, living rooms, bedrooms, children's rooms, bathrooms, and libraries where everyday life unfolded.[3] In short, Judd's residences and work places are private spaces, whereas his large-scale permanent installations are public spaces. There was a line between private and public spaces for Judd, but he conceived art as being integral to his whole living

1 Donald Judd, *Repères* (Paris: Galerie Maeght Lelong, 1987), 9.
2 Ibid.
3 Stockebrand, interview, 5 December 2005.

environment.

"Almost all spaces, especially if they contain art, should be livable," said Judd.[4] Whether in an intimate or a large space, it is easy to find a piece of furniture in the buildings Judd renovated in Marfa, such as the indoor entertaining hall called the Arena, the former gymnasium of Fort Ressel; the Chamberlain Building, the former office and warehouses for the sale of wool and mohair, which was transformed into installations devoted to works by John Chamberlain; and the Cobb House, named after the previous owner, which Judd made into an installation space for his early paintings. While none of these places were Judd's primary residences, these permanent installations were in use while Judd was alive.[5]

The idea of permanent installations was initially developed from Judd's living spaces, beginning in the late 1960s, to reiterate. Today, most of Judd's estates operated by the Judd Foundation in Marfa remain private; the artist's residence and workplaces are closed to the public, except for the Block, which is regularly opened to anyone by appointment. In contrast, the large-scale permanent installations operated by the Chinati Foundation were meant to be open to the public from the time the foundation was established in 1986, after Judd settled a legal battle against the Dia Art Foundation, which had initially agreed to finance the large-scale permanent installations at Fort D. A. Russell in Marfa. The two foundations—Chinati and the Judd Foundation—share the same mission of preserving Judd's legacy while residing and operating independently in Marfa.

A Simple Lifestyle and Renovation Scheme

Judd was consistent in his renovation projects; he adopted the same scheme that he developed with the first permanent installations at the Spring Street building.

4 Donald Judd, "Chamberlain Building," in *Donald Judd, Architektur*, 79. However, the large permanent projects at Chinati Foundation such as the mill aluminum works at the artillery sheds or Flavin's installations are free of any furniture.

5 Commenting on the use of furniture, Hoffmann observed, "There are always beds. Don had a lot of choices and places to sleep in Marfa. I am sure he slept in most of his beds that were used in his spaces, since Judd used his spaces as personal spaces during his lifetime. During open house, people slept wherever they could." Madeline Hoffmann, email correspondence with author, 20 April 2006. Meanwhile, Weiner and Stockebrand recalled that Judd primarily used beds located at the Block; Stockebrand, interview by author, Marfa, Tex., 6 June 2006.

Although Judd had a respect for the history of the 19th-century cast iron building, he did not express any nostalgic attachment to the past. Based on his extensive research and meticulous measurements of the installations at Judd's properties in Marfa, Urs Peter Flüeckiger rightly observes that Judd's renovation scheme is a "transformation" rather than a preservation or reconstruction of a certain historical moment.[6] Judd engaged in a drastic process of simplifying spaces while paying attention to some historical aspects of the old buildings. Judd wrote, "I've carefully tried to incorporate the existing buildings into a complete complex. They are not changed, only cleaned up. ... The old buildings should not drag down the new or the new denigrate the old. The conflicts you see everywhere between old and new are avoidable." [7] Judd "cleaned up" his old buildings by taking out walls or, in some cases, removing a bathroom or kitchen area from the structures to maximize clearly defined open spaces.

Judd wrote of the Spring Street building, "I thought the building should be repaired and basically not changed. It is a nineteenth-century building. It was pretty certain that each floor had been open, since there were no signs of original walls, which determined that each floor should have one purpose: sleeping, eating, working..." [8] By designating a single function to each floor, Judd's renovation scheme seems to follow the modern, rationalistic design legacy with an emphasis on utility, and each floor of the building has a spatial and functional unity. The undivided character of the space invites plenty of natural sunlight, a strategy commonplace in modernist architectural designs which often include expansive glass windows. However, the Spring Street building's spatial openness has a different character from Mies van der Rohe's idea of a "universal space" for accommodating multiple purposes since each floor serves a particular function.

Judd's preoccupation with wide open spaces surpassed any inconvenience he incurred by interfering with basic habitat conditions. For example, Judd removed all radiators from the fourth floor of the Spring Street building to achieve a spatial wholeness that eliminates small elements as much as possible.[9] The bathroom and

6 Urs Peter Flüeckiger, interview by author, Lubbock, Tex., 3 June 2006.
7 Judd, "Marfa, Texas," 22.
8 Donald Judd, "101 Spring Street," in *Donald Judd, Architektur*, 18.
9 Vinciarelli points out that it was a practical choice as well in order to save heating costs in winter because it is very expensive to heat the entire building. During a cold winter time, the unheated fourth floor was less in use compared to other seasons. Vinciarelli, interview.

kitchen facilities were completely removed from the Cobb House in Marfa, and the house was renovated into a sort of gallery with a domestic atmosphere. This basic scheme of "cleaning up" a structure to attain a spatial and functional unity persisted in Judd's renovation projects, both in his residences and in the large-scale permanent installations that unfolded in Marfa from the early 1970s to the end of his life.

In part, Judd's "cleaning up" process reflected his preoccupation with a pragmatic, immediate approach to the environment and perhaps the anarchistic self-managing desire for a more moral and simple way of life that he conceived in the late 1960s. Analyzing the new anarchism of the counter culture of the early 1970s, David E. Apter observed that the anarchist aims of reforming one's quality of life, family, education, and community seem to be politically indirect, but they call forth a lifestyle which could be potentially revolutionary:

> Anarchism if it can be anything is likely to be a social doctrine for more personalized living, a recipe for the homespun, and not a political solution for the world's problems. It is more a matter of lifestyle than explicit revolution. But perhaps there is nothing more revolutionary than that.[10]

George Woodcock also pointed out that an anarchist morality, more than a political outlook, was infused in the new radical thinking among the younger generation during the 1960s:

> What the anarchist tradition has to give the radical young is perhaps, first of all, the vision of a society in which every relation would have moral rather than political characteristics. The anarchist believes in a moral urge in man powerful enough to survive the destruction of authority and still to hold society together in the free and natural bonds of fraternity. ... The relations among men are moral in nature, and politics can never entirely embrace them. This the anarchists have always insisted.[11]

Woodcock further characterized an anarchistic, simple way of life as stemming

10 Apter, "The Old Anarchism and the New," 12–13.
11 Woodcock, "Anarchism Revisited," 58.

from an individual's own responsibility for making decisions without relying on any imposed dogmas or authorities:

> For them [the great anarchists] individual judgment held primacy; dogmas impeded one's understanding of the quality of life. That life, they believed, should be as simple and as near to nature as possible. This urge toward the simple, natural way of life made men like Kropotkin urgently concerned over the alienation of men in modern cities and the destruction of the countryside, themes that are dear to New Radicals.[12]

By idealizing a "simple life," anarchists did not necessarily mean returning to a primitive way of life and abandoning all technology. Rather, many anarchists believed that a non-authoritative, decentralization of technology would help people meet their essential needs for a good life.[13] For instance, on the fifth floor of the Spring Street building, Judd's sleeping area, there is no curtain, and only one bedside reading lamp on the low bed; a flashlight was used to move around the bathroom and closet area. Judd seemed to favor natural light. There is not even electricity at Judd's favorite residence, the most remote ranch in Marfa where he liked to spend most of his late days in the early 1990s.[14] Judd was not seeking to inconvenience himself; rather he preferred to work in the daytime, by daylight, and coped practically with the evening hours.[15] Favoring plain open spaces, he didn't elaborate his interiors in a sumptuous way with excessive decoration or unneeded technological advancements. Whether consciously following anarchist principles or not, Judd began forming his own simple way of living intertwined with his own interior designs in the late 1960s in New York. Later, maintaining the simple and pragmatic unity between form and function at each of the many

12 Ibid.
13 Michael Lerner, "Anarchism and the American Counter-Culture," in *Anarchism Today*, ed. Apter and Joll, 60–63.
14 In fact, Urs Peter Flückiger reports that Judd installed light fixtures on the ceiling of the guesthouse (one of four buildings at his remote ranch called Las Casas, Ayala de Chinati), but electricity was never available at the ranch. Judd used propane gas as the sole energy source at the ranch; Flückiger, *Donald Judd, Architecture in Marfa, Texas* (Basel and Boston: Birkhäuser, 2007), 130.
15 Lauretta Vinciarelli recalls that she and Judd didn't feel much inconvenience when they visited his ranch. She observed that Judd only worked during daytime. They used kerosene lamps in the evenings at the ranch; Vinciarelli, interview.

sites Judd owned increasingly became a complicated matter, given the ambitious, extensive renovation projects taking shape in Marfa during the 1980s and 1990s. Yet, it seems that Judd placed ever more emphasis on solitude and quietness in his living spaces during his final years.

Besides the design principles geared to simple living environments, the value of privacy was very important to Judd. He carefully avoided outside contact while devoting himself to his work. The old lift at the Spring Street building can not be operated from another floor because the motor can only be started on the floor where it is located.[16] Judd could easily shut himself off from the staircase as well and from telephone calls while he was at work on the second floor. For instance, the height of the exterior adobe enclosures at the Block in Marfa was determined to be 2/3 the height of the buildings. The height was proportionally determined following Judd's aesthetic judgment. The height of the enclosure struck his neighbors in Marfa because it was unprecedented in local architectural custom, which favored a very low fence or none at all.[17] An emphasis on securing privacy seems more an invention of modern city life, as well as a personal value for Judd both in New York and in the small town of Marfa.

In his library at the Block, Judd had the book *Small is Beautiful: Economics as if People Mattered* by E. F. Schumacher, which was published in 1973. Schumacher promoted the virtues of sustainable, small-scale business operations run in accordance with the fundamental needs of a city, as suggested by its size. He noted, "the technology of mass production is inherently violent, ecologically damaging"; and he further declared, "Man is small, and, therefore, small is beautiful. To go for gigantism is to go for self-destruction."[18] Unlike Marxist denouncements of

16 The reason why Judd kept the old fashioned elevator at the Spring Street building was in part due to the high expense of renewing it, rather than solely for securing his privacy, in Vinciarelli's view; Vinciarelli, interview.

17 Although Judd generally sought locally obtained materials and techniques for his renovations in Marfa, he applied his own design principles, which were not indigenous to south Texas. Adobe is a material typical in the region around Marfa, but the local residents observe that the adobe walls surrounding his residence, the Block, are atypically high; Nuñez, interview. Above all, even after he became a Texas resident Judd was an artist from New York City, and he seemed to remain a kind of foreigner in Marfa except for during the annual open house to which he invited everyone in town.

18 E. F. Schumacher *Small is Beautiful: Economics as if People Mattered* (New York: Harper & Row, Publishers, 1973), 150. Judd implicitly concurred with Schumacher when, for instance, in 1989 he criticized the culture of blockbuster exhibitions: "Art is pretty small. 'Small is beautiful.' Klein ist schon. The large exhibitions and collections are attempts to show that art can be institutionalized

private property, anarchists do not deny private ownership. Schumacher viewed private ownership as natural, fruitful, and just for small-scale enterprises, but not for medium and large-scale enterprises in which ownership ultimately rested on the exploitation of others' labor.[19]

In a way, Judd started the idea of permanent installation as a small-scale enterprise at the Spring Street building, but it soon grew to the larger undertaking. Judd became a major property owner in Marfa in the late 1980s, and his permanent installation projects expanded for a time to an international scope when he was commissioned to remodel Eichholteren in Switzerland. (This building was a former hotel and restaurant built in 1943, and Judd worked on this project between 1989 and 1993.)[20] After Judd died, the Judd Foundation was established and inherited buildings and ranches previously owned by Judd, while some additional buildings inherited by the foundation were sold. They are places that were privately used by Judd as his primary residences and working sites, such as La Mansana de Chinati (the Block), the Architecture Studio (the Bank), the Architecture Office, the Print Building, the Ranch Office, and the three Ranches. Making these properties his, and eventually leaving them to the Judd Foundation, seems to have been a moral choice made by Judd in order to prevent unwanted developers from taking over the town.[21] He was generally dubious of both government and large companies, and he called them "exploitative" for dismissing real civic needs through pseudo-democratic maneuvers.[22] Judd saw that private ownership grants a citizen a certain power to stand up against authority in society.

Judd's renovations, collections of artworks, and permanent installations at old buildings in Marfa became almost an obsessive lifework in the final years of his life. Martin Gayford reported on how Judd expanded his installations in Marfa and added to his extensive collections and possessions;

after all, that it's O.K., that it isn't subversive. And that it's part of the same economic system. And the same educational and cultural system." Donald Judd, "Ausstellungsleitungsstreit" (1989), in *Donald Judd: Book One, Unpublished Manuscript*, Chinati Foundation Archives.

19 Schumacher, *Small is Beautiful*, 250.
20 The project was terminated when the owner of the building changed. See, Adrian Jolles and Adrian Meyer, *Donald Judd, Eichholteren* (Stuttgard: Hatje, 1994).
21 Locals seem to have ambivalent feelings about the artist. Judd brought some business to Marfa, but the city was almost taken over by the stranger's buying power.
22 Judd, "Two Cultures," 124.

Once he had started buying in the town, Judd—funded initially by the avant-garde Dia Foundation—found it difficult to stop. In the last decade of his life—by then he was one of the most revered figures in contemporary art—he was making considerable amounts of money, and he spent it obsessively. For a minimalist, he was an extremely acquisitive man. Collections of all kinds abound in his living spaces at Marfa—numerous kitchens, for example, each lavishly equipped with every imaginable utensil. He accumulated a library large enough for an educational institution, mounds of native American jewellery, saddles, art, tools—all manner of beautiful things, costly and inexpensive, that caught his eye.[23]

Judd's collections of beautiful craftworks, functional objects, and furniture are so tremendous in size that they should be seen as an important part of his life. It is unlikely that all the different shapes and sizes of pans and utensils lined up neatly in his kitchen of the Block were ever in use. The splendid array of kitchen tools is way beyond the needs to cook meals for a family of three: Judd and his two children. The habit of collecting could be viewed in both positive and negative ways. The act of collecting could be seen as a positive, creative practice of forming one's taste; part of the liberal, pragmatic approach toward enriching life experiences proposed by American thinkers like John Dewey.[24] On the other hand, such collecting habits have been critically depicted as empty consumer fetishism, or as the "personalized act of consumption" described by Jean Baudrillard in his neo-Marxist point of view.[25]

23 Martin Gayford, "Best Little Art Town in Texas," *Sunday Telegraph Magazine*, 25 January 2004. Also, Paul Alexander pointed out, "In the late 1980's, as the sales and value of his artworks boomed, he [Judd] began to buy up more and more of the town – the old Marfa National Bank, a supermarket, a grocery store. Ultimately, he owned nine buildings in Marfa, plus 34,000 acres and three houses outside town." Paul Alexander, "Art Oasis," Travel + Leisure 35, no.9 (September 2005): 92. Judd's commercial success in the 1980s was also ironically received: "With Judd's esthetic of democracy, with his advocacy of the fresh and the new, and with the view that American art had to leave Europe behind, it is easy to see why American art became so marketable. Collectors were buying not just for art but a vision of America. How to react against Europe and point toward the future without reinforcing the American myth of itself as the new Eden is no easy task"; Michael Brenson, "Donald Judd's Boxes Are Enclosed by the 60's," *New York Times*, 13 November 1988, A38.
24 The positive aspects of collecting as an individual's creative process are closely discussed in Kevin Melchionne, "Cultivation: Art and Aesthetics in Everyday Life" (Ph.D. diss., State University of New York at Stony Brook), 1995.

In fact, Judd faced a dilemma about determining the right amount of private ownership, in view of Schumacher's ideal of "Small is beautiful." Visually, any given work of art, as a physical object, appears to be "small" in the expansive land under the infinite sky of west Texas. Yet, the scale of Judd's ownership in his late career was far removed from "small" by comparison to an ordinary individual's private property. In his mind, the right size of ownership turned out to be a large enterprise. Lauretta Vinciarelli, who closely witnessed Judd's life during the mid 1970s and 1980s, characterized Judd's interior design as correlating to the 18th-century "aristocratic use of space."[26] She saw that Judd did use all his places in Marfa, but in her view such an exceptionally lavish use of space was not based on the 19th-century middle class ideal of the comfortable home.

Judd indeed had had to achieve a privileged status to own such an enormous amount of real estate and to organize and use the spaces as he wanted. Initially, his large-scale permanent installations could not be realized without the financial support of the Dia Art Foundation, whose endowment stemmed from an oil drilling machinery company, Schlumberger. After the Dia Art Foundation removed its support, Judd established the Chinati Foundation. He had to run Chinati Foundation mostly on his own; the board members were mostly close affiliates of the artist, not strong funding resources. The management of such a wide variety of projects—renovating and constructing buildings, and making art and furniture at the same time—could not have been a simple, small scale operation, but was intrinsically complex with team efforts and a big cash flow. Judd was eager and financially able to realize his expansive and expensive vision; he was the sole contributor to the Chinati Foundation when he died in 1994.[27]

Robert Halpern, the publisher and editor of the local newspaper *Big Bend Sentinel*, recalled as to the operation of the Chinati Foundation when Judd was alive: "It was begrudgingly a public foundation … just enough to keep its nonprofit status, so to speak."[28] The complicated entities under the foundation's

25 Jean Baudrillard, "The System of Objects," in *Design After Modernism, Beyond the Object*, ed. John Thackara (New York: Thames and Hudson, 1988), 181.

26 Vinciarelli mentioned, as an example, the interior design of 18th-century aristocratic residences shown in the film *Barry Lyndon* (1975) directed by Stanley Kubrick in connection with Judd's use of spaces; Vinciarelli, interview.

27 Daphne Beal, "The Chinati Foundation: A Museum in Process," *Art in America* 88, no. 10 (October 2000): 119.

28 Robert Halpern, quoted in Beal, "The Chinati Foundation," 120.

direction were largely dependent on Judd's sole vision, leadership and funding. In this circumstance, it seems that the management of his personal property (residences and work places) and the public property (the large scale, permanent installations of the Chinati Foundation) were operated in a flexible business manner, responding to Judd's developing interests rather than a big, rigid corporate structure. After all, Judd did not make a strict line between his private and public spaces in his perspective on mingling art and life. The management of his personal properties and the Chinati Foundation were side by side and were inseparable from Judd's decentralized self-managing motive for shaping his own living environment, regardless of outside classifications of private or public spaces.

Towards the Makings of an Aesthetic Lifestyle

As his renovations of private spaces in Marfa expanded during the late 1980s and 1990s, Judd tried to theorize his idea of "a whole room" in aesthetic terms. He wrote in 1993 of, "the use of the whole room, which is now called an installation, which basically I began. Oldenburg's Store was a store but it could be called an installation. Bob Whitman's performances occurred in installations. Several years later Yayoi Kusama made a free-standing room and Lucas Samaras also." [29] Judd was, of course, not a pioneer of installation art because, in addition to Oldenburg and other peers, there were precursors from the prewar period such as El Lissitzky, Kurt Schwitters and Marcel Duchamp who explored a spatial presentation of art.[30] Minimalism as a movement, however, emerged at the same time when the notion of installation art began to form in the 1960s.[31]

Judd gradually developed the idea of the "whole room" through his experiments with installing his art pieces in relation to the given spaces or deciding the measurements of his works according to the size of a given site during the 1960s and the 1970s. The wall pieces, including the so-called "stacks," were extensions

29 Judd, "Some Aspects of Color," 84.
30 Claire Bishop explains that "installation art" is rather a fluid term and "loosely refers to the type of art into which the viewer physically enters, and which is often described as 'theatrical,' 'immersive' or 'experiential'"; Claire Bishop, *Installation Art, A Critical History* (London: Tate Publishing, 2005), 6.
31 There is a difference between an installation of art and installation art, but the line between the two has been ambiguous because artwork in situ was virtually presented and conceived as a singular entity by an "installation shot" in art publications during the 1960s. Ibid.

of his earlier experiments with floor pieces: "After I made the first works placed on the floor, knowing the new relationship to a surface, through at least 1963 I didn't think anything could be made which could be placed on the wall. Then I realized that the relationship to the wall could be the same as that to the floor." [32] He continued:

> My work on the floor was a new form, creating space amply and strongly. The relationship could be the same to the wall. It was necessary for the work to project sufficiently, at least as much as its height and width. I never made this minimum, which could be a cube. ... The necessary difference was that the work not be flattened, low or high, to the wall, whether it be small or large.[33]

For Judd, the size of art objects was very crucial so that their presence would not be so small as to go unnoticed or so big as to overwhelm viewers. The balanced relationship between objects and space was a key to his idea of "whole room." Judd also tried to achieve a spatial wholeness by unifying color and form: "Color and space occur together," as the materiality of the color plane defines space without any representational pictorial effect.[34] Being trained as a painter, Judd developed his thoughts about spaces in part via his response to the expansive color field paintings of some abstract expressionists. An empty square space with four walls seemed to be in Judd's mind when he wrote, "Perhaps Pollock, Newman, Rothko, and Still were the last painters. I like Agnes Martin's paintings. Someday, not soon, there will be another kind of painting, far from the easel, far beyond the easel, since our environment indoors is four walls, usually flat. Color to continue had to occur in space." [35] While seeking an integrated wholeness in his spatial artwork, Judd tried to distance his art and installations from the conventional Western dichotomy of art and non-art. Judd emphasized the immediacy of experience in his talk on "art and architecture" in 1983: "Everything happens together and exists together and does not divide because of a meaningless dichotomy." [36] His aesthetic principle of "wholeness" in art was spatially applied to his symmetrically-

32 Judd, "Some Aspects of Color," 90.
33 Ibid., 91.
34 Ibid., 110.
35 Ibid., 112.
36 Judd, "Art and Architecture, 1983," in *Judd, Complete Writings 1975–1986*, 31.

orchestrated, permanent installations. (fig.39/fig.40) It should be stressed that there is no hierarchical relationship among any of the objects placed in the spaces of Judd's residences because his use of symmetry created an anti-hierarchical, anti-compositional layout.

Following a symmetrical order, Judd tried to simplify some pieces of furniture into geometric cubes in his living room. When he furnished his residences, he arranged furniture as whole physical and material volumes in the same way as he arranged his artworks. For instance, in the living room of the Spring Street building, Judd designed a table to have the same height as the top of Rietveld's Zig-Zag Chairs in order to make them look compatible. (fig.41) From a distance, the set of table and chairs appears to be an integrated, unified volume in the middle of a larger space. Perhaps it was more challenging for Judd to include artwork, furniture and other everyday objects together in his living and working spaces than to install multiple, almost identically designed art pieces in a gallery space, but there is no fundamental difference in Judd's approach to these seemingly different spaces.

Allegedly, Judd did not spend long hours supervising the installations of his art exhibitions; he often came in during the last couple of days before the opening of a show.[37] In contrast, Judd spent an immense amount of time furnishing his own private spaces:

> You know that I have a building in New York and spaces in Texas. I spent an enormous amount of time pushing the art around, for years, taking things out, whether it's all mine or mixed with others. Just one room would continue for years. And the selection concerns me a great deal. One floor in the building in New York has two pieces of mine, a piece of Chamberlain, a piece of Oldenburg and a big piece of Flavin. I think it all goes together, somehow, but it took many years. I had a painting by Bob Irwin where the Oldenburg now is that never worked there. It should be alone. So the work by Oldenburg, which is fine in itself, thus had the useful side of having solved the problem of working well with the other pieces.[38]

37 Ballantine also mentioned a trial-and-error process in Judd's interior decorations. For instance, the interior of an elevator at the Spring Street building was once painted red, but Judd decided it was too decorative and removed the paint; Ballantine, interview, 20 January 2006.

38 Judd, "Discussion with Donald Judd," 56.

It seems that once Judd felt his installations of furniture and artworks were completed, they were not meant to be moved. Judd's daughter, Rainer Judd, recalls how her father carefully placed furniture in the family's living spaces and told his children "Don't touch!" [39] Judd's son, Flavin, also stated, regarding his father's meticulous interior renovations, "When finished, some of the buildings were too good to stay in," and "The whole space became an installation." [40] Rainer Judd recalls her childhood memory of her home "reverence." She also saw in her father's personality "a spiritual person in denial." [41] This suggests that Judd's interiors were orchestrated as a total work of art with a certain spiritual sentiment underlying his firm belief in going his own way.

However, there is not an absolute, perfect, harmonious unity between art and life in Judd's interiors in a Platonic sense.[42] Compared with early modernist interior designs, such as Rietveld's Schröder House (1923–24) in Utrecht with its strict formal consistency throughout the interior and furniture design, there is no stylistic uniformity in Judd's interiors at his residences. (fig.42) The early modernist totality of design was shaped by an ideal vision concerning the new world to come, whereas Judd had a rigorous and practical approach to the real world, finding furniture pieces and design objects in different styles and from different periods and regions, chosen by his taste and placed in balance with pre-existing spaces; rather than creating items which fit within a unified totality, he basically recycled existing pieces. Each space renovated and furnished by Judd establishes its own order from various objects that are displayed as being equally important. When one enters Judd's living room, the space conveys a clear impression of what is present in various locations, here and there, in relation to where one stands, while there is also a sense that one is free to make choices in moving through the space

39 Rainer Judd discussed her memories about her father Donald Judd at the panel, "Thesis, Anthesis, Synthesis" moderated by Barbara Bloemink. Rainer Judd, "Symposium: Dialogues on the Relationship between Art and Design" held at Cooper Union in New York City in November 6, 2004.
40 Flavin Judd, quoted in Mauk, "Donald Judd's Marfa," 2004.
41 Rainer Judd, quoted in Catherine Croft, "Floor Show," *World of Interiors* 24 (February 2004): 86.
42 Judd stated, "One conspicuous misinterpretation [of Judd's artwork] for example is the idea of order: most writers in the United States have always said that it's platonic in some way and involved in some great scheme of order. If I know about that and talk to a person, that's certainly wrong"; Judd, "Discussion with Donald Judd," 54. This statement is linked to Judd's pragmatist perspective, a matter of factual effects evident in his art objects instead of a mystical viewpoint.

without being disrupted by conspicuous objects or a layout with a predetermined, dominant path.

Although Judd's career as a designer was not well established in the United States during his lifetime, as his permanent installations and residences gradually took shape, in the Spring Street building and at Marfa, his projects made their way into design, architecture, home decoration, and fashion magazines, such as *Domus, Architectural Record, House and Garden, Esquire, Architects' Journal, Progressive Architecture* and others, beginning in 1983. There are many articles featuring his large permanent installations, but there are fewer featuring Judd's interior designs. Judd's residences and design works were especially well represented by *Domus*, an Italian design magazine with bilingual publications in Italian and English. *Domus* emphasized the aesthetic quality of the interior spaces, paying special attention to the balance of formal elements and the sense of domesticity. (fig.43)

Judd's residence, the Block in Marfa, was also featured in a 1985 issue of the home decorating and furnishing magazine *House and Garden* with beautiful color photographs. (fig.44) The visual rhetoric of the article presented readers with the unique home furnishings created by the sophisticated and genuine taste of an artist. The article was accompanied by an essay by Judd, which begins with a travelogue of his research through the Southwest for a perfect site for his permanent installations, and it goes on to explain the renovation processes of his residences and permanently maintained contemporary art installations. Even though, toward the end of his essay on the Block, Judd declared, "It's against the idea of the suburban house on its lawn," his home renovations were gracefully presented by the editors in such a way as to appeal visually to the conservative tastes of middle and upper middle class readers.[43] A vanguard member of the do-it-yourself cohort of the 1960s thus ended up filling a mass-circulation home decoration magazine in the 1980s with colorful pictures, suggesting the ambivalence entailed in the do-it-yourself phenomenon from the outset. The would-be decentralized simple way of life was increasingly portrayed in the popular media as the aesthetic lifestyle of a unique individual.

43 Judd, "Marfa, Texas," 22–23.

Living with Judd's Design = Living like Judd

When he had a show entitled "Donald Judd, Architecture" at MAK, the museum of applied arts and contemporary art in Vienna in 1991, Judd submitted two essays to the exhibition catalogue: "Nie wieder Krieg" (Never Again War) and "Art and Architecture." Brigitte Huck, the curator of this show, and Rudi Fuchs, Judd's long-time friend and a former Director of the Stedelijk Museum, contributed essays which mainly focused on Judd's architectural projects; i.e., the permanent installations that were unfolding in Marfa. Both writers agreed that Judd was an architect in his own right, regardless of his lack of traditional architectural training. In fact, Judd worked on many of the renovations of existing buildings. He also designed simple, geometrical architectural constructions at his residence La Mansana de Chinati (The Block) and huge ranches collectively called Ayala de Chinati. Judd designed simple, geometric structures such as a chicken coop and a pool at the Block; a bath and storage compound near Casa Pérez at one of his ranches between 1983 and 1987; the Bunkhouse at Las Casas, Ayala de Chinati; and Concrete Buildings (unfinished) for displays of art at the Chinati Foundation in Marfa in 1987.[44] The writers of the catalogue essays did not discuss Judd's architectural projects in relation to other architects' works or put Judd into a broader architectural, historical context.[45] Rather, they stressed that Judd's particularly American, individualistic, artistic spirit of freedom as manifest in his

[44] See Flückiger's chronology of Judd's architectural work; Flückiger, *Donald Judd, Architecture* 146–48.

[45] Meanwhile, Judd himself was alert to the latest trends in architecture. He was critical of the postmodern tendency toward a decorative use of historical styles, as seen in Philip Johnson's AT & T Building (1984) in Manhattan. Judd also saw the postmodern sculpturalizing of architecture as disastrous. While admiring Mies and Louis Kahn, Judd argued against the idea of modernism as an official style of cultural institutions: "I avoid the Museum of Modern Art in New York, an originating source of power as style"; Judd, "Two Cultures," 119–22. Judd emphasized that architecture should be functional in the first place; he admitted architecture's potential as an art form by responding to a question as to whether architecture is art, "Yeah, but utility to me is really important. It's really serious. It's a nice thing, and utility does not bring it down at all. In fact, it might elevate it a little bit." Moreover, Judd criticized Peter Eisenman, "He [Eisenman] wants to be an artist. He talks like that. It's silly and as an artist … He's an old fashioned derivative artist. I mean, he's a bad artist"; Judd, "Book, Beliefs, Life and Architecture: Donald Judd interviewed by Kerry Freeman," *Detour Magazine* (October 1990): 26–29.

establishing of permanent architectural environments and in the philosophical links to his own art. Huck summed up her essay with a quotation from Franz Meyer: "Donald Judd's architecture, like his sculpture, is an instrument for communicating his very personal attitude as an artist. It is based on philosophical empiricism as well as on the 'Puritanism that determines American spirituality.'" [46]

Interestingly, Peter Noever, the Director of MAK, recalled over a decade later that during Judd's visit to Vienna he mostly talked to the international and local press about the then current war between the United States and Iraq rather than about his own architectural projects or the furniture shown at the exhibition.[47] This reinforces the idea that his design and architectural projects were rooted in his attitude towards moral conduct in socio-political environments, and towards a particular way of life.

As with his art work, Judd's furniture designs follow his empirical formal concerns, which demand an adjustment on the part of the viewer and user. In Judd's residences many things that are common in an ordinary household are missing, such as wardrobes, shower curtains, and window curtains. Rob Weiner at the Chinati Foundation also remembers that Judd removed all the handles from old cupboards in favor of simplifying them and eliminating detailed elements.[48] Unlike commercial interior designers, Judd did not design a complete set of fashionable interior ensembles, from furniture, to fabrics, to light fixtures. He thought some standard items were actually unnecessary to his everyday conduct. For instance, he did not design light fixtures because either he was satisfied with what was available on the market, or he found that designing the necessary mechanisms was too complicated for his skills.[49]

Owners of Judd's furniture sometimes have to adjust how they use his particularly designed objects. For example, Marianne Stockebrand, Emeritus Director of the Chinati Foundation, who uses one of Judd's plywood tables, noted that his furniture, like his art pieces, should be placed away from the wall in order to allow access from all sides.[50] There are pine shelves installed against the walls in

46 Brigitte Huck, "Donald Judd: Architecture," in *Donald Judd: Architecture*, ed. Peter Noever and others (1991); rev. 2d ed., (Ostfildern: Hatje Cantz, 2003), 38.
47 Peter Noever, "Art and War" in *Judd: Architecture*, 8–9.
48 Weiner, interview, 15 December 2005.
49 Stockebrand, interview, 6 June 2006.
50 Stockebrand, interview, 6 June 2006.

128 FUNCTIONAL ART IN A DYSFUNCTIONAL SOCIETY: DONALD JUDD'S FURNITURE

his residences and libraries, but much of Judd's other furniture for sale, such as a sheet metal or wood bookshelf and his desks need enough space for one to move around them. (fig.45) The staff members at the Chinati Foundation have been using tables and desks designed by Judd, and curiously, they have developed the same habits and working style as Judd in using his desks and tables: papers, books and other materials are spread out over the surface of large desks and tables. Both David Tompkins, former Development Associate at the Foundation, and Stockebrand told me that they love Judd's desks and tables, which provide a wide space to spread out several on-going projects, while allowing all the items to be instantly perceived from any spot.[51] (fig.46/fig.47) As requested by Stockebrand, Judd designed shelves for a plywood desk.[52] (fig.48) In order to reach the files placed in front, one has to stand up and walk around the desk.

Fig.45 Donald Judd, Bookshelf #34, Image Courtesy JuddFoundation/Judd Furniture

Although Judd felt that his chairs were comfortable enough, I found that none of the staff at the Chinati Foundation were using Judd's chairs when I visited in 2005 and 2006. One of the staff members told me with a bitter smile that it is too painful to sit on any of Judd's chairs for an entire day. Most of them prefer to use a more standard office chair. I personally tried one of Judd's cubic library chairs at the library of the Chinati Foundation. (fig.49) On the first day, I felt uncomfortable because I was sitting lightly, intimidated by its rigid appearance and afraid of how it would actually feel. On the second day, I gradually learned how my body could actually fit into it: I found where and how I could rest my foot and back comfortably. Once I learned a more perfect posture, with my back straight and my foot resting on the edge of the chair, I could spend a whole

51 David Tompkins, interview by the author, Marfa, Tex., 6 June 2006.
52 Stockebrand, interview, 5 December 2005

fig.46 David Tompkins in his office at the Chinati Foundation, a large table designed by Donald Judd, photograph by author, 2006.

fig.47 Robert Helpern in his local newspaper office building *Big Bend Sentinel*, Marfa, a bench designed by Donald Judd, photograph by author, 2006.

afternoon sitting on the chair and feel good about it. His chair insists that one be seated upright; it makes it difficult to take a languid posture. Rather, it suggests a more disciplined way of sitting at attention and in this way Judd's design definitely reflects his philosophical approach to everyday conduct. On the third day, however, I found that—since I am about 5 feet tall—the chair's height was simply a little high for my legs. I began to feel uncomfortable because the back of my knees kept pressing on the edges of the wood seat. I must say it was not a perfect chair for me, but neither are most of the standard sized chairs on the market. In fact, I was rather thrilled to go through the somewhat playful, physical experiment of adjusting myself to Judd's chair and hence to his concept of a chair.

Yet the concept always effects the use as well. For instance, Judd's largest tables are too wide to facilitate conversation. When there was a free breakfast served at the large tables in the Arena during the annual Open House in Marfa in 2005, one girl said to her friend seated on the other side of the table, "Oh, you are so far away. I have to yell at you." The size of the large tables was determined simply by assembling pine planks with a standardized width. Reducing the number of planks, Judd could have made a narrower table, but

fig.48 Judd Furniture Desk #74, Architecture Office, Marfa, TX, Image Courtesy JuddFurniture.com/Judd Foundation

fig.49 Donald Judd, library chairs at Chinati Foundation, photograph by author, 2005

it would appear small in such a huge interior space without making a good balance. The big tables work best in such a large banquet hall to host a large number of guests. They also serve a visual function as central pieces that can effectively gather guests in the Arena. In addition, the open shelves in the kitchens of Judd's residences let plates, glasses and utensils get dusty quickly, but Judd refused to cover the shelves with sliding glass panels or other doors, wanting all items to be visible and in reach without any intermediary steps. The idea of a thing being presented as a whole with prompt accessibility thus took priority over the common economics of efficiency and the reduction of the household chores of cleaning, emphasizing the primacy and immediacy of everyday experiences rather than other considerations.

A Life Attached to the Land: Social Ecology

The renovations of each of Judd's buildings embody his preoccupation with acting in the here-and-now, through everyday tasks. Basically, except for his ranches, each building or space owned by Judd in Marfa was used for a specific purpose in his various projects.[53] Judd traveled from one building to another in order to work on different projects, conducting printings at the Print Building, ranch business at the Ranch Building, and design work at the Architecture Studio. In other words, Judd's working sites were spread out all over the small city. As he worked around the city, Judd's preoccupation with spatial wholeness extended in scope from individual art pieces to architectural spaces and even to the landscape of Marfa in conjunction with the immediacy of his lifestyle. In a way, Judd was

53 Flavin Judd wrote, "After buying La Mansana (the Block) Don bought a bank, an old hotel and thirteen other structures each having a clearly defined purpose; ranch office, writing house, print building, studio, architecture studio. If a building didn't have a purpose, a purpose for him, he tried to give it one before he did anything to it. The only buildings that didn't need a defined purpose were the ranch houses. They were self-explanatory, that was where one sat, worked, read and lived"; Flavin Judd, "Marfa, Texas: An Introduction," *Chinati Foundation* 2 (November 1996): 19.

moving forward with his own individualist tenets of the anarchist mission during the 1980s and 1990s. Flavin Judd recalls his father's way of life as facing toward the wide open land in Marfa: "For my dad, it was about living in that open space and how you react to where you're living," and "The land was on par with art for him. He had a passion for it and the preservation of it. The whole reason for being in Marfa was those ranches. The Block is a big space, but open space is as big as it gets." [54]

Judd lamented the increasing separation between art and architecture in postwar society, and the fact that artists were usually excluded from architectural projects until the last moment, when a given building or public space was about to be completed.[55] Furthermore, Judd was an environmentalist with a tremendous attachment to the West Texas land, and he bought a large ranch in order to preserve it and to prevent it from unwanted, random development which would destroy its natural state.[56] It is interesting to examine how the anarchist spirit of the 1960s, which emphasized a simple way of life, eventually influenced the environmental concerns of the 1980s. In her dissertation on Judd's permanent installations and architectural projects in Marfa, Allen considers Judd as a "social ecologist" in his efforts to maintain the natural state of the land. She draws this term from Murray Bookchin (1921–2006),[57] a trade-union activist, theorist and libertarian socialist.[58]

54 Flavin Judd, quoted in Mauk, "Donald Judd's Marfa," 127.
55 Donald Judd, "Art and Architecture, 1984," in *Donald Judd, Architektur*, 189.
56 Marianne Stockebrand, "Introduction," in *Art in Landscape*, ed. Carl Andre and others (Marfa, Tex.: Chinati Foundation, 2000), 9. Raskin also discussed Judd's commitment to protect the natural environment of his ranch and his involvement in environmentalist activities in Texas. For instance, Raskin reported that Judd was a member of the Texas chapter of the Environmental Defense Fund (EDF), and he donated his artwork in 1990 to the EDF to assist their funding. Raskin, "Judd's Skepticism,"143–44. See also Raskin, *Donald Judd*, 108–110.
57 Allen, "Judd and Marfa Objective," 116–17. I discovered Allen's discussion on Bookchin after my own research into how the anarchist movement of the 1960s and '70s shifted in the 1980s. Allen and I draw upon different sources by Bookchin; she cited Bookchin's "The Crisis in the Ecology Movement," *Left Green Perspectives* (May 1988), whereas I use his "What is Social Ecology?" in my own, rather different argument, below. Murray Bookchin, "What is Social Ecology ?" in *The Modern Crisis*, rev. 2d ed. (New York: Black Rose Books, 1987).
58 Bookchin was first an anarchist thinker within a tradition of anarcho-communism; he proposed the concept of "social ecology" by integrating anarchism with sociology in the 1960s through the 1980s. Eventually he moved from anarchism to libertarian socialism. Keith Jordan, email correspondence with author, 18 April 2007. I thank Keith Jordan, assistant professor at ↗

In 1984, Bookchin wrote "What is Social Ecology ?" in which he warned about an impending crisis of society, land and natural resources due to egotism, limitless capital growth, and exploitation. He located the source of this crisis in western dualisms:

> Indeed, as we shall see, social ecology places the human mind, like humanity itself, within a natural context and explores it in terms of its own natural history, so that the sharp cleavages between thought and nature, subject and object, mind and body, and the social and natural are overcome, and the traditional dualisms of western culture are transcended by an evolutionary interpretation of consciousness with its rich wealth of gradations over the course of natural history.[59]

Bookchin's idea of "social ecology" proposed a way of life in which society would be unified in its diversity, just like an ecosystem in nature. He rejected any association of this unity with social hierarchy or the mysticism of "natural evolution." [60] He espoused the organic wholeness of a new model of selfhood and human-scaled communities:

> We can also foster a new sensibility toward otherness that, *in a nonhierarchical society*, is based on complementarity rather than rivalry, and new communities that, scaled to human dimensions, are tailored to the ecosystem in which they are located and open a new, decentralized, self-managed public realm for new forms of selfhood as well as directly democratic forms of social management.[61]

In the 1980s Bookchin proposed a vision of a decentralized community blended with the natural order of a given ecosystem. Likewise, Judd was concerned about environmental issues while he was against the "strip city" because its highways cut the organic unity between the old and new parts of the city:

↘ the Department of Art and Design, California State University, Fresno for sharing his extensive knowledge about anarchism as a movement and philosophy.
59 Bookchin, "What is Social Ecology ?" 55.
60 Ibid., 74.
61 Ibid., 75–76.

fig.50 Ayala de Chinati, view of Casa Pérez and three constructions by Donald Judd, photograph by author, 2005.

The Americans invented the strip city after World War II thus destroying the *civitas* and the whole visible history of American towns. This is unique to this country and is one of the great changes and tragedies of the century. Robert Venturi assumed that the people liked the strip city and its silly symbols; he certified it as natural and took orders for more. The strip city is a development ... It's not a desire of the populace. At the same time, there began the arbitrary rejuvenation of the old downtowns, a desire of businessmen. Both developments are wasteful and destructive. They are one of the main economic efforts of the U.S. since the war.[62]

62 Judd, "A Long Discussion Part I," 179. Judd also disliked billboards or mass-products as a means of communication: "The fins, the statue on the radiator, the chrome and the color of the fat automobiles are signs of status to be read; the doorways of the strip city are the same; now the skyscrapers are given adventitious status by the signs of history. Everything is to be read; nothing is to be appreciated"; Judd, "Art and Architecture, 1984," 186–89. Here, Judd was arguing against an idea prompted by a book: Robert Venturi, Denise Scott Brown, and Steven Izenour, *Learning from Las Vegas: the forgotten symbolism of architectural form* (Cambridge: MIT Press, 1977).

Judd made no attempt to create something iconic or symbolic in his outdoor projects in Marfa. As with his indoor installations, there is no single focal point in Judd's outdoor installations of art pieces and design works. There is an underlying concept of equilibrium applied to architectural constructions and art pieces arranged in a landscape setting. For instance, Judd designed outdoor storage buildings and bathrooms, as well as tables and benches for Casa Pérez, Ayala de Chinati, one of his ranches. (fig.50) These outdoor structures, made of yellow pine, are carefully placed in relation to the surrounding natural environment, which creates a sense of organic unity with the land. Judd wrote in 1989 about the process of designing structures in relation to the land:

> The house [Casa Pérez] needed more shade, but putting a large porch around it would only increase its conventional aspects. Also, unlike the other house, it faced west into the afternoon sun, and it had no relation to the bluff and hills around it. Finally I thought that the best thing to do would be to leave the house alone and build new and separate structures for shade, bathing and storage perpendicular to the bluff and to the nearest and highest hill across the arroyo, which I named Collina Sapienza because its strata make a spiral.[63]

In a comparable way, outdoor concrete sculptures at the Chinati Foundation are lined up in a subtle balance with the three axes of a nearby highway 67, cottonwood trees, and a complex of buildings at the Chinati Foundation; they therefore create a minimum of visual disturbance to the natural landscape. As with the design elements at Casa Pérez, Ayala de Chinati, these outdoor installations do not provide any dramatic, culminating, central viewpoint, but rather evoke a feeling of organic interplay between viewers, objects and the landscape. The viewer who interacts with these objects becomes the center of a whole experience located in a particular environment. The viewer has to be an active subject in this experience.

Judd's austere, mute objects hardly manifest a populist appeal, but his notion of a wholistic art was conceived to encompass the local environment and its people. During the 1980s and 1990s, Judd seemed to struggle to reinforce his rigorous, individualist, decentralized tenet of controlling the quality of living

63 Donald Judd, "Ayala de Chinati," in *Donald Judd, Architektur*, 61.

conditions within a local community. His minimalist works were too eccentric to be completely accepted by local residents, but he was a generous employer in the town. Even though many residents were skeptical about his works, they were aware that Judd made Marfa famous and that he hired many of its residents as he rescued the town's virtually abandoned historic buildings.[64] Nonetheless, his "demanding personality" sometimes came in conflict with the easy-going mentality of the rural community.[65] For instance, Judd abruptly called off his annual open house in 1993 because of his outrage over the noise of trucks caused by neighboring industry. Disturbed by the noise and fumes from the trucks parked on the west side of the street by his residence, in January 1989, Judd requested that the Marfa Zoning Board members allow non-commercial vehicles to park along the west side of the street in order to prevent the area from being occupied by noisy trucks. The Board denied Judd's request because the area is an industrial zone and business operations could not be hindered by a private motive.[66]

While some residents and friends of Judd were likely sympathetic to the angry artist, who just wanted a quiet environment, others thought he was a bit arrogant and irrational since he chose to live in such a noisy, inhospitable, industrial neighborhood in the first place. Yet the noise dispute indicates that Judd made particular choices in his way of life in terms of his preference for where to live and how to design his places, while seeking to maintain maximum control over his living environment, regardless of whether it seemed to fall in the private or public realm.

Judd made related choices in both his life and his creative processes. As the notion of fine art has developed in the modern age, the artist's creative process has generally been regarded as a human act superior to everyday tasks as well as to the crafting of decorative art. The intensity of thought and the time Judd invested in making subtle choices in producing his artwork is not comparable to the more casual choices he made in other daily activities, such as choosing what to eat or drink at each particular meal. However, Judd's choices in both the private and public realm were based on the same fundamental principles, such as his anti-

64 Suzanne Gamboa, "Contemporary artist touched the lives of Marfa's residents," *Austin American-Statesman*, 15 February 1994, B2.
65 Ibid.
66 "Judd seeks parking remedies," *Big Bend Sentinel*, 19 January 1989; "Judd denied parking stripes," *Big Bend Sentinel*, January 1989.

dualism, interest in the unified wholeness of space, his anti-hierarchical stance towards authority, and his reliance on principles of symmetry. These fundamental principles informed how Judd shaped his living environments as his creative attention expanded from making furniture for his residences to designing the landscape around them.

For Judd, the processes of making permanent installations at Marfa were inseparable from his experiences of renovating his own residences and workplaces. In other words, the permanent installations were generated in part through his analyses of the natural and practical rhythms found in his everyday living environments. As such, the renovated spaces of his homes with art and functional objects do not entail a superficial beautification or embellishment. His extensive collections may prompt the criticism that he fetishized functional objects, but such a claim would oversimplify the artist's perspectives and way of life, both of which were inseparable from the processes of making art and furniture alike in society. The careful choices he made in his creative process were integral to the way he considered his way of life as it unfolded in the specific space and time where he positioned or found himself. Hence, the designs and uses for Judd's furniture profoundly reflect a keen experience of reality focused on the immediate actions of everyday life.

CHAPTER 5

ART INTO LIFE: DONALD JUDD AND SCOTT BURTON

Theater and Minimalism

As functional objects, Judd's furniture is difficult to categorize and not nearly as well known as his art pieces. His furniture is not easily placed in either design or art discourse. It had not been collected by major art and design museums in New York City such as The Museum of Modern Art, the Cooper-Hewitt National Design Museum, the Metropolitan Museum of Art, or the Solomon R. Guggenheim Museum as confirmed in 2014. The primarily hand-crafted production scheme of his furniture does not fit perfectly with the simplified process of the modern furniture industry or with contemporary design discourse in their emphasis on innovation in technology and use of material. Yet the development of Judd's furniture production paralleled post-Minimalist trends in which a number of artists explored the relationship between art and furniture during the 1970s and 1980s.

This chapter will pay attention to Judd's and other Minimal artists' association with theater and their familiarity with the use of theater-objects in order to illuminate the later development of usable artworks and architectural installations which were created by a succeeding generations of artists, such as Scott Burton, R.M. Fischer, Siah Armajani, Vito Acconci, and Robert Wilson. This chapter will pay particularly close attention to works by Scott Burton (1939–1989), who has been seen as one of the leading artists investigating the assumptions underlying the distinction between design and art in both his work and writing. Burton moved to New York City in the late 1950s. Like Judd, Burton partly supported himself as an art critic in his early career during the1960s, and he was a regular contributor to *Art News*, *Art in America*, and *Art Scene*. Although Burton's artistic career was very short, he had a critical impact on the New York art world during the 1980s.

His functional art objects were highly visible not only at major art museums and galleries in the city, but also through his involvement in public art projects that stimulated new agendas about the relationship between artwork and audiences in the following generation of the 1990s. I will examine Judd's and Burton's different approaches toward the concept of furniture and early modernist furniture design in conjunction with the discourse on design and art during the 1980s and 1990s.

The discourse about the relationship between design and art was not very extensive in the United States during the 1980s and '90s, nor is it very advanced even now. However, it seems that the discourse has gradually shifted away from its emphasis on the meaning of the real in art during the 1970s and the 1980s; in later decades, a new generation of artists, including Andrea Zittel and Jorge Pardo, paid closer attention to the participation of audiences and continued to explore design-oriented works, which often entailed the involvement of users, including the artists themselves. Looking back and comparing design works by Judd and Burton, this chapter examines a complicated, fluid, and open-ended discourse on design and art which encompasses different agendas about the reality of everyday life, private and public arenas, and the evolving roles of artists and audiences in society.

The design aspect of Minimalism was criticized as early as the mid-1960s by formalist critics Clement Greenberg and Michael Fried, based on their premise about the specificity and autonomy of individual art media. Greenberg saw the Minimalists' geometric objects as being closer to design than to art objects, and hence considered them lesser.[1] Likewise, in his essay "Art and Objecthood" (1967) Fried characterized the artwork of Minimalism as being confrontational and examined it according to theatrical formulations. He argued that Judd and Morris had ambiguous attitudes toward sculpture, as was evident in the way they presented their pieces as objects, in effect seeking something outside of traditional sculpture.[2] Fried pointed out that Minimal artists adopted "objecthood" in their works.[3] For Fried, "objecthood" is a category that belongs to the genre of theater because it requires the presence of audiences. Inasmuch as Minimalism granted a significant role to beholders, Fried saw that the objects themselves turned out to

1 Greenberg, "Recentess of Sculpture," 180-86.
2 Michael Fried, "Art and Objecthood," *Artforum* 5, no.10 (June 1967); reprint in *Minimal Art, A Critical Anthology*, ed. Battcock, 117-19.
3 Ibid., 125.

be "less self-important"—their effects were not about the nature of art itself, by his account, but about the open-ended, theatrical experiences of audiences.[4] He thought that the high art of his time should overcome these elements of theater, because in his view: *"Art degenerates as it approaches the condition of theatre."* [5] Although Fried accurately analyzed the theatrical effect entailed in Minimalist art, he had a biased notion about theater being positioned below the high, modernist art of painting and sculpture. This dominant, formalist perspective in the heyday of Abstract Expressionism in the New York art scene led to the neglect of the achievement of artists who were engaged with theatrical projects, including Isamu Noguchi's creative input to theater between the 1930s and the 1960s. Noguchi wrote about how sculpture is enlivened by performers and by musical effects, and he hoped that sculpture in everyday life would be similarly lively:

> The theater of the dance in particular adds the movement of bodies, in relation to form and space, together with music. There is joy in seeing sculpture come to life on the stage in its own world of timeless time. Then the air becomes charged with meaning and emotion, and form plays its integral part in the re-enactment of a ritual. Theater is a ceremonial [sic]; the performance is a rite. Sculpture in daily life should or could be like this. In the meantime, the theater gives me its poetic, exalted equivalent.[6]

In 1984 Barbara Haskell curated an exhibition, *Blam! The Explosion of Pop, Minimalism, and Performance 1958–1964*, which illuminated vigorous creative activities that unfolded in the United States art scene at a fertile moment, free from conventional categorical divisions: performance, sculpture, painting, and installation. Pop, Minimalist or Performance artists, who are now associated with one movement or another, were so categorized more in hindsight and could not be easily pigeonholed at the time because, in reality, these movements were all cross-pollinating and the artists were influenced by one another's works throughout the late 1950s and 1960s.

In a more social and political perspective on these events, Anna Chave

4 Ibid., 127–28.
5 Ibid., 141.
6 Isamu Noguchi, *Isamu Noguchi, Sculptor's World* (New York: Harper & Row, Publishers, 1968), 123.

observes that the leading Minimalists' debt to performance has been overlooked in the scholarship on Minimalism. The male, elite, New York-based artists who dominated the movement were familiar with the field of contemporary performances at a personal level as well, Chave points out. Judd's first wife, Julie Finch, was a dancer, and the couple named their daughter Rainer, after the choreographer and filmmaker Yvonne Rainer, whom Finch admired. Robert Morris's first wife, Simone Forti, was a choreographer who pioneered the use of props, which looked like Minimalist sculptures avant le lettre, in her performances. Having been inspired by his then wife's prop-based choreography while the couple shared a studio in 1961, Morris would use a prop in a performance of his own in 1962.[7] As Chave pointed out, the prop Morris used—an elongated wooden box—was subsequently transformed into an autonomous piece of sculpture. The first Minimalist object was, in fact, initially designed by Forti for her choreography of "dance construction" and "Platforms," which were first performed at Yoko Ono's Chamber Street loft in 1961.[8] The significant role of a female choreographer in creating some of the first Minimalist objects has been neglected because Minimalism as a movement has been viewed from a predominantly masculinist perspective, so Chave argues. Chave states, "Such divisions [between performance and sculpture] traduce the category-shaking radicality of Forti's and Morris's early efforts, however, and unjustifiably narrow the parameters of Minimalism as a movement." [9] There were indeed notable similarities between the formal configurations of Minimalist works and the new dance practices explored by Rainer and Forti, who focused on ordinary movements and the repetition of non-dance, deskilled tasks.[10]

Rainer herself examined the role of audiences in terms of the degree of their participation by comparing Andy Warhol's film *Chelsea Girls* and Morris's objects. She analyzed the unique oddity of Warhol's hands-off treatment of his subjects using a dual screen method, juxtaposing two scenes, whereas she saw a concrete presence yet limited participatory motive offered by Morris's sculpture:

You feel you can sit back and observe *Chelsea Girls* with a certain amount of

7 Anna Chave, "Minimalism and Biography," *Art Bulletin* 82, no. 1 (March 2000): 155.
8 Ibid.
9 Ibid., 156.
10 Ibid., 157.

detachment, certain that you need bring nothing more to the experience than your ability to observe it. Perhaps this detachment is more characteristic of most movie or theater experiences than it is of the static object experience, contrary as that may appear. *Chelsea Girls* does not demand participation, whereas a Morris sculpture does. Or so it would seem at this point in art history.

In the later case one is drawn into a situation of 'complicity' with the object, to borrow a term from Robbe-Grillet. Its flatness and grayness are transposed anthropomorphically into inertness and retreat. Its simplicity becomes 'noncommunicative,' or 'noncommittal.' Its self-containment becomes 'silence.' Its singularity becomes [']boredom.' These are all conditions imposed onto the work through our reluctance or inability to enjoy it at face value.[11]

Rainer continues, "In front of a Morris I have a reverie; I wait for the object to 'look back' at me, then hold it responsible when it doesn't."[12] The muteness of Morris's object to the beholder is in fact a different kind of presence from the way in which she uses a prop in theater: "Have I (along with other people working in theater today) created 'theater-objects' that don't 'look back' at the audience (therefore making 'excessive' demands on them), and, if so, how is that possible where human performance is involved?"[13] Thus, from a professional performer's viewpoint, Morris's objects are not truly about theater because they dismiss involvement with audiences, while involvement is a fundamental component of theater.

This poor performativity of Minimalist objects in a theatrical sense comes into the foreground as we investigate the influences of Minimalism on the following generation of artists who dealt with the design aspects of art. Some writings on this topic touch upon the effect of theater, the role of audiences, the meaning of the real and the deception of art objects located in a certain spatial context.

Scott Burton came to furniture-sculpture hybrid objects through his early experiments in theater and performance. He participated in the New York Street Works group between the late 1960s and early 1970s. This group was founded

11 Yvonne Rainer, "Don't Give the Game Away," *Arts Magazine* 41, no. 6 (April 1967): 47.
12 Ibid.
13 Ibid.

142 FUNCTIONAL ART IN A DYSFUNCTIONAL SOCIETY: DONALD JUDD'S FURNITURE

by the poet John Perreault to reinvent traditional theater and reconsider ideas about performing and physical components on stage.[14] In 1969 Burton presented himself in various problematic ways in public spaces: he walked the streets in the guise of a woman evidently without being noticed (*Self-Work I*); slept on a stretcher-like bunk at the corner of the room throughout the opening of an exhibition (*Street Work IV [Self-Work III] A*); and strolled naked down a street in New York City at midnight (*Street Work IV [Self-Work III] B*). There is a question about the presence or non-presence of the real self being tested in the public arena through his gender bending, his lack of presence due to his public sleeping, and the vulnerable situation of his naked self on the street.

Burton's first use of pieces of furniture in his temporary installations was in 1970.[15] These pieces created a unique stage set in the heavily wooded and overgrown landscape in Johnson County, Iowa; Burton arranged the pieces of furniture as if they were part of an ordinary floor plan of a house. Burton was fascinated not only by the eloquent presence of each piece of furniture itself in such a contingent natural setting, but also its invitation to beholders, as if it were waiting for something to happen. Burton wrote about the installation, "The setting, a unification of natural and artificial environments, of the outside and the interior, provokes 'the action' of the piece—the behavior of the viewer as he moves through the space, from 'room' to 'room.'"[16]

Burton conducted a similar installation in SoHo in 1972; he placed an English, nineteenth-century Queen Anne style chair, left at his apartment by a previous tenant, outside on the street, and observed how pedestrians interacted with the chair. The chair was cast in bronze in 1975. Burton also used furniture as if an actor on stage in *Chair Drama* (1971): "A mini-melodrama. With a 'cast' of 10

14 This group consisted of poets and artists: Vito Hannibal Acconci, Hannah Weiner, Bernadette Mayer, Eduardo Costa, Anne Waldman and Marjorie Strider. See Ana María Torres, "Scott. Chairs. Eloquently," in *Scott Burton* (Valencia: IVAM Institut Valencià d'Art Modern, 2004), 14.

15 Burton was not the first to use furniture in installations while expecting beholders to interact with it. George Brecht used a chair for his performance scores in the early 1960s. In his score "chair," Brecht placed a chair in the gallery and let it be used and moved by gallery attendants. See Barbara Haskell, *Blam! The Explosion of Pop, Minimalism, and Performance 1958–1964* (New York: Whitney Museum of American Art, 1984), 51–53.

16 Scott Burton, "Furniture Landscape (sofa, tables, chairs, pictures, etc.), 1970," The Museum of Modern Art Archives, New York, New York. Scott Burton. Box 19; quoted in Torres, *Scott Burton*, 62.

identical chairs, a 'play' in motionless scenes (changed out of view of audience) is presented: included are battle scenes, love scenes, monologues, trial[s], and others conveyed solely through the placement of the chairs in relation to each other." [17]

Burton penetrated the anthropomorphic, performative potential of furniture as theater-objects through his experiments in using pieces of furniture in his stage performances and temporary installations. Burton's series of performances in the 1970s was titled "Behavior Tableaux" and consisted of non-verbal, robotic human behaviors which were staged as if picturing lively tableaux evoking psychological dramas hidden in the social interaction of performers. Michael Auping saw Burton's *Behavior Tableaux* as a "pictorialization of performances" and found it difficult to categorize in any specific genre.[18] This was indeed confirmed by the artist in a puzzling way, "Performance is in medium a form of theater but in category a form of sculpture." [19] Through this bridging of theater, painting, and sculpture, Burton's usable sculptures were generated.

Comparing Furniture by Judd and Burton

Simultaneously with his theater productions, Burton began to design his own furniture as art pieces in 1973. It was a logical process for Burton to wonder where to place his furniture as he fabricated it, and then he encountered public art projects.[20] Burton discussed the conceptual dimensions of public art by using the term "social function":

17 This is one of eighteen pieces performed in 1971 at the Art Society of Finch College, New York, and each piece is about three minutes long. Scott Burton, "Eighteen Pieces" (1971), The Museum of Modern Art Archives, New York, New York. Scott Burton. Box 17; quoted in Torres, *Scott Burton*, 78.
18 Michael Auping, *Scott Burton* (Berkeley, Calif.: University Art Museum, 1980), np.
19 Scott Burton, "Lecture on Self" (1973), in Torres, *Scott Burton*, 60.
20 Public art grew in the mid-1970s, stimulated by governmental funding and artists' searching for alternative venues to show their artwork outside of museum and gallery spaces. For instance, the National Endowment for the Arts (NEA), an independent agency of the United States government, was established in 1965 to give grants for cultural activities in fields such as literature, music, theatre, film, dance, fine arts, and crafts projects. Its first grant to a public art project was in 1967. At a local level, the Public Art Fund was founded in 1977 in New York City. As a leading municipal organization, it has commissioned artists' projects which are installed in public spaces outside of museums and galleries in the city. See Miwon Kwon's critical insights on the development of public art in *One Place after Another: Site-Specific Art and Locational Identity* (Cambridge: MIT Press, 2002).

"What is public art?" It is in my definition art that is not only made for a public space but also has some kind of social function. In fact, what architecture or design and public art have in common is their social function or content. Public art has descended from, but must not be confused with, large-scale outdoor sculpture, site-specific sculpture and architectural or environmental sculpture. Architectural sculpture is still sculpture. Public art is not sculpture. In it one is dealing with a total situation—a situation with a shared psychology, where there's a whole set of needs. Probably the culminating form of public art will be some kind of social planning, just as earthworks are leading us to a new notion of art as landscape architecture.[21]

Burton was invited by the New York State Council on the Arts' Visual Arts Special Panel, along with two other artists, to propose a public project in Smithtown, Long Island in 1976. He proposed an outdoor living room with bronze chairs in different styles from American history. Although Burton's plan didn't win the competition, it was a turning point for him to engage with public art projects. He was thrilled to see how his pieces could engage a wider audience outside the art world: "I think that for me, one great motivation is new audiences. I think the non-art audience is the important audience for us." [22] Unlike Judd's insistence on the separation between his art and furniture, Burton took the ambiguous position of defining his furniture as usable art: i.e., a hybrid furniture/sculpture object. He was, however, aware that his was not an anti-art, Dada gesture because his works were shown and collected by galleries and museums.[23] Burton also spent

21 Scott Burton, "The Meaning of Place in Art and Architecture," *Design Quarterly* 122 (1983), in Torres, *Scott Burton*, 236.

22 Scott Burton, interview by Jeffrey Cruikshank and Robert Campbell, "Interview: Scott Burton," in Cruikshank and Campbell, *Artists and Architects Collaborate: Designing the Wiesner Building* (Cambridge: MIT Press, 1985), 62.

23 Ibid., 61. By contrast with the absence of Judd's furniture in the collections of major art museums, Burton's *Spattered Table* (1977) entered the collection of the Guggenheim Museum in 1978 as part of an Exxon Corporation Purchase Award, and MoMA owns several pieces purchased mostly by the Scott Burton Fund. The Scott Burton Fund was established as Burton left his estate to the MoMA "to be used as the Museum saw fit, with the stipulation that the proceeds be used for exhibition funding, publications and acquisitions that explore and further the appreciation of the close relationship between the fine and applied arts, in keeping with the spirit of Burton's work"; Mattias Herold, Manager, The Painting and Sculpture Study Center, Department of Painting and Sculpture, MoMA, NY, email correspondence with author, 18 April 2008.

a great amount of time choosing and examining materials, proportions, and craftsmanship.

Many of Burton's works appear to be ordinary pieces of furniture at first glance, but there is generally something about them notably different from common furniture in terms of their materials, shapes, and proportions. He appropriated and exaggerated certain elements or features of common furniture with a sense of humor. Take for example, how Burton transformed an Adirondack chair, almost an icon of outdoor summer vacations, into *Lawn Chairs (A pair)* (1979) veneered with Formica and exaggerated in their proportions by two wing-like legs which extend from their backs.[24] Both Judd and Burton admired modernist furniture designers, including Rietveld. A comparison of furniture designs by Judd and Burton reveals their different approaches toward modernist furniture, however.

Judd collected many of Rietveld's pieces and installed them along with his own furniture at his Architecture Studio (The Bank), a former bank building in Marfa that Judd purchased in 1988 and renovated as his workplace for design projects. Judd installed his standing writing desk (1984) along with Rietveld's Berlin Chairs (1923) and the Red and Blue Chair (1923) in one of the rooms on the second floor of the Bank. These objects are all similarly made of solid wood planes with simple joints and the parts combined into perfectly proportioned shapes. There is a structural clarity in the pieces of furniture designed by Judd and Rietveld, but their objects differ conspicuously in terms of being painted versus non-painted, asymmetrical versus symmetrical. The Red and Blue Chair was painted in red, blue, and yellow, in keeping with a mystical vision of the world's essential colors and geometric shapes that was endemic in the De Stijl movement with which Rietveld was affiliated since the late 1910s. Judd liked the abstract quality of furniture designed by Rietveld, but he was not in agreement with the symbolic implications of the De Stijl movement. As he wrote, "The use of color by Rietveld is very nice but does not exceed decoration by much." [25] Yet even Judd's "very nice" suggests that he was in part charmed by Rietveld's use of colors. Judd also

24 Burton collected photographs of a variety of Adirondack chairs and saw the chair as "a great American cultural object." Scott Burton, in Paula Deitz, "The Adirondack chair, a perennial outdoor favorite," *New York Times*, Thursday, 4 July 1985, C9; Deitz mentioned Burton's Lawn Chairs in relation to a popular Adirondack chair, possibly originated at the turn of the century in the Adirondack area, then a popular summer resort for wealthy families in the United States.
25 Judd, "Some Aspects of Color," 99.

noted in 1985 that he preferred symmetry for its matter-of-fact effect rather than the asymmetrical equilibrium of De Stijl principles.[26] Although Judd refused the mystical implications of their designs, he was rather sympathetic to early modernist attempts to realize utopian visions of re-designing living environments:

> Mondrian, Malevich, van Doesburg, and others made or tried to make art and architecture as part of a new civilization, which obviously it was, and obviously still is. They are generally disparaged as being idealistic and utopian, Mondrian's philosophy aside. Why is it idealistic—even what does that mean—to want to do something new and beneficial, practical also, in a new civilization?[27]

After the waning of the utopian momentum of the late 1960s, and notwithstanding the postmodern optimism of the 1980s, Judd's interest in Rietveld's furniture was not about a mystical regeneration of the early modernist utopia.[28] Rather, Judd's zeal was as an artist concerned with the level of individual, solitary initiatives in the local community, both in terms of political action and creative production. Although the furniture pieces created by Rietveld and Judd seem to share certain formal similarities, they were actually generated from diametrically opposed approaches. On the one hand, Rietveld's furniture was inspired by De Stijl's mystical aspirations towards a new society and environmental equilibrium. On the other hand, Judd's furniture design was an extension of his rigorous pragmatist interest in the observed facts of the physical world, which he conceived of as potentially awakening individual consciousness about what is real in everyday experience.[29]

26 Judd, "Symmetry," 92–95.
27 Judd, "Some Aspects of Color," 100.
28 Donald Kuspit criticized Judd's 1984/85 furniture show at Max Protetch Gallery: "Judd has converted the intellectual utopianism of De Stijl constructivist vein [sic] into the utopian capitalism that 'fine art product' tends to convey today. He has made the perfect art for the illusory golden age of un-self-reflective capitalism"; Donald Kuspit, "Donald Judd, Leo Castelli Gallery, Max Protetch Gallery," *Artforum* 23, no.5 (February 1985): 92–93.
29 When Judd was asked in 1990 about the utopian implications of his art, he replied, "No, art is not a kind of utopia, because it really exists. It's not utopia. ... I don't know what has happened to the pragmatic, empirical attitude of paying attention to what is here and now"; Judd, "Discussion with Donald Judd," 56.

Unlike Judd's denial of metaphor in abstract forms, Burton's attitude toward early modernist furniture constructs a more open and playful dialogue, while embracing both anthropomorphic and decorative directions in his furniture design. Burton passionately argued for a reevaluation of Rietveld's furniture for its artistic quality of "furniture-approaching-sculpture" [30] along with Brancusi's bases and studio furniture. In his view, the keen creative vigor embodied in Rietveld's and Brancusi's functional objects is crucial to himself and many other contemporaneous artists in developing an architectural and spatial orchestration in their artwork. Burton discussed Rietveld's various furniture pieces as artwork using terms commonly used to describe art, such as "abstract" and "figurative," because Burton saw that Rietveld's significant achievements were more than innovative methods of design production or technology: "Furniture is furniture, and it makes no sense to speak of an abstract table or chest of drawers. But Rietveld's Berlin Chair can rightly, I think, be spoken of as an abstract chair—because it eliminates (as what chair before it ever did?) any latent figurative presence." Burton continued to describe it as, "A chair yet a pure structure and a hallmark in the short history of nonobjective art." Meanwhile, commenting on Rietveld's Zig-Zag Chair, Burton compared its figurative shape with sculptures by Gonzalez and Giacometti.[31] In short, Burton apprehended the latent artistic values in Rietveld's furniture designs and drew different lessons about means of expression, whereas Judd was primarily preoccupied with Rietveld's furniture for its clarity of shapes and structures, which appealed to his positivist approach of comprehending material facts in the external world.

Burton's adaptation of lessons from Rietveld's furniture was sincere, yet his own furniture designs appear to be a product of his conversational, whimsical, and even parodic approach toward the early modern masterpieces. He took the formal vocabularies of abstraction or figurative compositions, symmetry or asymmetry, from Rietveld's designs but freely interpreted them into various materials, exaggerated proportions, and a decorative richness with ornate finishing. Inspired by Rietveld's Side Table (1923), which he admired—"Not the first asymmetrical table in history but doubtless the first asymmetrical monopod table, it is effortlessly both furniture and a work of sculpture"—Burton designed two similar

30 Scott Burton, "Furniture Journal: Rietveld," *Art in America* 68, no.9 (November 1980): 103.
31 Ibid., 108.

tables made with geometric shapes.[32] They do not appear structurally as radical or formally as striking as the cantilever support of Rietveld's Side Table, but following Rietveld's lead Burton tested the possibility of balancing geometric shapes to hold the whole unit together. (fig.51/fig.52/fig.53) Burton's works are not about the invention of original forms or structures that surpass Rietveld's design, but rather about Burton's similarly trying to solve certain formal and structural problems that Rietveld went through. It is about an intimate dialogue between Burton and Rietveld at the level of the production process.

Three tables by Rietveld, Judd, and Burton reveal their different approaches to furniture design despite their shared application of a simple joinery method, common symmetrical configurations, and similar use of plain materials, planks and plywood. (fig.54/fig.55/fig.56) Rietveld's Crate Table was part of a series of crate furniture he designed in the 1930s to promote inexpensive furniture made by a simple construction method and easily available planks.[33] Although Judd used commercially available, common plywood, his plywood furniture is professionally and precisely fabricated. It appears more sophisticated and elegant than Rietveld's Crate Desk made of coarse planks because Judd's furniture displays expansive lengths of thin planes of plywood with fine surfaces. There is a sense of lightness, volume, and fragility due to the thin legs (flat planes) that support the whole piece. In contrast, Burton's table is made of chunky, thick, exotic-looking solid wood, called Zebrawood. The contrasting effect of the dark and light graining in tandem with the sturdy body loosely recall an actual zebra; there is a visual pun. The wildly animated surface patterns and exhibitionistic joints projecting from the table top seem to parody Judd's refined plywood table with its seamless joints. Burton's table is not designed to accommodate the conservative tastes of upper-middle class customers who are looking for a beautiful piece of furniture for their home interiors. *Zebrawood Table* is a perfectly usable piece, but it could easily be considered a decorative "conversation piece"; its bold, robust presence speaks too much to be a mute, ordinary piece of furniture. There is something comical and ironical about Burton's furniture pieces because they often appear to be wishing to

32 Ibid., 106.
33 Some of his crate furniture pieces were briefly sold as a do-it-yourself kit with instructive drawings. Since it could be plainly constructed with coarse material, it was mostly meant for the casual settings of a weekend house or children's room. See Peter Drijver and Johannes Niemeijer, *How to Construct Rietveld Furniture* (Bussum, Netherlands: THOTH Publishers, 2001), 7, 105.

fig.55 Donald Judd, Desk #75, 1990, Birch plywood, 29.5 x 98.5 x 49.25 in. (75 x 250 x 125 cm). fabricated by Pro Raum, Cologne, Germany, Image Courtesy Judd Foundation/Judd Furniture

engage their users or beholders like performers on stage. Many pieces of Burton's design show a resemblance to masterpieces of early modern furniture or sculptures by artists ranging from Brancusi to the Minimalists. Unlike Judd, Burton freely adopted stylistic diversity and different materials, regardless of the conventions of the art or design fields. Some stone chairs by Burton made of two pieces recall the construction of Brancusi's *The Kiss* (1916)—with its male and female counter parts united into one whole—and some of Burton's stone tables resemble Brancusi's pedestals. (fig.57/fig.58) *Rock Chair* (1981) seems to be paying a tribute to Noguchi, who used natural rocks from the mountains and often exaggerated the contrast between smooth and rough textures of a stone in his sculptures. (fig.59/fig.60)

Burton's series of *Steel Furniture* (1978) recalls Minimalist, hard-edged geometrical objects made of industrial materials. (fig.61) There are three types of furniture pieces in differing quantities: two tables, eight stools, and six chairs, with backs lined up to delineate a square space in the center of the installation. The installation evokes ceremonial solemnity; it looks as if it is awaiting an event to take place on a stage set. It imparts a sense of hierarchy following from the differing sizes of the furniture designs in each group; the two large tables appear to hold the superior rank, as of King and Queen. The different sizes and formal

features could be associated with theatrical characters.

Although the installation of Burton's *Concrete Tables* (1980) echoed certain of Judd's serial pieces, with their slight modifications, symmetrically arranged on the floor, Burton's tables designed with circular and square tops may evoke gendered characteristics. The tables also look like large chess pieces neatly lined up on the floor, waiting for action in the imagination of the beholders. Audiences who are familiar with contemporary artwork can easily notice the visual parody entailed in Burton's furniture. Roberta Smith, for one, found a playful, interactive aspect in Burton's small *Inlaid Table* (1977–78) made of galvanized steel and mother-of-pearl:

> One table, really a small upright box, is fabricated in macho-Minimalist galvanized steel, but it is inset on its sides and top with luxurious, feminine mother-of-pearl squares which define, somewhat ambiguously, both the negatives between the table "legs" (like an Artschwager), and a positive, the "tablecloth." This combination is at once dazzling—the two substances sharing a light-catching multi-facetedness—and amusing, with the parody made richer by the fact that the mother-of-pearl "titles" add up to small, delicate grids like miniaturized, Fabergéd Carl Andres.[34]

Since both Brancusi and Noguchi embraced the idea of functional objects as a part of their art-making practices, Burton's appropriation of the example of these two masters pays homage to them, as demonstrated in his usable sculpture. In contrast, Burton's adaptation of Minimalist formal and serial vocabularies in his work appears to be critiquing Minimalism, as a predominantly masculine art movement, seemingly far removed from the conventionally secondary genres of design and crafts. Burton undermined the powerful rhetoric of Minimalism by tactically effeminizing it. He turned the rigidly mute, factory-made surfaces of Minimalist objects into his own more anthropomorphic geometry—lively, interactive pieces which engaged audiences at both the mental and physical level.

Burton admitted the impact that canonical Minimalist artists such as Judd, Andre, and LeWitt had on the way in which he configured his works:

34 Roberta Smith, "Scott Burton: Designs on Minimalism," *Art in America* 66, no. 6 (November/December 1978): 140.

> As a matter of fact, I think my tables and chairs must be indebted in some way to artists like Judd, Lewitt and Andre. I see them as artists of another generation, however, as part of a different tradition. I consider Judd's term "specific object" applies more accurately to my work than his own, which I see as sculpture. I do not consider my furniture pieces sculpture.[35]

In contrast to Judd's dogmatic rhetoric, members of the following generation used a more playful, noncoercive rhetoric to introduce instability into the apparently clear definitions of sculpture and furniture. The way in which Burton developed his idea of usable art objects ironically conjured up Judd's argument about new art in his "Specific Objects." When Burton explained his works, he was in part mimicking and parodying Judd's aggressive rhetoric.

> My chairs and tables are independent, specific objects that you can walk around to look at from all sides; I want them to have presence. So, in many ways, I have a very sculptural definition of the furniture. I want the work to be forceful but not have too much tension.[36]

Unlike Judd's attempt to separate the marketing venues of his furniture from his artwork, Burton's furniture was handled at art galleries as a sculpture. Judd stopped making limited editions of his wood furniture in the late 1980s, whereas Burton's works are mostly unique, though some pieces of furniture were editioned, such as *Two Curved Chair* (1989, lacquered hot-rolled steel in an edition of ten and one prototype) and *Two Part Chair* (1989, in an edition of five and one prototype), when they were shown at Max Protetch in 1995.[37] Burton's usable sculpture attained a certain visibility in museums and public art projects, but Judd's furniture largely remains invisible and escaped being classified as either art or design. Judd and Burton were aware that fine art receives more serious attention than design objects in western society. This dominant western cultural system does

35 Scott Burton, in Linda Shearer, *Young American Artists, 1978 Exxon National Exhibition* (New York: Solomon R. Guggenheim Museum, 1978), 19.
36 Ibid., 22.
37 Max Protetch, *Scott Burton: Sculpture not Previously Exhibited* (New York: Max Protetch Gallery, 1995). Burton wished to make some of his furniture mass-produced, but this was never realized. See John Perreault, *Usable Art* (Plattsburgh, N.Y.: State University College, 1981).

not function for both artists who investigated the field of design. In fact, they both worked within this rigid cultural premise and system. However, Burton made the most of it, gaining a higher visibility for usable art objects in public arenas and opening up a dialogue between design and art.

Art and Design Discourse
Is Real Furniture Real Art?

In the realm of the art world, Judd's art objects stimulated a succeeding generation's speculation about and experimentation with the relationship between sculpture and furniture. There were a few experimental exhibitions related to this agenda in the1970s: "Improbable Furniture" at the Institute of Contemporary Art, University of Pennsylvania, Philadelphia in 1977, "Isamu Noguchi; Sculptor as Designer" at MoMA in 1977, and "American Chairs: Form, Function and Fantasy" at the John Michael Kohler Arts Center, Wisconsin in 1978. Other group exhibitions, such as the Whitney Biennial of 1975 and "Young American Artists: 1978 Exxon National Exhibition" at the Solomon R. Guggenheim Museum included Burton's and other artists' designs and architecturally oriented sculptures that gradually called the attention of art critics to the ambiguous boundary between furniture and art pieces.

In the 1980s there was an increasing number of exhibitions featuring this subject, which also encompassed the issue between art and life: "Usable Art" curated by John Perreault in 1981 at the Myers Fine Arts Gallery, State University College, Plattsburgh, New York which traveled to The Queens Museum, Flushing, New York and two other venues; "Filling in the Gap" organized by Saul Ostrow in 1989 for Feigen Incorporated in Chicago; "Furniture, Furnishings: Subject and Object," at the Museum of Art, Rhode Island School of Design in 1984; "The Chair Fair" organized by The Architectural League of New York in 1988; and "Furniture as Art" at the Boijmans Museum in Rotterdam in 1988. Noguchi also showed his *Akari* at the Venice Biennale in 1986. In addition, a book was published on this topic, *Artists Design Furniture* (1984) by Denise Domergue. Yet an in-depth discourse on the relationship between art and furniture has not emerged, even though Burton's and other artists' design-oriented works were highly visible and the market quickly responded to this trend in the early 1980s.

Mostly, until recently, literature on this topic is found in texts featuring Burton's works because he was perhaps the most conspicuous artist engaged with this under-investigated field. Initially, in the New York art scene of the 1970s, art historian Robert Pincus-Witten, writer John Perreault, and art critic and artist Burton himself were vocal about this topic. Their arguments are, however, not very thorough or convincing. Rather, they reveal the difficulty of dealing with this issue without a firm theoretical model. The early arguments about the relationship between art and design were somewhat tormented by the dominant formalist claims for the autonomy of art as a medium. But the focus soon shifted to the meaning of the real and the experience of reality in artworks. This seems to have reflected trends towards Photorealism and Conceptual Art in the art world during the 1970s. These dead end questions about the real and truth in usable artwork continued throughout the 1980s.

In a 1977 catalogue essay entitled "The Furniture Paradigm," Pincus-Witten saw that fine art was fundamentally associated with metaphorical content and aesthetic formal qualities, while he found artistic value also in the well-proportioned, sophisticated forms of early modernist furniture.[38] He observed that, by contrast with the spiritually imbued *Table of Silence* by Brancusi, there was an absence of such religious awe in the case of the industrial-looking Minimalist objects. As such, he argued that the floor-bound, geometric Minimalist works belong more to the paradigm of furniture. His argument somewhat laments the loss of uplifting content and a hands-on creative spirit in the factory-made, seemingly mute Minimalist productions, which seemed to sink to a lower status by being associated with functional objects attached to ordinary, everyday experiences.

John Perreault also saw that the "depedestalization" of many Minimalist objects was inherited from Brancusi's practice and subsequently adopted by post-Minimalist artists as well.[39] Perreault further commented on the line between fine art and functional objects; when art objects were presented on a human scale

38 Robert Pincus-Witten, "The Furniture Paradigm," in *Improbable Furniture* (Philadelphia: Institute of Contemporary Art, University of Pennsylvania, 1977), 8–16. As Pincus-Witten noted, his essay was inspired by Joseph Masheck, "The Carpet Paradigm: Critical Prolegomena to a Theory of Flatness," *Arts Magazine* 51, no.1 (September 1976): 82–107. Masheck stressed the inspirational role of ornamentation in textile, carpet, and wallpaper designs in the development of abstract values in modern paintings.

39 John Perreault, "False Objects: Duplicates, Replicas and Types," *Artforum* 16, no.6 (February 1978): 26.

and with a physical verisimilitude to furniture from everyday life, there was an increasing doubt about where the salient differences between artwork and furniture lay. Perreault's argument was concerned with a search for a sense of the real and truth in everyday experience. In a sense, to him the difference between art and furniture was less important than the invitation such comparisons offered to consider playfully one's methods of perception, thinking, and interpretation.

Perreault described Scott Burton's functional sculpture as a *"trompe l'oeil* sculpture."[40] *Trompe l'oeil* is a technique associated especially with the conventional genre of still life painting. In the western academic tradition, this genre was treated as being of a lower status than history painting, which required narrative content and sophisticated techniques for depicting human figures. Using this specific term, Perreault suggests increasing doubts about the hierarchical divisions between fine art and functional objects. While *trompe l'oeil* relates to conventional artistic skills for deceiving viewers through different methods of representation, Minimalists and post-Minimalists further complicated such ideas by creating artworks that were no longer about representation at all. Burton's usable furniture presented another complication in this debate, since his art pieces are meant to be used as real furniture.

Perreault saw that the hybrid aspects in functional art objects stimulate the beholder's shifting state of mind between art and life, art and the real, as when he wrote about R.M. Fischer's lamps in 1983 (fig.62):

> Not all lamps are equal; not all lamps are art. Is it only the considering and the intending that make one lamp an artwork and another not? When an architect designs a lamp for mass production is it any less art than when a sculptor constructs a lamp in a studio and then shows it in an art gallery ? Who decides? We cannot leave it to time to tell, for often it does not. The eyes too must have their say.
>
> My eyes (and feelings and brain) have told me for some time now that Fischer's lamps are splendid concoctions that operate effectively on both aesthetic and social planes. They have the virtue, too, of not being pompous or overtly propagandistic. Their friendly humor appeals to the handyman-woman, the zany inventor in us all. They are made up of found parts and

40 Ibid., 27.

odds and ends, the refuse of domestic and industrial life. Out of the attic and into the gallery. Out of the cellar and into the living room. Out of the streets and into the museums. Out of the pages of art history into life.[41]

Meanwhile, the museum protocol of "no touching" would confuse the line between the staged and real event. In his essay for the exhibition catalogue of *Furniture as Art* (1988), Huub Mous pointed out with a tone of irony that the interior of the museum turned out to be a theater, where objects become props and visitors are the performers, and the museum interior provides a perfect setting for such a masquerade.[42] It seems that the uncertainty and hybrid identity of the furniture-sculpture object continue to be negatively received throughout the 1980s by critics who had a firm belief in the presence of absolute truth and the real in fine art, strikingly different from ordinary life experiences.

Burton was represented at Documenta 8 in Kassel in 1987. One of the organizers, Pierre Restany, also saw the ambiguity between artwork and productions at Documenta 8 as part of a mannerist mode in art: "video monumentalism, reference to environmental art, the recovery of the objet-trouvé, the anthropological-cultural transfer of the ideology of décor into architecture and design: widespread aesthetics, a vision of romantic dandyism and of unbridled individualism, the product of a new use of the critical dimension and another function of the museum." [43] He addressed the trend with a tone of irony but seemed to welcome its open-endedness in freeing the public's apprehensions:

> This end-of-the-century mannerism, by proposing sculptures that are works/products whose usage is subjected to our free will, to whatever we choose to do with them, accomplishes the most salutary of demystifying tasks. It steers the art of today back into proper measure, the one designated by Marcel Mauss's bright maxim: "Art is what the social group recognizes as such at a

41 John Perreault, "Furniturism: Four Artists, New Sculpture or High-Priced Furniture," *Los Angeles Institute of Contemporary Art Journal* 36 (Spring 1983): 67.

42 Huub Mous, "Art as the masquerade of furniture" in *Furniture as Art* (Rotterdam: Museum Boymans-van Beuningen, 1988), 22–23. His argument echoes Michael Fried's initial criticism of Minimalism as mere theater, undermining the absolute autonomy of medium specificity in fine art practice.

43 Pierre Restany, "Widespread Aesthetics: The Kassel Approach," *Domus* 686 (September 1987): XXII.

given moment."[44]

Numerous artists and critics sensed a paradigm shift of moral values in the 1980s, from an emphasis on the real and truth discovered by art connoisseurs to social and ethical values found in artwork by common people. For instance, "I think that the moral, the ethical dimension of art is mostly gone, and only in a newly significant relationship with a non-art audience can any ethical or social dimension come back to art," said Burton in 1985.[45] This moral question about seeking something real and truthful in art persists in art and design discourse, as I will discuss further.

No Utopian Unity between Art and Design

Neither Burton nor Judd had an uplifting vision of changing an entire society through their functional objects in the post Vietnam War periods of the late 1970s and 1980s. As I discussed, to connect Judd's furniture with early modernist furniture under a common umbrella of promoting an ideal unity between art and design would be an erroneous conclusion. First of all, Judd's own insistence on the hierarchical division between art and functional objects makes him opposed to the mission of uniting art and life prevalent among the early modernist movements of the Bauhaus, De Stijl, and Russian Constructivism. There is of course a historical, geographical, and socio-cultural gap between the inter-war modernist movements and the post-war, Cold War movements centered on advancing civil rights and ending the Vietnam War. The pre-war utopian spirit is simply not applicable in comprehending Judd's design products. Judd's and Burton's functional objects are concerned with actual experiences in space, and they belong to a discourse about the immediate, earthly reality of everyday experiences. Burton's playful adaptation of various styles from the past was far removed from a belief system invested in geometry by the theosophy-inspired De Stijl group, from the communist ideals of the Constructivists, or from the "form follows function" outlook on design at the Bauhaus.

Meanwhile, as a designer of furniture and architectural projects, Judd received

44 Ibid.
45 Scott Burton, quoted in Campbell and Cruikshank, "Art in Architecture," *Artists and Architects Collaborate*, 11.

a certain recognition in Europe in the late 1980s and the early 1990s, having European exhibitions of his furniture and architectural projects during that time, and winning two prizes, the Sikkensprijs Prize from the Sikkens Foundation in the Netherlands in 1993 and the Stankowski Award from the Stankowski Foundation in Germany the same year. The former prize was first awarded to Gerrit Rietveld in 1959; Le Corbusier won it in 1963; and Theo van Doesburg won it in 1968. Judd was recognized along with a group of well-established modernist designers and architects. The prize awarded by the Stankowski Foundation was started in 1985 and is uniquely focused on achievements in connecting art and design. The award recognizes achievement in "the unity of free and applied art," and winners of the prize can be "artists and designers, persons and institutions particularly promoting the connection of art and design—whether in science, technology or in other social areas."[46]

By the late 1960s, an ideal of early modernist furniture was itself being criticized for emphasizing formal beauty rather than more user-centered values. In his article "Chairs as Art" (1967), Reyner Banham, an architecture historian, criticized canonical modern furniture pieces by Mies and Charles Eames for their lack of attention to utility and comfort: "Quite as much as painting or sculpture, the great chairs are prized as pure creations of the human spirit, and damn their functions."[47] Banham's observation could also be applied to Judd's furniture in view of his primary preoccupation with form over function. However, the notion of "comfort" varies from time to time and from person to person.[48] As Galen Cranz points out in her work *The Chair, Rethinking Culture, Body, and Design* (1998), "comfort" is often judged from the cozy look, padding, size, and style of a chair instead of from each individual's physical experience.[49]

Cranz saw that most modernist chairs are not ergonomically designed, but that some famous modernist chairs are not as uncomfortable as they appear.[50] For

46 http://www.stankowski-stiftung.de/award.html (accessed May 23, 2007); the Stankowski Foundation facilitated and financed the exhibition catalogue *Räume: Art+Design* and his exhibitions held in Wiesbaden, Chemnitz, Karlsruhe, Oxford, and Berlin. See Donald Judd, *Räume: Art+Design* (Stuttgart: Cantz Verlag, 1993), 7, 158–59.

47 Reyner Banham, "Chairs as Art," *New Society*, 20 April 1967, 567.

48 See the comprehensive discussion of "comfort" and cultural and ergonomic dynamics of the chair in Galen Cranz, *The Chair, Rethinking Culture, Body, and Design* (New York and London: W.W. Norton & Company, 1998), 111–15.

49 Ibid., 113.

instance, according to Cranz's investigation, the Wassily Chair (1925) designed by Breuer can accommodate a wide range of body types and allows more body movement than other modernist chairs; likewise, the Red and Blue Chair by Rietveld can provide "long-term comfort" by sufficiently and naturally supporting the spine.[51] Cranz also points out that Burton's stone settees at the south plaza of the Equitable Center, in the PaineWebber Building in Manhattan are better for human bodies than easy chairs for the same reason.[52]

Accusations that Judd's chairs are "impractical" prevailed throughout the 1980s and even persist today.[53] There are formal similarities between Judd's design and early modernist furniture design. In part because Judd's furniture pieces have been associated with the idealist visions of pre-war modernism, they have similarly—if rather confusingly—received the oversimplified criticism of being elitist in taste and favoring lofty ideals of formal beauty. Criticism about the physical comfort of modernist furniture and Judd's furniture seems to be irrelevant; such furniture was not custom-made for individual comfort or driven by an ergonomic science of comfort.

As some artists explored the potential of utility by designing functional artwork, designers such as Ettore Sottsass and architects such as Frank Gehry and Robert Venturi also reexamined the modernist approach to design by making furniture with free sculptural forms or applications of different historical styles during the 1970s and 1980s.[54] However, artists and designers were sure about the distinct

50 Ibid., 138–39.
51 Ibid., 139, 144–45.
52 Ibid., 154.
53 Louisa Guinness stated at a round-table discussion on the relationship between art and design; "I think you have to call his [Judd's] furniture a work of art, even if he didn't necessarily want it to be. If you want a truly functional piece of furniture go elsewhere. It's more about the aesthetics. I live and work with his furniture and I find it perfectly comfortable to use, but they're not the most practical pieces. People who buy his furniture buy it because they like Judd and his vision." Guinness, "What's the use of art?" *Art Review* 2, no.2 (February 2004): 62.
54 See analyses of the shifting social trends of interior and furniture design in the United States in Lisa Phillips and others, *High Style, Twentieth-Century American Design* (New York: Whitney Museum of American Art and Summit Books, 1985). Daralice Dankervoet Boles reported the parallel phenomenon of furniture as art in what he called The Art Furniture Movement in the United States comparable to Memphis in Milan. He characterized Art Furniture as "Emphatically anti-'good design,' dysfunctional, atypical, custom-designed as opposed to mass-produced, the work runs the gamut from facetious pun to serious statement, from knocked-out-overnight to painstakingly tooled." In his view, the movement was launched in 1977 by a gallery in SoHo, Art et Industrie, run ↗

identity of their own professions. Unlike the prewar situation in which the profession of industrial designer was about to emerge, the professions of art and design were independently developed in the education system and business world in postwar society. In reality, the prewar utopian vision of the professional artist-engineer or artist-technician building a bright future for modern society did not come true. Burton remarked on his position as an artist instead of a designer:

> I make a kind of work which is, as far as I'm concerned, equally furniture and sculpture. It's not *arty* furniture, like Memphis-type style, which I consider "art furniture," to revive an old term. That's designer's work. One of the meanings for me of my furniture is that as an artist who is designing, in some way my work is a critique of existing ideas of sculpture. I mean, Richard Serra and Joel Shapiro both—that's fine art. Art as design can, I feel, connect with a non-art audience. I'm very anti-art in certain ways. Although, yes, I show in galleries and museums; and yes, I'm collected.[55]

Italian designer Ettore Sottsass, known for his richly colorful and sculpturally monumental furniture designs, kept close ties with his artist friends, including Francesco Clemente and Paladino, and was inspired by Cubism, but he looked at himself as more of a designer and architect: "The word artist scares me. In fact, the project of Memphis was to make reproducible objects, not unique pieces of furniture, things where the signs of the individual hand were gone, and this makes me feel more like an architect and a designer. But my attempt at staying in close touch with existence sets me close to art." [56] Burton's furniture pieces often

↘ by Rick Kaufman. Designers associated with this group were: Main +Main, James Hong, Howard Meister, Carmen Spera, Forrest Myers, and Elizabeth Browning Jackson. These designers, along with the Memphis designers, were not recognized by the Museum of Modern Art which declined to show their furniture. In contrast, architects enjoyed better recognition for designing furniture: "Michael Graves, Richard Meier, Emilio Ambasz, Charles Gwathmy, Aldo Rossi, Mario Botta and others have all designed for major manufacturers. The pieces are not intended for a mass market but are issued in limited editions, often signed and numbered like lithographs, and introduced at elaborate openings." Boles suggests that Art Furniture stimulated the establishment of a new genre and a new furniture market in the United States. Daralice Dankervoet Boles, "The good, the bad and the ugly," *Industrial Design* 31, no.3 (May/June 1984): 16-21. Exceptionally, Michael Graves' functional objects, designed for production in mass quantities, are currently available through Target Corporation an American retailing company.

55 Burton, "Interview: Scott Burton," 61.

present a decorative, material texture, like the work of Sottsass, who "wanted to make things that are sensually perceivable, with a ritual and metaphysical direction." It seems that Burton's usable furniture does not usually exceed the normal intimate scale of ordinary furniture, whereas Sottsass' designs are elastic in size and exuberant in color. In this freely exaggerated application of colors and forms, these designs seem to be "*arty* furniture" in Burton's words. Meanwhile, the Memphis collection and Venturi's historically shaped chairs represented a novel approach to furniture design.[57] Hence, on the part of artists and designers, there is not a strong sense of utopian integration between the different professions of art and design as they created their works during the 1980s. Rather, they pushed the boundary of art and design on their own, departing from their given profession because the preexisting categories did not function. In effect, they created a space for communication about usable artwork and arty furniture in which beholders or users were invited to participate at the everyday level.

Social Function of Art

The hybrid identity of furniture/sculpture pieces received both positive and negative reactions from critics throughout the 1980s and 1990s.[58] Arthur C.

56 Ettore Sottsass, interview with Giacinto Di Pietrantonio, "Ettore Sottsass," *Flash Art* 135 (October 1987): 77. Allessandro Mendini and Sottsass organized the Studio Alchymia in 1978, and the group designed the Memphis collection of furnishings.

57 See Steven Holt, "Venturi and Diffrient: from a single root," *Industrial Design* 31, no.3 (May/June 1984): 28-37. Venturi and Denise Scott Brown designed a line of furniture for Knoll International in 1984. Each chair design was based on a historical style: Chippendale, Queen Anne, Empire style, Gothic Revival, Biedermeier, Art Nouveau, or Art Deco. Based on the collaboration inherent in Knoll's sophisticated manufacturing orchestrations, the chairs were made of molded, laminated plywood with additional handwork incorporated. The stylistic eclecticism in Venturi's chairs paralleled Burton's usable sculpture designs, but Venturi's work rose more out of the realm of production, whereas Burton's work remained unique pieces. In the process of designing the chairs, Scott Brown pointed out that the weight of a particular prototype was too heavy, and her opinion was reflected in the final furniture design, whereas Burton's stone furniture for indoor and outdoor use is immovable, unlike regular furniture. The two are working in fundamentally different realms and professions when they design furniture.

58 Long before Burton's attempt at combining sculptural and functional objects, Isamu Noguchi, who was inspired by Brancusi and by his own Japanese cultural background, was exploring the designs of lamps, which he called *Akari*, or "light sculptures," as an art medium, beginning in 1951, and he tried to present them at art venues, including galleries and museums. Although Noguchi ↗

Danto, a professor of philosophy and an art critic, seemed to be most sympathetic to the trend of furniture as art. When The Architectural League of New York organized an exhibition entitled "The Chair Fair," Danto gave a lecture on the phenomenon of reinventing the chair in the 1980s. The show was responding to the renewed interest in the chair as an artistic opportunity for architects, craftsmen, and artists. League board member Richard Artschwager helped to set the criteria for selecting chairs.[59] Danto was positive about the critical potential of the chair as an artistic vehicle. He wrote:

> That the chair should in recent days have entered art as a medium or a form rather than as subject, that the chair should have become art—subject to a range of surrealist modifications as, say, in the work of Lucas Samaras—strikes me as a sign that a certain barrier has been made visible by being broken. In the act of artistic celebration or artistic aggression (they are perhaps inseparable), we may be trying to liberate ourselves from forms of life that the chair condenses as part of its steady message.[60]

Danto optimistically saw in this trend a kind of creative vigor. It seems that in his view, the creative impetus of making chairs as art was equated with the political force of overturning the power structures embedded in the social hierarchy: "in a more revolutionary way of thinking, the shambling of chairs, the artistic attack on chairs, may be an attack on a concept of power, rank, submission, subservience we feel inconsistent with a more liberal form of life." [61]

The following year, in 1989, Scott Burton organized the show "Artist's Choice:

↘ showed large pieces of Akari at the United States Pavilion for the Venice Biennale in 1986, they did not prompt a critical debate on the relationship between art and functional objects at that time, in part due to Western cultural preconceptions about a lamp being no more than a design object. Interestingly, Burton talked about Noguchi: "I think he's a major, major figure for all of us" and admired Noguchi's "whole idea of art as a place," as embodied in his early models for playgrounds in the 1930s. Burton also recalled the crucial impact of Akari on himself personally, stating, "I had one [Akari] as a teenager. It was very important to me—an Akari lamp. It was a very, very big icon. It was an icon of modernism in the 50s"; Scott Burton, interview by Lewis Kachur, September 25, 1987, transcript, p.65–66, Archives of American Art, Smithsonian Institute, Washington, D.C. (hereafter AAA).

59 Frances Halsband, "Preface," in *397 Chairs* (New York: Harry N. Abrams, 1988), 6.
60 Arthur C. Danto, "The Seat of the Soul," in *397 Chairs*, 16.
61 Ibid.

Burton on Brancusi" at MoMA as part of a project to invite individual artists to curate an exhibition using the collections of the museum. The show was controversial because Burton removed Brancusi's sculptures from their pedestals and displayed the bases as artwork. Danto saw Burton's gesture against the sacred "Temple" of modern art as being no less radical than Warhol's *Brillo Box* and the way they overturned the division between high and low culture in the 1960s.[62] Others viewed it as a dangerous, iconoclastic, dismemberment of Brancusi's masterpieces.[63] Burton expanded on Brancusi's practice of moving his bases around the studio. In effect, Burton created a formal theater in which Brancusi's bases perform publicly, while the dramatic dynamics of everyday, private experiments within the studio are lost. This suggests the difficulty of conjuring up lively and subtle studio practices in the inevitably staged museum context.

There was some positive reception for the ethical, social, and public values evident in Burton's involvement with public art projects. Nancy Princenthal wrote positively about artists' design oriented works, as she saw them bringing art into the public domain. She saw Burton, Armajani, Fischer, and Smyth as "populists who believe that their work's success should be judged by its users."[64] In another essay on Burton, she defended the artist's preoccupation with "social function" in his art-furniture and public art projects.[65] She also acknowledged that Burton's stone chairs are comfortable, but the comfort and practicality of furniture is not his first priority since he was concerned with form and worked with heavy materials such as stone and metals.

More reserved criticism within the art and design discourse has come from

62 Arthur C. Danto, "High Art, Low Art, and the Spirit of History," in *Beyond the Brillo Box, The Visual Arts in Post-Historical Perspective* (Berkeley, Calif.: University of California Press, 1992), 156–57. Other positive responses came from Jack Flam "The Gallery: MOMA's 'Artist's Choice'," *Wall Street Journal*, 26 April 1989, and Neil Baldwin, "MOMA exhibit views Brancusi through another sculptor's eyes," *Record, Hackensack, NJ*, 19 May 1989.

63 Michael Brenson was more reserved. Though he thought it was an interesting attempt, he also saw it as a dangerous idea. Michael Brenson, "Rearranging the Brancusis," *New York Times*, 16 April 1989, H33. Robert Pincus-Witten and Hilton Kramer were clearly furious about the show. Robert Pincus-Witten, "Entries: Geist, Zeitgeist & Breaking The Zero Barrier," *Arts Magazine* 64, no.2 (October 1989): 58–61; Hilton Kramer "'Artist's Choice' Show at MoMA Is Gruesome Aesthetic Vandalism," *New York Observer*, 1 May 1989.

64 Nancy Princenthal, "Art with Designers on the Public Domain," *Industrial Design* 31, no.2 (March/April 1984): 46.

65 Nancy Princenthal, "Social Seating," *Art in America* 75, no. 6 (June 1987):130–36.

formalist or left-leaning intellectuals.[66] These critics and art historians are mostly cautious about public art projects in general because, in their view, public projects are constrained by governmental and urban regulations and corporate power while operating under the name of art. Their claims are intellectually sound and consistent with their motivations, but they together comprise only a fraction of the many voices commenting on the complicated situation of public art projects and their diverse audiences. In the 1990s and 2000s, the discourse on design and art seems to be shifting its emphasis from questions about the hierarchy between the two disciplines and the perception of the real in art experiences to a closer examination of the social nature of participatory observers and users of functional art objects.[67]

Did hybrid sculpture truly overcome the dysfunctional hierarchical categories of Western cultural standards as Danto assumed? Looking back on the postmodern drive toward breaking the boundary between art and non-art, fiction and reality, during the 1980s, Peter Bürger observed that, as of the early 1990s, such boundaries had not vanished as much as postmodern theorists perceived.[68] He described postmodernism as a "post-avant-garde" era characterized by "the failure of [the] historical avant-garde's attack on the artistic institution." [69] Bürger suggested that cultural institutions and auction houses continued to play the dominant role in establishing what fine art is in bourgeois society.[70] Meanwhile, currently there are a number of artists, such as Jorge Pardo and Andrea Zittel, who have been making design objects which incorporate social and personal concerns about living circumstances and environments, including the ecological crisis, globalization, customized lifestyles, and local community issues.

66 Some examples of the skeptical critical reception of usable art include: Donald Kuspit, "Scott Burton," exhibition review, *Artforum* 21, no.7 (March 1983): 78; Hal Foster, "Design and Crime," in *Design and Crime (and other Diatribes)* (London: Verso, 2002), 13–26; and Miwon Kwon, "Jorge Pardo's Designs" in *Design and Art*, ed. Coles, 74–87.

67 See Claire Bishop's introduction and other essays on the theory and criticism of viewer participation with artwork in *Participation*, ed. Claire Bishop (London: Whitechapel; Cambridge: MIT Press, 2006).

68 Peter Bürger, "Aporias of Modern Aesthetics," trans. Ben Morgan in *Thinking Art: Beyond Traditional Aesthetics*, ed. Andrew Benjamin and Peter Osborne (London: Institute of Contemporary Arts, 1991), 4–5.

69 Ibid., 14.

70 Ibid., 12–13.

Did hybrid furniture/sculpture of the 1980s provide an effective model for these projects addressed to the social and political issues of the 2000s? It did not directly provide solutions to these current issues, but its visibility laid the groundwork for functional artworks in the public arena and served as a springboard for a following generation of artists to create socially-invested design projects and engage, to an extent, with audiences outside of the art world. For instance, Jorge Pardo, a Cuban-born artist who lives in the U.S., has been exploring projects involving interior design, sculpture, and architecture since the early 1990s. The colorful interior designs of Pardo's *Project* (2000) included remodeling the entrance area, bookstore and first floor of the Dia Center for the Arts in the Chelsea neighborhood of New York, and presented a bold contrast with their collections of canonical, Minimalist art in its rigorous and mute formal vocabularies. Pardo's work transformed the industrial, cold interior spaces of Dia's building into something more cheerful, inviting, and hospitable for audiences. (fig.63) It also prompted a discourse on art and design, as noted in Nana Last's essay, "Function and Field, Demarcating Conceptual Practices," which compared Pardo with Peter Eisenman.[71] She argues that "utility" in artwork should not form a bar between art and the world because such a category-bound perspective simply treats functional arts as secondary without producing any further critical discourse.

In his concern with art merging into everyday environments, Burton himself had no intention to shock the public through his furniture design into a certain political action or awareness. For him, the process of designing furniture was more of a personal, social and moral commitment than a politically-motivated action.[72] Together with Siah Armajani, whom Burton admired, he conceived that public art should not assault, control, or menace the public, but have a neighborly presence in a community or site.[73] He was more interested in "everydayness" as

71 Nana Last, "Function and Field, Demarcating Conceptual Practices" in *Theory in Contemporary Art since 1985*, ed. Zoya Kocur and Simon Leung (Malden, Mass.: Blackwell Publishing, 2005), 318–30.

72 Burton, interview, transcript, p.19, AAA.

73 See Brenda Richardson, *Scott Burton* (Baltimore: Baltimore Museum of Art, 1986). This was the first major retrospective exhibition of the artist, encompassing works from 1973 to 1986. Burton felt very ambivalent in his response to the big controversy about Richard Serra's Tilted Arc at Federal Plaza in New York City. Burton defended Serra because he saw that the removal of Serra's would-be permanent piece was an attack on art, which was a "minority culture" in society. Scott Burton, "Scott Burton—Artists Gallery Talks," March 1, 1988, Sound Recording of Museum-Related Events, ↗

a fundamental means to connect himself to audiences and situate the viewer at the center of experiences in space and time. Burton criticized Christo and Jean-Claude's temporary installations for fostering pure spectacle. Instead, he wanted his works to be "integrated itself into the normal fabric of life."[74] He happily claimed, "I am a lunch artist," in reference to his public art projects in the business district of a city.[75] For him, public art should provide a pleasant amenity and is successful only if social activities are enhanced or prompted at the site.[76] As such, his work is less about an artist's ego being manifest at a certain spot and more about the open-ended experiences of the public who actually enter the space.

This stance was generated through his early practice in performance: "the psychology of the viewer is a major element in the unfolding character of the performance," and he argued: "Performance art reevaluates the role of the artist in the culture, submitting him to the transaction with the viewer."[77] Burton took part in embracing the shifting position of the author in the late 1960s and the 1970s, when the autonomy of art was no longer an absolute value, while the active role of audiences came into foreground, as discussed in Roland Barthes's essay "The Death of the Author" (1968). Burton was preoccupied with the psychological dimension entailed in human behavior in social settings and the sociological agendas in modern public spaces; he read *Personal Space, The Behavioral Basis of Design* (1969) by Robert Sommer and *The Fall of Public Man* (1977) by Richard Sennett. Burton referred to Sennett's work for its acute observations about the dead public space created around the entrance areas of large buildings by their entirely glass walls, which provide the ultimate visibility but create a barrier from outside and reject functioning as a public square.[78] Burton was aware of some problems with the inhumanity of the dysfunctional urban environment and hoped to create user-oriented design in his public art projects.

↘ 98.67. The MoMA Archives, NY. Serra's *Tilted Arc* was commissioned by the Arts-in-Architecture program of the U.S. General Services Administration and was installed in 1981. After a public hearing in 1985, it was removed in 1989. It generated a controversy over the nature of government funding and the rights of the artist.

74 Burton, interview, transcript, p.61, AAA.
75 Burton, SR, 98.67. MoMA Archives, NY.
76 Burton, SR, 98.67. MoMA Archives, NY.
77 Burton, "Lecture on Self," 60.
78 Burton, SR, 98.67. MoMA Archives, NY. In this talk, Burton especially referred to a section, "Dead Public Space," in Chapter 1, "The Public Domain," of Sennett's book.

fig.64 Scott Burton, *Chairs and Settees*, 1988, New York, photograph by author, 2008.

What is the significance of benches and tables provided in the public domain? To me, Burton's furniture in public spaces is more of a witty antidote to the powerful rhetoric of Minimalism and leftist discourse. His pieces do not provoke any political actions or responses. Burton's furniture appears quietly eloquent as to the way in which art enters into the public/private domain when people meaningfully participate, ideally on a daily basis. For instance, at the North and South plazas of the Equitable Life Assurance Society of the United States, Equitable Center, PaineWebber Building in New York City, the seating is placed so that sitters can view pedestrians and passing vehicles. (fig.64/fig.65) This creates subtle theatrical situations of looking and being looked at. The effect is ephemeral, merged into familiar, everyday experiences and embraces the small, contingent dramas that unfold in public spaces, as one happens to be momentarily involved as a witness or participant. This might add to the bittersweet, slightly lonely, and unexpected human encounters that dot the cityscape. While such small everyday incidences may be forgotten, they may also be remembered as a form of poetry, sound, scent or scene, imbued with some social concern about others as they exist in relation to one's self: who they are, where they are from, how they dress or behave; remain reserved or mingle. I would rather take part in such an everyday event, finding my spot to get a slice of stimulation from commonplace circumstances, than passively wait for some miraculous revelation. In the flow of ordinary, real life, an artist can't manifest any absolute control over the ways in which people feel and perceive things at a site.

Both Judd and Burton eventually looked beyond the institutional limits of the white cubes of art galleries and museums. While Burton increasingly engaged with the public domain in the 1980s, Judd was on his own private mission to establish permanent installations. Burton's works were collected by the MoMA and the Guggenheim Museum and, in effect, treated as art objects, whereas Judd's pieces mostly remained invisible in the private realms of collectors and in privileged spaces.[79] Burton's functional sculptures, which are installed in public settings

fig.65 Scott Burton, *Tables and Stools*, 1988, New York, photograph by author, 2008.

such as the Public Table at Princeton University (1979), *Picnic Table and Benches* installed at Artpark in Lewiston, New York (1983), and the seating at Battery Park City (1989), are more visible and accessible to large crowds of office workers, residents, and tourists than Judd's furniture, which is crafted in limited numbers and only available to the privileged clients who can afford it. Likewise, Judd generally established permanent installations at remote sites away from general public access.

In fact, neither Judd's nor Burton's furniture has been thoroughly discussed in art and design discourses because their pieces exist in a way outside of both worlds. Judd's furniture is hardly collected by art and design museums. After all, not having been trained as a designer or as an architect, Judd remained an outsider in both fields, and it seems to have been impossible for him to come to occupy a pivotal role in the disciplinary or historical currents of design and architecture.

79 Judd's rustic wood furniture became available to the public in Marfa. The Judd Foundation donated pergola tables, constructed by Randy Sanchez and Rico Roman, staff members of the foundation, to a newly constructed, large shaded pavilion in downtown Marfa. The idea came from Rainer Judd. Sympathetic to her vision, Tim Crowley financed the structure and offered the lot that he mostly owns. The place is becoming a gathering spot in the town for locals. Tobin Levy, "Businessman and foundation collaborate in downtown Marfa gathering space," *Big Bend Sentinel*, Marfa, Texas, 10 April 2008. I thank Professors Elizabeth and Josh Burns in Marfa for sending this article to the author.

Due to the bias that art is superior to design, furniture designed by artists has been largely neglected in serious criticism and museum collections and displays. As a matter of fact, Burton's *Pair of Rock Chairs* (1980–81) was installed in the outdoor sculpture garden at MoMA in 2008 which seemed to be the best way for functional art pieces to be actually put to use at the museum.

For Judd and Burton, their furniture creations merge into the realm of everyday life. For Judd, his furniture is inseparable from his empiricist philosophy and everyday behavior, whereas Burton's furniture offers open-ended, contingent, everyday small dramas unfolding in public spaces. Their furniture is not about a utopian unity between art and design or a calling for radical political change in society. Rather, their furniture calls attention to the dysfunctional cultural system within our society. It is about slow social change toward a better recognition of the values of everyday life as discovered through the actual experiences of being on site; thus, one's physical presence and mental engagement with furniture in a certain environment truly matters in generating a discourse on art and design. It was not so much a taste for "good design," but rather participation and action with theater as a model that led from Minimalist art to a post-Minimalist art engaged with everyday life. The artists' furniture and design projects force us to redefine the function of art in the next society.

CONCLUSION

Although Judd tried to maintain a line between his furniture and art pieces, the works were all closely bound up by his pragmatist and decentralized self-managing philosophy. On a practical level, the creation of his furniture and art unfolded side by side in every aspect: formal and material considerations, actual production processes, marketing, and installations in both private and public spaces. Since Judd's furniture was generated from his own living environments, it reflects his simple, pragmatic and immediate everyday behavior even as it demands that other users adjust to the way Judd himself interacted with his furniture. Private concerns of how to live are disseminated through his pieces of furniture as they in effect instruct the public on how to engage with his furniture.

It makes sense that Judd's furniture is located in his residences and shaped by his politically and conceptually motivated, do-it-yourself logic. Clearly defined physical existence matters in Judd's art and furniture, but the virtual nonexistence of this internationally renowned artist's furniture in the collections of major art museums in New York City, even two decades after his death, seems poignant—the result of the western dominant system that places fine art above functional objects, a system that is still pervasive in cultural institutions and the market system. Judd ambivalently tried to work *within* this cultural and economical dysfunctional system as an artist, while creating his own spaces as an artist/designer working from *outside* this rigid division. This putaire rule prevents creative impetus toward *functionging* art in our society.

Judd's written comments about the notion of a whole space as a total work of art remove any doubt that his art pieces can be separated from his everyday objects and be granted a higher status. Contrary to his repeated statements about the hierarchical division between artworks and functional objects, Judd created a grey zone where the division between art and furniture does not quite matter in the experience of an immediate here-and-now. What is left is a direct, spatial relationship between a subject and objects devoid of the artist's mediation. Decentralized installations free up expectations about the hierarchical status of art and furniture so that they act together to assert their real, material existence

as "things" in space. In short, both furniture and art pieces are treated as physical elements that balance the entire space of his permanent installations and residences: i.e., public and private places.

Although Judd persisted in making claims for the high status of art, he denied metaphysical readings of his artwork. The way in which Judd defined and explored the concept of the "whole" reveals that he faced a moral dilemma in deciding between the empiricist approach of questioning prior knowledge about traditional aesthetics and the unshakable, conventional status of art being above functional objects. Judd's revolt *within* the cultural hierarchy was also fueled by his organic, decentralized sense of a way of life. It seems that Judd's ambivalence about the hierarchical order between art and functional objects was in part a byproduct of piecemeal changes in dysfunctional society rather than any dramatic revolution. The actual division was subtle, but did exist in Judd's mind and provided a moral anchor of order, while processes of making art and furniture were inseparable in his encompassing web of everyday conduct and in his environments.

The art scene during the social unrest of the late 1960s was (re)formed, not through a collective overturning of institutions but through the artist's individual actions fueled by the independent, do-it-yourself spirit of anarchism in the 1960s and 1970s. In the 1980s and 1990s, Judd's discussion of the aestheticization of spaces as a whole suggests that the anarchistic preference for a simple way of life was transformed into an emphasis on the everyday environment as an artistic medium. The philosophy of aestheticization of whole spaces expanded from his private spaces to public arenas as a natural outcome and extension of his chosen lifestyle.

Scott Burton also worked *within* the system through his unique functional sculptures, but unlike Judd, Burton made the pre-existing division visible in the public arena—declaring that "utility" is no longer a valid criterion for dividing fine art from decorative art. Neither Judd nor Burton sought a utopian or Platonic unity between art and life because they both wanted to offer experiences in the here-and-now. Judd was concerned with material things in space and focused on actual on-site experiences. Rather, Judd's pragmatic, rigorous attitude toward ways of living led him to negotiate between private and public, personal and political concerns. Judd's large-scale permanent installations are meant to be open to the public and some of them are furnished with beds and large benches, creating a sense of a gallery and a huge bedroom at the same time. Whether one would feel

comfortable or not sleeping overnight in such a big space, Judd's philosophy that art is not alienated from life is presented by the integration of the furniture in some of his permanent installations as well as his residences.

It is important to note that anarchists were not commonly utopians because they preferred to leave the future open-ended for the next generations rather than imposing grand blueprints which could prove to be a burden for those to come.[1] Woodcock saw that the here-and-now, existentialist nature of anarchists was flexible enough to contribute to reforming the modern, complex society in its own piecemeal processes while upholding individual freedom and responsibilities.

Judd basically left behind two independent foundations with different characters, the Chinati Foundation and the Judd Foundation. The former has had a public nature from its outset and remains in charge of operating large-scale, permanent installations by Judd and others that are open to the public, whereas the latter has a private character in the way in which it was established by his children with the pivotal task of maintaining Judd's own private properties, including his archives, collections, and estates. The destiny of the two foundations bespeaks in a way the open-ended endeavors that Judd trusted would carry on into the future. After all, Judd was never being absolutely specific in defining his creations as either art or functional objects; they are not quite definable, not identical, but reciprocal, existing at the practical level of creation and life.

Judd's creations were generated as he moved from one place to another and shaped his everyday life in clusters of immediate experience. Being in interior spaces designed by Judd, I felt that his artwork, furniture, and spaces in situ had inspired him to move physically and mentally—to actively think and to act thoughtfully in his spaces, local communities and natural environments. Using Judd's furniture is like sharing the physical experiences Judd went through. In other words, in part, one performs the same way Judd did in interacting with his furniture. Some furniture pieces with an ambiguous identity, both bench and bed or table and bench, allow free ways of interacting with them, whereas other furniture works are specifically designed to frame a particular way of using them, such as a chair, a large desk with open shelves, or a standing desk. If one doesn't want to or can't adjust to Judd's ways, one still can enjoy looking at his well-proportioned beautiful pieces of furniture as fine art objects. After all, how

1 Woodcock, "Anarchism Revisited," 59.

to perceive and interact with furniture pieces rests with audiences. The presence and participation of the audience is crucial to the criticism of furniture designed by artists, and this should always be a starting point as design and art discourse moves forward. This discourse is not directed toward a singular, utopian place, but to a space for negotiating, finding a better understanding of the philosophies of everyday life and the conditions of living environments without being hindered by the boundary between art and design. As long ethically motivated artists survive, functional art will continues to exist in a dysfunctional society. The neglect and underestimation of functional art due to its usability is amoral in today and the next society of tomorrow. Art has missions and social functions. Society should make art and let the participants be the judge what works and what doesn't work in their life and to their local community. Functional art and its ideas should be examined and adopted by individuals in everyday life and may eventually lead to a better functioning society. It is a piecemeal progress, but this is one way art can peacefully moves our complex and diverse society forward.

APPENDIX

FURNITURE COLLECTIONS AND INSTALLATIONS AT THE ARCHITECTURE STUDIO, MARFA

A close analysis of Judd's extensive furniture collections and installations at his Architecture Studio (The Bank) in Marfa will provide insights into how Judd located his own furniture to be seen in relation to early modern pieces of furniture by designers such as Alvar Aalto, Gerrit Rietveld, and Mies van der Rohe. Judd bought the former Marfa National Bank building in 1988 and installed his extensive collections of modernist and antique furniture there, along with art and furniture pieces of his own which he added during the early 1990s.[1] (fig.66) The building named the Architecture Studio was where Judd primarily worked on his design projects, and it has been informally called "The Bank" or "The Bank Building." The building was built in 1933 and designed by the architect Leighton Green Knipe.[2] It is located on the corner of Highland Avenue and Oak Street in the heart of town; windows on the front and the south side of the building invite plenty of light into the interior space. The design of the former bank appears to be an amalgam of an austere state office building in the academic tradition and a light-filled white cube in the modern architectural manner characteristic of the International Style that emerged in the 1920s.[3] It has a subtle, local touch in the

1 Urs Peter Flückiger's architectural study of Judd's residences, work places, and permanent installations in Marfa includes interior drawings indicating exact placements of each object. This is the latest contribution to the scholarship on Judd as a designer and architect. In the introduction of the book he emphasizes Judd's concern with proportions and symmetry as design principles that could be linked to a western classical tradition found in both Renaissance and some Modernist architecture such as that designed by Mies van der Rohe and Le Corbusier; Flückiger, *Donald Judd, Architecture*, 25–47, 110–17.
2 See the brief explanation of the Architecture Studio in Flückiger, *Donald Judd, Architecture*, 110–11.
3 See Henry Russel Hitchcock and Philip Johnson, *The International Style: Architecture Since 1922* (New York: The Museum of Modern Art, 1932). The term "International Style" was coined and disseminated through this book, which notwithstanding its oversimplifications had a crucial impact on defining the modern style in architecture to the public at large.

fig.66 Architechture Studio (The Bank), Marfa, photograph by author, 2006.

ceramic tiles that decorate its exterior facade and the interior mural depicting a landscape with cattle, illustrating the town's major business before World War II, namely ranching. The spacious entrance hall with high ceilings was a receiving area for customers, and there is another room beyond this large reception area on the ground floor. Judd renovated the ground floor into its essential structural elements as he stripped off the ceiling, and the air conditioning system it contained.[4] The former director's office was located on the mezzanine level, with windows overlooking the ground floor. The second floor consists of compartments of small or medium sized rooms, numbering eleven in all.

Judd's extensive collections of furniture at the Bank reflect his own taste in modern, antique, and vernacular furniture. Beginning in the 1960s, Judd admired and acquired furniture variously from the Arts and Crafts period and from Africa, along with more commonplace pieces. Later, in the early 1990s, he obtained a large amount of early modernist furniture. The wood furniture generally favored by Judd was not a random choice, but based on his preference for simplicity and clarity of structure and the straightforward use of materials.[5] Some of the pieces of antique furniture Judd acquired have some ornamental elements, but they are mostly modest and not excessively decorative.

Judd installed his own furniture made of wood, iron, and painted aluminum sheets alongside antique furniture and pivotal early modernist furniture by Alvar Aalto, Gerrit Rietveld, Mies van der Rohe, and Marcel Breuer. Although Judd did not use metal tubing in his own furniture designs, he saw the innovative industrial furniture by Le Corbusier, Breuer and Mies as an "almost forgivable sentimentalizing of the machine."[6] Judd collected metal tubing chairs by Mies,

4 Flückiger, *Donald Judd, Architecture*, 110–11.
5 Joseph Cunningham discusses how Judd's early artwork and furniture designs were inspired by the Arts and Crafts and Mission style furniture: i.e., "the vernacular Modernist designs" exemplified by Gustav Stickley and Gerrit Rietveld. Cunningham, "Then/Now: Decorative Art by Minimalist and Post-Minimalist Artists and Modern Design," in *Design≠Art*, 165.

whose design and architectural projects he greatly admired. However, Judd showed no interest in the further developments of new materials and technological advancements adopted in modern furniture design. Additionally, there is no furniture or functional objects made of plastics at the Architecture Studio. This demonstrates Judd's preoccupation with real materials (wood, stone, ceramics, or metal) in situ, whereas plastics are an artificial material which can imitate material surfaces of any kind.[7]

The installation of furniture at the Architecture Studio might appear to be arbitrary, but there is a subtly eclectic sense of a personal narrative embedded in Judd's selections and placement. (Judd did not collect any given modernist designer's works chronologically or comprehensively.) The first floor presents a combination of Judd's own furniture and early wall pieces, antique furniture, and modernist furniture and design objects. The mezzanine is primarily occupied by antique furniture and abstract paintings by other artists. The second floor is mainly devoted to Judd's furniture and modernist furniture along with Judd's furniture and architectural drawings and drawings by others. Among all the designers Judd collected, the Finnish architect and designer Alvar Aalto (1898–1976) is best represented, with a total of twenty-four furniture pieces, whereas Judd's own furniture pieces number eighteen in the interior of the Architecture Studio.[8] There are thirteen furniture pieces designed by Garret Rietveld (1888–1964) in addition to his two lamps, Hanging Lamp (1924) and Table Lamp (1925). There are six pieces of furniture by Mies van der Rohe and only one wood child's chair by Marcel Breuer.

Judd's preference for Aalto's furniture is intriguing in that Judd's preference for austere, hard-edged geometric forms in his furniture designs is in opposition to the gently fluid, curvy shapes of Aalto's furniture. Aalto is known for his humanistic modern designs, integrating overall organic shapes and using innovative bent plywood techniques. Judd seemed to be charmed by the beautiful simplicity and clear delineation of form in Aalto's furniture. Similarly, Judd's interest in Rietveld's

6 Judd, "It's Hard to Find a Good Lamp," 9.
7 See Roland Barthes's critical insight into plastic as magical "imitation materials," replacing precious natural substances including aortas. Roland Barthes, "Plastic," (1957); trans. Annette Lavers in *Mythologies* (New York: Hill and Wang, 1972), 97–99.
8 Judd bought about twenty pieces of furniture by Aalto during his trip to Helsinki, Finland in 1990. Ballantine, interview, 14 April 2006.

furniture had to do with its abstract quality and clarity of construction. Judd extensively collected the iconic furniture designs of Rietveld: the Berlin Chair (1923), Zig-Zag Chair (1932), Side Table (1923), Red and Blue Chair (1923; one copy made by Ichiro Kato for Judd), and Crate Chair (1934), in addition to two benches originally designed for Hoeksteen Church, Uithoorn (1963) are all found in the Architecture Studio.

There are also several pieces of furniture by Mies. Even though Breuer is better known for the bent tubular chair he designed while he was a member of Bauhaus, there is no metal tube furniture by Breuer at the Architecture Studio. Instead, Judd collected the same type of cantilever chairs designed by Mies whose precisely proportional details Judd must have deeply respected. However, Mies' celebrated Barcelona Chair is not to be found at the Architecture Studio. As far as I know, Judd did not collect the Barcelona Chair, which, with its luxurious, elegant leather cushions, typically occupies the entrance lobbies of fine hotels or corporate buildings. Judd instead chose the most austere and plain of Mies' furniture designs as they better fit his own perspective on modern furniture.

Unlike his focus on the simplest designs of early modernist furniture, Judd's collection of antique furniture at the Architecture Studio is very diverse in terms of formal qualities, periods and regions of origin. He installed antique wood furniture in Biedermeier and Shaker styles and rustic furniture from regions such as Africa, Sweden, Mexico, and United States. Each piece of antique furniture is marked either by formal sophistication or a bold, rustic quality. As such, each one has a very distinctive sense of presence in space.[9]

The antique, vernacular, wood furniture from different regions and periods on the first floor of the Architecture Studio gives the impression that commonplace furniture had a crucial impact on influencing modernist furniture designs such

[9] Judd liked Arts and Crafts furniture and put many pieces in his residence at La Mansana de Chinati (the Block) in Marfa. There is, however, no furniture by Rudolph M. Schindler at the Architecture Studio. Schindler's furniture is characterized by its robust dignity, large volume, and heavy weight, and constructed by sophisticated craftsmen using fine, thick, solid wood. Judd made a specific choice to eliminate austere Arts and Crafts furniture from the Architecture Studio. It seems that choice was determined by the characteristics of the architecture. The former office building has a modern, pristine outlook, whereas his primary residence, the Block, is a former hangar and has a rough, factory-like open space. The impressive volume of Arts and Crafts furniture better suited Judd's living room at the Block, with its rich, adobe wall texture, rather than the pristine, light-filled modernist, environment of white enclosures at the Architecture Studio.

Fig. 67 Architecture Studio, view of ground floor, main hall with modernist, antique, and Judd's furniture, photographer Florian Holzherr, Image Courtesy Judd Foundation/Judd Furniture

as Mies's cantilever chair and Rietveld's church benches, especially as they are all arranged in the same space. (fig.67) But some of the large, antique furniture in the entrance hall on the ground floor is rather vulgar and worn out. Judd symmetrically laid out a big, thick, antique wood table side by side with his large, grid iron table and solid wood chairs in the central area of the ground floor. Compared with the bulky, somewhat clumsy antique furniture, Judd's furniture appears more simple, skeletal, and modern. However, the chronological gap is leveled by the fundamental formal similarity of plain geometry among different pieces of furniture and their symmetrical installation, which creates a sense of order among the varieties of furniture installed in the entrance hall.

The director's office at the mezzanine level is entirely occupied by antique furniture, a set of table and chairs in the Biedermeier style, a piece of Shaker furniture, and other artworks, including a large abstract painting by Larry Bell and a picture by Josef Albers. None of Judd's own furniture or artwork is present on the mezzanine level. The nature of this space is intimate compared with the large entrance hall on the ground floor.

Although the Biedermeier style could be both ornate and austere, its primary features of simplicity, proportion, and utility were conceived for an educated taste

and embraced by the emerging middle class in central Europe and Scandinavia during the early decades of the nineteenth century, and it had a crucial impact on the development of modern furniture design.[10] Shaker furniture has also been known for its perfect unity between function and form and its beautifully crafted proportions. Both Biedermeier and Shaker furniture may in a sense be seen as embodiments of the social, cultural and moral values of their owners. And Judd's choosing this furniture be seen as an indicator of his views about these forerunners to modernist furniture. This glimpse of a prehistory of the development of modern furniture design at the mezzanine level serves as a prelude to the second floor and its arrangement of modernist furniture primarily designed in the early twentieth century.

Judd displayed much of his own wood and aluminum furniture along with canonical modernist furniture pieces on the second floor of the Architecture Studio. Interestingly, Judd did not include any of his own rustic, humbly-made wood furniture at the location. Rather than using such intentionally naïve, do-it-yourself furniture to represent himself in this context, he instead presented finely made furniture pieces. This was rather an ambitious attempt on Judd's part as a professional designer to stage his furniture amongst modernist, progressive design works. Once Judd employed others to construct his furniture designs, he was able to play the skill level up or down. Moreover, he could shift occupational identities among artist, designer, and amateur do-it-yourselfer once his things were made by others.

There is not much emphasis on technological development and material advancement in Judd's furniture compared with early modernist furniture. For instance, Judd explored furniture made of industrial materials such as sheet metal as early as 1971 in pieces fabricated by the Bernstein Brothers. The use of sheet metal for furniture was not novel in the early 1970s because it has been in use in office furniture before the war. Sheet metal furniture has the practical advantage of being non-flammable and collapsible for easy transport, but it tends to be unattractive because of its angular shapes and dim colors.[11] Still, even today sheet

10 Biedermeier is attributed to "the period between 1815 and 1848 in Germany and to styles, furnishings, etc., characteristic of that period, esp. to a type of furniture derived from the French Empire style," according to *Oxford Dictionary*, 2d ed., s.v. "Biedermeier." See also *Biedermeier, The Invention of Simplicity*, ed. Albrecht Pyritz, Maria Luise Stemath-Shuppanz, Paul Asenbaum and others (Ostfildern: Hatje Cantz, 2006).

metal designs widely serve in office interiors to keep files safe; to provide sturdy, tall book shelves; and to comprise large desks with cabinets.

Compared with such routine and substantial office furniture, the novelty of Judd's painted aluminum furniture is found in its relatively small scale and its introduction of up to twenty brilliant colors. All the pieces in Judd's series of aluminum sheet metal furniture are not large and are rather suited for domestic use, including a design of a bed. The tallest design, a set of aluminum book shelves, is 100 cm (39.37 inches) high, and the widest piece is a bed with a width of 200 cm (78.75 inches). The aluminum desk is square like a table and measures 100 cm x 100 cm (39.37 inches x 39.37 inches). Unlike some metal office furniture, made with a view to economizing on transportation costs, Judd's aluminum furniture is not collapsible. Rather than undertaking to design novel technically-invested pieces of furniture, Judd would find alternative forms for furniture made of aluminum sheets using pre-existing methods of fabrication, while developing the less-explored area of aluminum furniture for home interiors.

The formal similarities between Judd's furniture and early modernist furniture are found in their shared interest in proportional balance, abstract formal elements, and simplicity of structure and clarity of volume. Many chairs sharing the same room on the second floor are facing in directions evidently calculated for an optimum display position as one enters, more so than for use. There is enough space between each piece of furniture to allow visitors to inspect each object like an art piece. It is unlikely that all the pieces of furniture at the Architecture Studio were in use on a daily basis. Judd used the Architecture Studio for his design projects; many drawings of ideas for furniture were left on desks on the second floor at the time of his death. The space was both a showcase for his favorite design items and a workplace for Judd. It was a creative workplace for the artist to be inspired and surrounded by a variety of notably beautiful pieces of furniture made of real, non-plastic materials.

In collecting furniture, Judd made eclectic choices from modern and antique designs that were compatible with his pragmatist philosophy and straightforward use of materials in clearly defined forms and spaces. It is noteworthy that—whereas some asymmetrical pieces of furniture by Rietveld and an armchair with a curved plywood back by Aalto seem almost to float in the air—Judd's primarily

11 Gordon Logie, *Furniture from Machine* (London: George Allen and Unwin, 1947), 111–18.

symmetrical, cubic furniture never appears to be suspended in space, but rather seems as if fixed to the ground where it stubbornly stands. Judd's unexpected, curious juxtapositions of different kinds of old and new furniture pieces arranged in symmetrically ordered spaces bespeak a vision that resisted the major, linear, historical framework with its designations of advanced or regressive, novel or anachronistic modes in furniture designs. There is no hierarchy imposed among the various pieces of furniture Judd collected in terms of technological development. The Architecture Studio became a sort of time capsule of Judd's vision in which the various pieces of furniture from different places and time periods all reside together in the same space without conflict.

BIBLIOGRAPHY

Philosophies of Anarchism

Apter, David E, and James Joll. *Anarchism Today*. Garden City, N.Y.: Doubleday, 1972.
Armand, Emile. *Anarchism and Individualism*, Three Essays by E. Armand. London: S.E. Parker, 1962.
_____. *Four Essays on Individualist Anarchism*. London: Libertaria, 1972.
Barclay, Harold. *Culture and Anarchism*. London: Freedom Press, 1997.
Bookchin, Murray. *The Modern Crisis*. rev. 2d ed. Montreal and New York: Black Rose Books, 1987.
_____. *The Ecology of Freedom: The Emergence and Dissolution of Hierarchy*. rev. ed. Montreal and New York: Black Rose Books, 1991.
_____. *The Philosophy of Social Ecology: Essays on Dialectical Naturalism*. rev. 2d ed. Montreal and New York: Black Rose Books, 1995.
_____. *Social Anarchism or Lifestyle Anarchism, an Unbridgeable Chasm*. San Francisco: AK Press, 1995.
Carter, April. *The Political Theory of Anarchism*. New York and London: Harper & Row, Publishers, 1971.
DeLeon, David. *The American as Anarchist: Reflections on Indigenous Radicalism*. Baltimore and London: Johns Hopkins University Press, 1978.
Gilbert, James. *Another Chance: Postwar America, 1945–1985*. 2d ed. Chicago: Dorsey Press, 1986.
Goldman, Emma. *Living My Life*. Vol. I and II. 1931, Reprint. New York: Da Capo Press, 1970.
Goodman, Paul. *Art and Social Nature*. New York: Vinco Publishing, 1946.
_____. "The Black Flag of Anarchism." *New York Times*, 14 July 1968, SM 10–13.
Goodway, David., ed. *For Anarchism: History, Theory, and Practice*. London: Routledge, 1989.
Klaus, H. Gustav, and Stephen Knight., ed. *'to Hell with Culture': Anarchism and Twentieth-Century British Literature*. Cardiff, U.K.: University of Wales Press, 2005.
Landstreicher, Wolfi. *From Politics to Life: Ridding Anarchy of the Leftist Millstone*. Los Angeles: Venomous Butterfly Publications, 2002.
Leuchtenburg, William E. *A Troubled Feast: American Society since 1945*. rev. ed. Boston and Toronto: Little, Brown and Company, 1979.
Marshall, Peter. *Demanding the Impossible: A History of Anarchism*. London: HarperCollins Publishers, 1992.
Mumford, Lewis. *The Condition of Man*. New York: Harcourt, Brace, 1944.
_____. *Roots of Contemporary American Architecture*. New York: Reinhold, 1952; 2d ed. New York: Grove Press, 1959.
_____. "Authoritarian and Democratic Technics." *Technology and Culture* 5 (1964): 1–8.
_____. *The Myth of the Machine*. New York: Harcourt, Brace & World, 1967.
_____. *The Lewis Mumford Reader*, ed. Donald Miller. New York: Pantheon Books, 1986.
Read, Herbert. *To Hell with Culture and Other Essays on Art and Society*. New York: Schocken Books,

_____. "Chair as Art." *New Society*, 20 April 1967, 566–68.
_____. *Theory and Design in the First Machine Age*. 2nd ed. New York and Washington: Praeger Publishers, 1967.
_____. *The Aspen Papers: Twenty Years of Design Theory from the International Design Conference in Aspen*. New York and Washington: Praeger Publishers, 1974.
_____. *Reyner Banham: Design by Choice*, ed. Penny Sparke. New York: Rizzoli 1981.
Battcock, Gregory, ed. *Minimal Art: A Critical Anthology*. New York: E.P. Dutton, 1968. Reprint, Berkeley, Calif.: University of California Press, 1995.
Baudrillard, Jean. "The System of Objects." In *Design after Modernism, Beyond the Object*, ed. John Thackara, 171–82. New York: Thames and Hudson, 1988.
Betsky, Aaron. *Sitting on the Edge: Modernist Design from the Collection of Michael and Gabrielle Boyd*. San Francisco: San Francisco Museum of Modern Art, 1998.
Beyer, Steven, and Mark Robbins. *Against Design*. Philadelphia: Institute of Contemporary Art, University of Pennsylvania, 2000.
Bishop, Claire. "Antagonism and Relational Aesthetics." *October* 110 (Fall 2004): 51–79.
_____, ed. *Participation*. London: Whitechapel; Cambridge: MIT Press, 2006.
Bloemink, Barbara, and Joseph Cunningham. *Design ≠ Art: Functional Objects from Donald Judd to Rachel Whiteread*. New York: Merrell and Cooper-Hewitt National Design Museum, 2004.
Bochner, Mel. "Art in Process-Structures." *Arts Magazine* 40, no.9 (September/October 1966): 38–39.
Boles, Daralice Dankervoet. "The Good, the Bad and the Ugly." *Industrial Design* 31, no.3 (May/June 1984): 16–21.
Bourdieu, Pierre. *Distinction, a Social Critique of the Judgment of Taste*. Translated by Richard Nice. Cambridge: Harvard University Press, 1984.
Bourdon, David. "The Razed Sites of Carl Andre, a Sculptor Laid Low by the Brancusi Syndrome." *Artforum* 5, no.2 (October 1966): 15–17.
Bourriaud, Nicolas. *Relational Aesthetics*. Translated by Simon Pleasance and Fronza Woods. English ed. Dijon: Les presses du réel, 2002.
Bowsher, John, Frances Colpitt, Ronny Cohen, John Perreault, and Melinda Wortz. "Furniturism: Four Artists New Sculpture or High-Priced Furniture." *Los Angeles Institute of Contemporary Art Journal* 36 (Spring 1983): 60–71.
Brett, Guy. "Documenta 8: Myth and Mummification." *Studio* 200, no.1018 (November 1987): 3–7.
Buchloh, Benjamin H. D. "Critical Reflections." *Artforum* 35, no.5 (January 1997): 68–69,102.
Bürger, Peter. "Aporias of Modern Aesthetics." In *Thinking Art: Beyond Traditional Aesthetics*, ed. Andrew Benjamin and Peter Osborne, 3–16. London: Institute of Contemporary Arts, 1991.
Burton, Scott. "An Article on Scott Burton, in the Form of a Resume." *Art-Rite* 8 (Winter 1975): 8–10.
_____. "Situation Esthetics: Impermanent Art and the Seventies Audience." *Artforum* 18, no.5 (January 1980): 23–24.
_____. "Furniture Journal: Rietveld." *Art in America* 68, no.9 (November 1980): 102–08.
_____. "My Brancusi." *Art in America* 78, no.3 (March 1990): 149–58.
_____, Lynne Cooke, Richard Francis, and Jiri Svestka. *Scott Burton, Sculptures 1980–1989*. Dusseldorf: Kunstverein für die Rheinlande und Westfalen, 1989.
Campbell, Robert, and Jeffrey Cruikshank. *Artists and Architects Collaborate: Designing the Wiesner Building*. Cambridge: MIT Press, 1985.
Casciani, Stefano. "Artist Furniture: A Difficult Balance." *Abitare* 314, no.166 (January 1993): 118–22.

Chave, Anna C. *Constantin Brancusi: Shifting the Bases of Art*. New Haven: Yale University Press, 1993.
———. "Minimalism and Biography." *Art Bulletin* 82, no.1 (March 2000): 149–63.
———. "Revaluing Minimalism: Patronage, Aura, and Place." *Art Bulletin* 90, no.3 (September 2008): 466–86.
Coles, Alex. *Designart: On Art's Romance with Design*. London: Tate Publishing, 2005.
———, ed. *Design and Art*. London: Whitechapel; Cambridge: MIT Press, 2007.
Cranz, Galen. *The Chair: Rethinking Culture, Body, and Design*. New York and London: W.W. Norton & Company, 1998.
Danto, Arthur. *397 Chairs: Based on an Exhibition Created by the Architectural League of New York*. New York: Harry N. Abrams, 1988.
de Zurko, Edward Robert. *Origins of Functionalist Theory*. New York: Columbia University Press, 1957.
Documenta 7. Vol. I and II. Kassel: Paul Dierichs, 1982.
Documenta 8. Vol. I, II and III. Kassel: Weber & Weidemeyer, 1987.
Domergue, Denise. *Artists Design Furniture*. New York: Henry N. Abrams, 1984.
Drucker, Peter F. *Technology, Management, and Society*. New York: Harper & Row Publishers, 1970.
———. *Adventures of a Bystander*. New York: Harper & Row Publishers, 178.
———. *Managing the Non-Profit Organization*. New York: HarperCollins, 1990.
———. *The Ecological Vision*. New Brunswick, NJ: Transaction Publishers, 1993.
———. *Management Challenges for the 21st Century*. New York: HarperCollins, 1999.
———. *Managing in the Next Society*. New York: St. Martin's Press, 2002.
Dubois, J. Harry. *Plastics History U.S.A.* Boston: Cahners Books, 1972.
Finger, Anke and Danielle Follett eds. *The Aesthetics of the Total Artwork*. Baltimore, Maryland: The John Hopkins University Press, 2011.
Flavin, Dan. "'... In Daylight or Cool White,' an Autobiographical Sketch." *Artforum* 4, no.4 (December 1965): 21–24.
Forty, Adrian. *Objects of Desire*. New York: Pantheon Books, 1986.
Foster, Hal. *Design and Crime (and other Diatribes)*. London: Verso, 2002.
Fox, Judith Hoos. *Furniture, Furnishings: Subject and Object*. Rhode Island: Museum of Art Rhode Island School of Design, 1984.
Gilman, Naomi. *American Chairs: Form, Function and Fantasy*. Sheboygan, Wisc.: John Michael Kohler Arts Center, 1978.
Gloag, John. *Furniture from Machine*. London: George Allen and Unwin Ltd, 1947.
Graham, Dan. "Home for America." *Arts Magazine* 41, no.3 (December/January 1966/67): 21–22.
———. *Art as Design, Design as Art*. Edinburgh: Fruitmarket Gallery, 1987.
Hanks, David A, and Anne Hoy. *Design for Living*. New York: Flammarion; Montreal: Montreal Museum of Fine Arts, 2000.
Harleman, Kathleen, Linda Taalman, Alan Koch, Cara Mullio, and L.D. Riehle. *Trespassing: Houses X Artists*. Los Angeles: MAK Center for Art and Architecture, 2002.
Haskell, Barbara. *Blam! The Explosion of Pop, Minimalism, and Performance 1958–1964*. New York: Whitney Museum of American Art, 1984.
Hogben, Carol., ed. *Modern Chairs 1918–1970*. London: Whitechapel Art Gallery; Boston: Boston Book and Art Publisher, 1970.
Holt, Steven. "Venturi and Diffrient: From a Single Root." *Industrial Design* 31, no.3 (May/June 1984): 28–37.

Huygen, Frederike. "Art - Design." *Kunst & Museumjournaal* 3, no.5 (1992): 14–19.
Irace, Fulvio. "If Art Is Mobile." *Abitare* 281, no.134 (January 1990): 129.
Johnstone, Stephen., ed. *The Everyday*. London: Whitechapel; Cambridge: MIT Press, 2008.
Kalina, Richard. "Figuring Scott Burton." *Art in America* 80, no.1 (January 1992): 96–99.
Kirwan-Taylor, Helen. "Art by Design." *Art Review* 2, no.2 (February 2004): 48–53.
Koss, Juliet. *Modernism after Wagner*. Minneapolis: University of Minnesota Press, 2010.
Kuo, Michelle. "Industrial Revolution." *Artforum* 46, no.2 (October 2007): 306–14, 396.
Kuspit, Donald. "Scott Burton." *Artforum* 21, no.7 (March 1983): 78.
Kwon, Miwon. *One Place after Another: Site-Specific Art and Locational Identity*. Cambridge: MIT Press, 2002.
Last, Nana. "Function and Field: Demarcating Conceptual Practices." In *Theory in Contemporary Art since 1985*, ed. Zoya Kocur and Simon Leung, 318–30. Malden, Mass: Blackwell Publishing, 2005.
Lawrence, Sidney. "Declaration of Function: Documents from the Museum of Modern Art's Design Crusade, 1933–1950," *Design Issues* 2, no.1 (Spring 1985): 65–77.
Lewin, Susan Grant., ed. *Formica & Design, from the Counter Top to High Art*. New York: Rizzoli, 1991.
LeWitt, Sol. "Paragraphs on Conceptual Art." *Artforum* 5, no.10 (June 1967): 79–83.
Lind, Maria, and Sara Ilstedt Hjelm. *What If Art on the Verge of Architecture and Design*. Stockholm: Moderna Musset, 2000.
Logie, Gordon. *Furniture from Machine*. London: George Allen and Unwin, 1947.
Maciariello, Joseph A. and Karen E. Linkletter. *Drucker's Lost Art of Management*. New York: McGraw-Hill Books, 2011.
Madoff, Steven Henry. "Richard Artschwager's Sleight of Mind." *Art News* 87, no.1 (January 1988): 114–21.
Margolin, Victor., ed. *Design Discourse: History, Theory, Criticism*. Chicago and London: University of Chicago Press, 1984.
Masheck, Joseph. "Embalmed Objects: Design at the Modern." *Artforum* 13, no.6 (February 1975): 49–55.
———. "The Carpet Paradigm: Critical Prolegomena to a Theory of Flatness." *Arts Magazine* 51, no.1 (September 1976): 82–109.
McDonough, Michael. "Taste, Risk and the Party Line." *Industrial Design* 31, no.3 (May/June 1984): 22–27.
Meikle, Jeffrey L. *American Plastic, a Cultural History*. New Brunswick, N.J.: Rutgers University Press, 1995.
Melchionne, Kevin. "Cultivation: Art and Aesthetics in Everyday Life." Ph.D. diss., State University of New York at Stony Brook, 1995.
Morineau, Camille. "Art and Design: Yes, but Who Designed the Urinal?" *Art Press* 287 (Fall 2003): 39–49.
Mous, Huub. *Furniture as Art*. Rotterdam: Museum Boymans-van Beuningen, 1988.
Murayama, Nina. "Furniture and Artwork as Paradoxical Counterparts in the Works of Donald Judd." *Design Issues* (Summer 2011): 47–59.
Murphy, Kevin D. "Design ≠ Art: The Debate Continues at the Cooper-Hewitt." *Art New England* 26, no.2 (April/May 2005): 16–17, 59.
Naumann, Francis. "From Origin to Influence and Beyond: Brancusi's 'Column without End'." *Arts*

FUNCTIONAL ART IN A DYSFUNCTIONAL SOCIETY
DONALD JUDD'S FURNITURE

2015年2月28日　第1版第1刷発行	検印省略

<div>

著　者　村　山　に　な

発行者　前　野　　　隆

発行所　㈱ 文　眞　堂
東京都新宿区早稲田鶴巻町533
電　話　03(3202)8480
FAX　03(3203)2638
http://www.bunshin-do.co.jp/
〒162-0041 振替00120-2-96437

</div>

印刷・真興社／製本・イマヰ製本所
© 2015
定価はカバー裏に表示してあります
ISBN978-4-8309-4840-4　C3071